CUT FROM PLAIN CLOTH

The 2011 Wisconsin Workers Protests

Publisher's Cataloging-in-Publication Data
(Provided by Quality Books, Inc.)

Weidemann, Dennis.
 Cut from plain cloth : the 2011 Wisconsin workers rallies / by Dennis Weidemann.
 p. cm.
 ISBN-13: 978-0-9796852-1-7
 ISBN-10: 0-9796852-1-4

 1. Labor movement--Wisconsin--History--21st century. 2. Protest movements--Wisconsin--History--21st century. 3. Labor laws and legislation--Wisconsin. I. Title.

HD8083.W6W45 2011 331.8'09775
QBI11-200023

Printed in the United States of America by Worzalla Publishing, Stevens Point, Wisconsin.

CUT FROM PLAIN CLOTH

The 2011 Wisconsin Workers Protests

Dennis Weidemann

BERENS HOUSE

CONTENTS

PREFACE

By the time I graduated from high school in 1976, protesting had succumbed to a changing world. The Vietnam War was over, the Civil Rights Act had been around for a decade, and the Environmental Protection Agency had been created to prevent rivers from catching fire. That's not to say my class didn't get up in arms over important issues. We did boycott tasteless school lunches. For twenty minutes one day, we marched in solidarity over bad mac and cheese.

Although I missed out on the protest era, when the Wisconsin demonstrations presented an opportunity to see what it may have been like, I didn't immediately jump in there. I'm old, brittle, and don't like crowds. And, really, who but crazy people would march in the snow for hours holding a sign on a stick? But, my wife, who is braver than me, did go downtown.

Each night she would come home, peel off seven layers of winter clothing, and tell stories about the people she met—people who sounded a lot like our neighbors.

I had to go see for myself, and was instantly fascinated by both the number and diversity of protesters. They *were* our neighbors—farmers, librarians, firefighters, police officers, potato factory workers, and teachers. And that is who this book is about. It is about those thousands of tiny faces in the vast crowds. It is about the finely dressed corporate wife dancing with the drummers. It is about Amanda, who after being interviewed for a half hour, suddenly got nervous and said, "I'm not used to people listening to what I have to say."

It is about us.

INTRODUCTION

On an otherwise unremarkable Friday in February 2011, the new governor of Wisconsin unveiled a budget bill containing drastic changes in state policy, including an end to most collective bargaining rights for public employees. The following Monday, Valentine's Day, a group of students from the University of Wisconsin Teaching Assistants' Association marched on the Capitol to deliver valentines opposing the bill. By Saturday, tens of thousands of protesters from all walks of life circled the statehouse, capping off the first week in a series of demonstrations that would become the largest to hit Wisconsin in forty years.

The peak protests took place in February and March, with the largest rally drawing an estimated 150,000 people. Marked by extraordinary peace and diversity, the demonstrations continued into the summer, and at the time of this writing, smaller groups still converge on the Capitol.

Historians and policy analysts will debate the politics and issues behind the protests for decades; the text of this book leaves such tasks to them. The nineteen stories included here are intended for another purpose—to peek into the lives of ordinary citizens willing to stand in opposition to their government. Until now, their stories have gone largely untold, which is unfortunate, because protesting is as old as America. As one person recently remarked, "We are a country of rebels. Why does *this* surprise anyone?" It should not, but maybe we just surprise ourselves.

It should be noted that no real names are used in this book. Farmston does not exist, but the community it represents does. This decision was not at the behest of interviewees. Many were happy to use their real names; however, anonymity allowed people to relax and speak openly when approached by a stranger with a notepad, claiming to be writing a book.

Throughout these pages, one theme stands—ordinary people are far from ordinary. Every protester has a unique story. Perhaps something in their history drew them to Madison. Perhaps they took away a new thought or value. Some of the stories are emotional. Others are humorous. All of them provide an intimate look into the 2011 worker protests, and those rebels we call Americans.

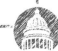

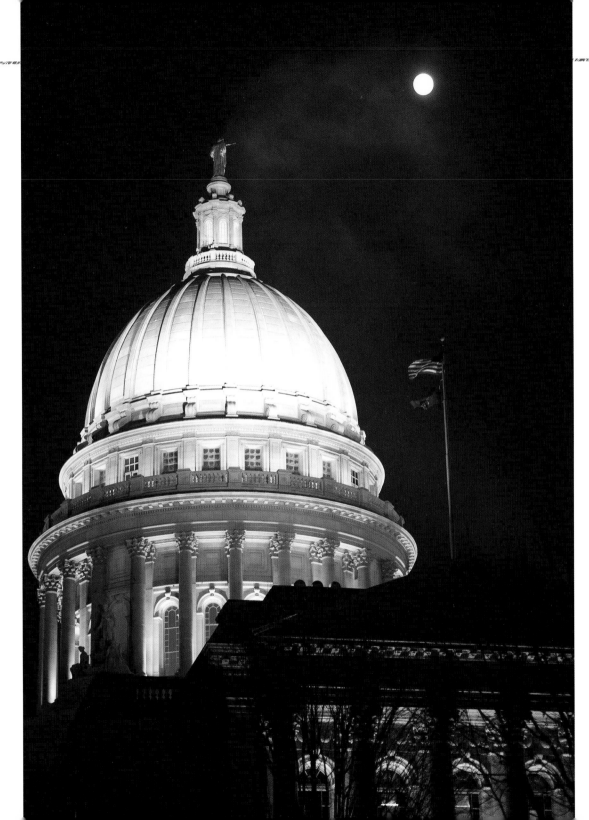

For those whose lives make history, but whose names do not.

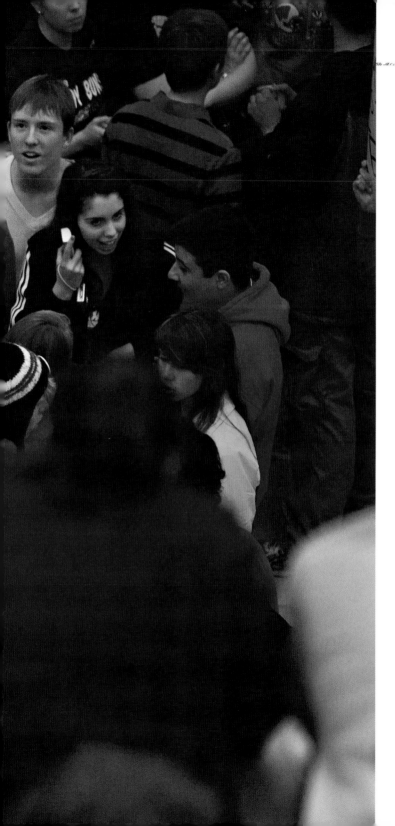

LA REVOLUCIÓN

It is lunchtime at a high school in Madison, Wisconsin. A Spanish teacher of twenty years sits at her desk, catching up on a four-day backlog of lesson plans. Classes had been postponed for nearly a week when teachers joined the protests against the governor's bill to restrict collective bargaining for state employees. A second-generation Italian immigrant, Mrs. B has toiled her way to the top of the teaching profession, winning awards for creativity and dedication. She wrote the grant proposal that got her school SMART Boards—magic devices that are more advanced than Princess Leia's holographic cry for help in the original *Star Wars*. Every fourth weekend, she voluntarily drives four hours to attend a meeting dedicated to better teaching.

Glancing up from her papers, she notices a tall, sturdy boy with dangling dreadlocks enter the door. A tough kid perched on the fence of life, he often stops at lunch to get the assignment he has procrastinated, then tries to finish it before the afternoon class. More times than not, he doesn't. It is not because he lacks the skill, or even the drive; his personal life just always seemed to be in some stage of upheaval. Once when he was late, he told Mrs. B, "I had to keep my friends from getting into a fight."

Approaching the desk, the young man quietly asks for the previous day's homework, averting his eyes from the fiery Italian who peers at him with raised eyebrows. He knows the drill. He must first suffer the *look* from Mrs. B—that universal teacher tool capable of seeing through the deepest of crapola.

Assignment in hand, the boy lingers uncharacteristically, shifting his weight from foot to foot. It is obvious he wants to say something to the woman whose suburban life is alien to his, but he can't find the right words. Suddenly, his eyes glow and he turns to fix her with an unblinking gaze.

"Ya'll went all revolutionary on us, Señora!"

Mrs. B smiles. Teachers are under a school administration "gag order" to refrain from talking to students about why they are protesting. She disagrees with the "silence policy," but is already going to be fined four days' salary and will have to make up any lost time. After a moment of thought, she answers carefully, "Sometimes you have to stand up for what you believe."

"Viva La Résistance!" snaps the boy in his best French accent, beaming at his teacher as if he has just seen her for the first time.

"Viva La Revolución," corrects Mrs. B. "This is Spanish." ★

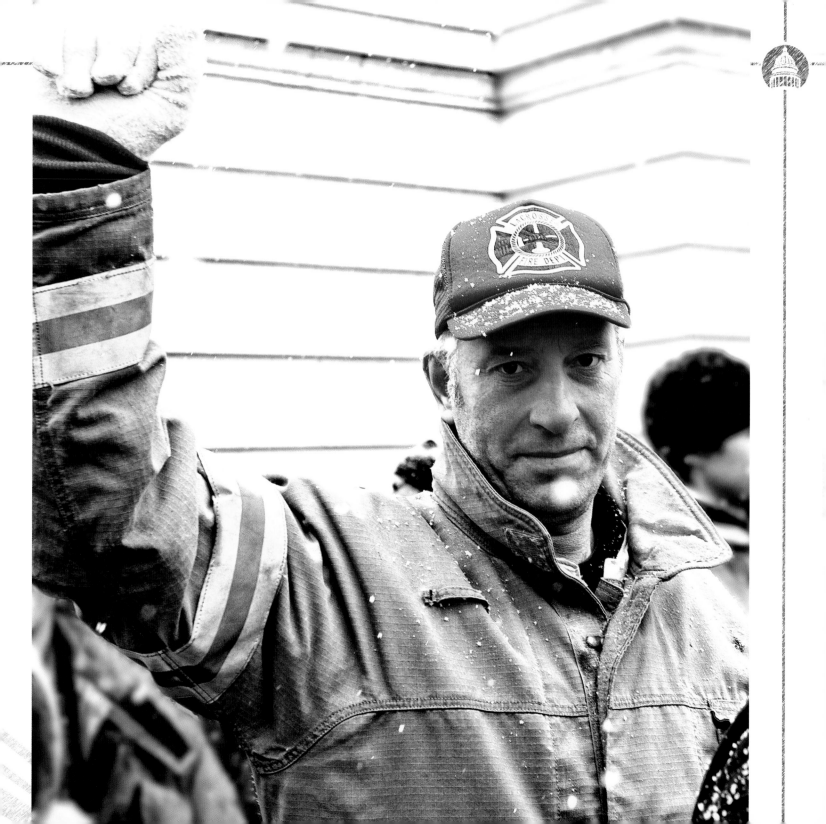

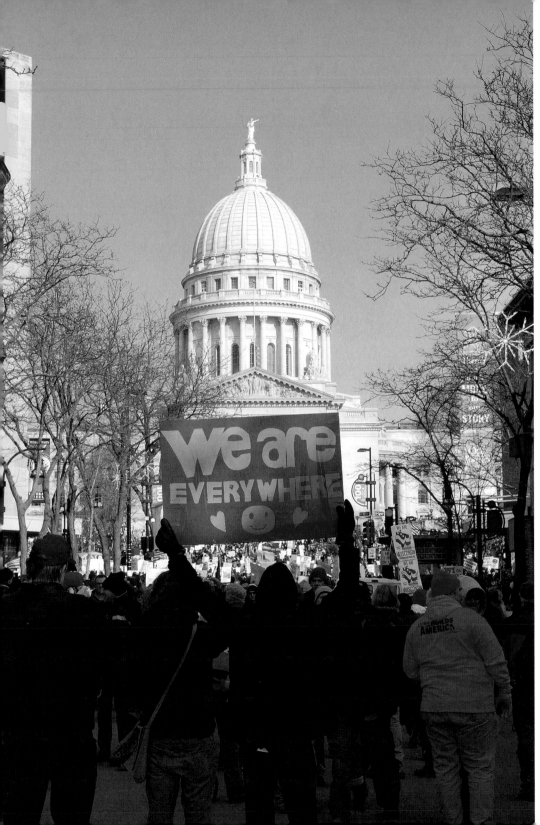
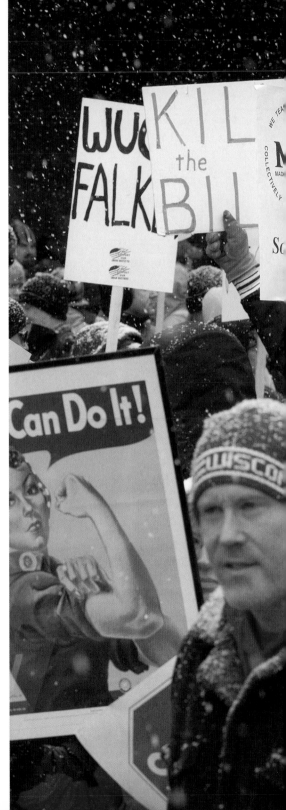

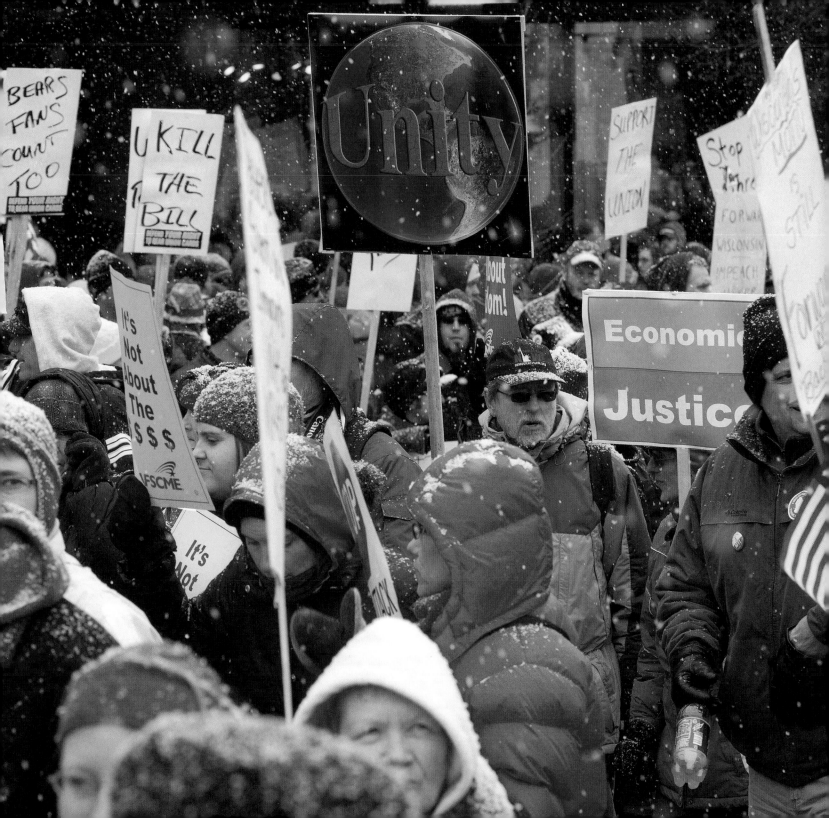

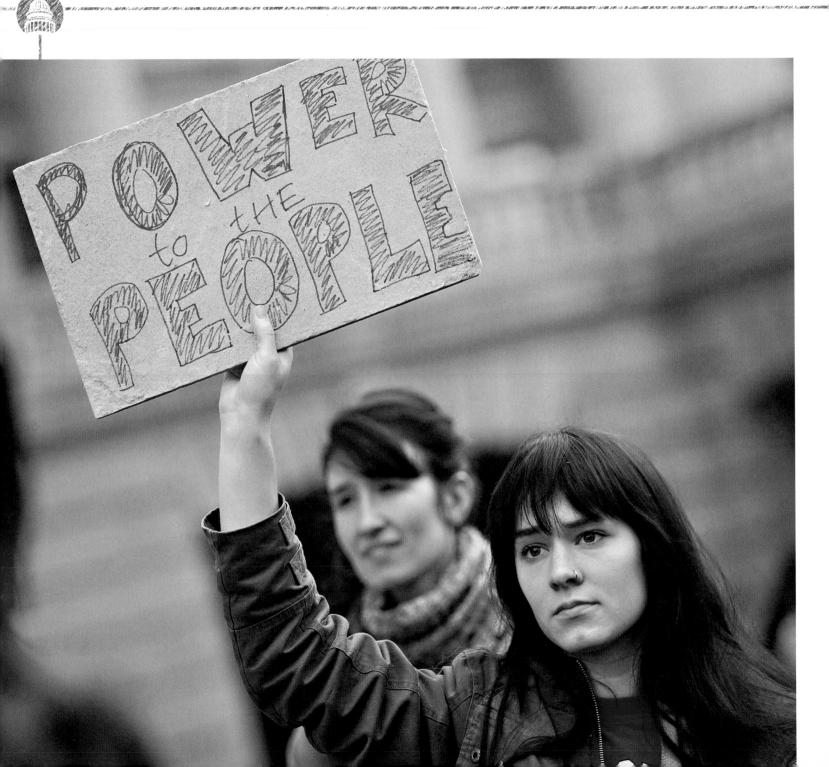

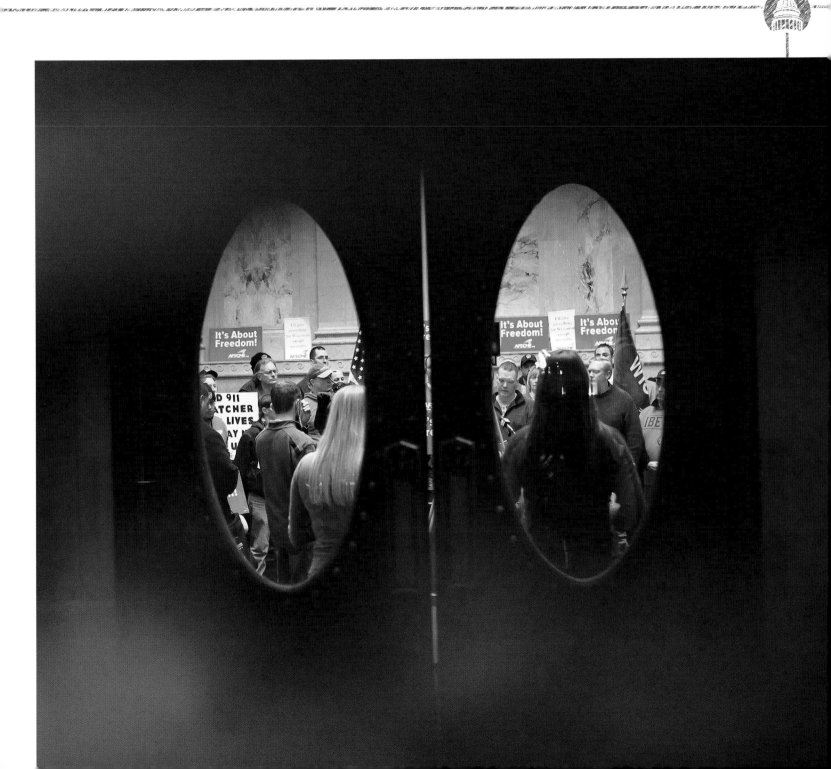

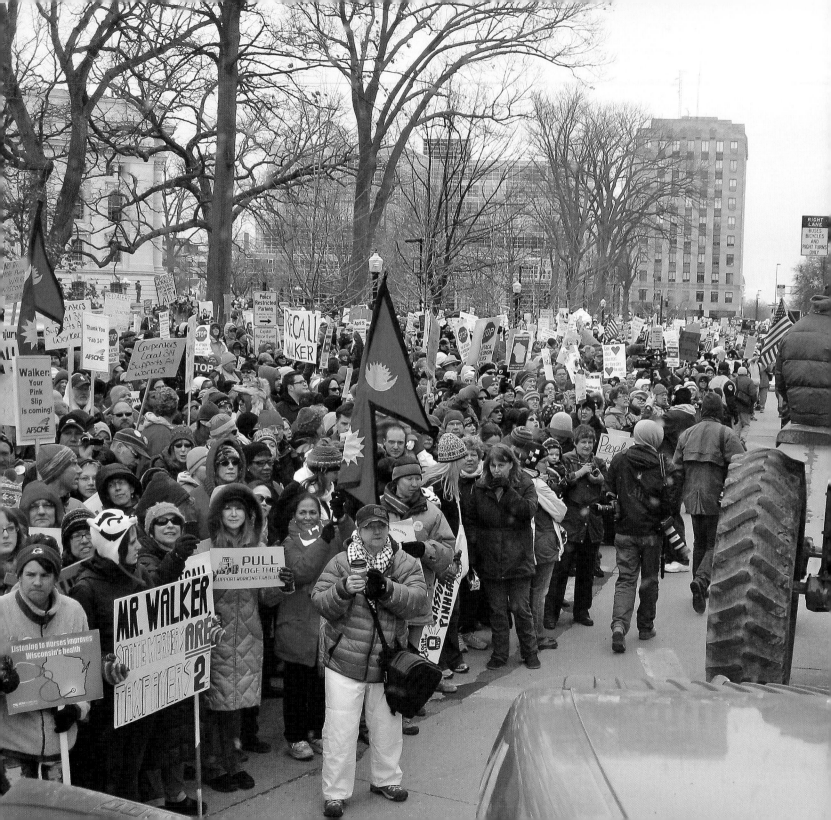

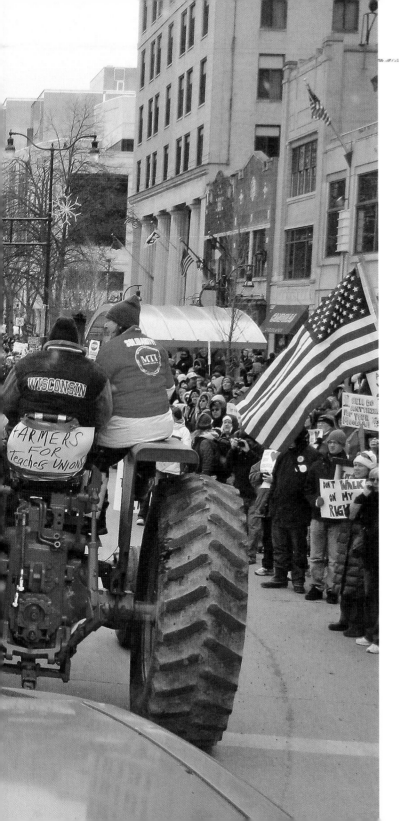

GOIN' TO TOWN

If Midwesterners are the salt of the earth, Midwest farmers are the salt mine. They will kindly tow a city slicker's car out of the ditch in a raging blizzard, call him an imbecile for traveling in bad weather, then feed him steak. Matched only by cowboys for their individualism, soil tillers rarely protest—but when they get riled enough to take action, they do it with style. Dumping milk, blocking roads, and penny auctions are all written in farm history. Although such extremes are absent in Madison, farmers don't just show up with a sign and a stick; they bring power tools.

When a train of tractors crosses the John Nolen causeway into a downtown bursting with 150,000 protesters, the re-action is more akin to a Bon Jovi concert than a demonstra-tion. Rapturous supporters jump around, cry, kiss, and grasp at the rock stars of dirt. There are blue-collar groupies, white-collar groupies, self-employed groupies, and strollers filled with future groupies.

To those who grew up in the country, the fuss might seem strange. Farm work is hardly supermodel glamorous. Coun-try life is epitomized by a shivering neighbor kid who dragged a load of grain to town behind an uncovered tractor every morning. But, on "farm day" at the Capitol, cow pie–covered boots are as dazzling as Elle Macpherson's swimsuit. It's as if protesters are searching for something in the humble life of farming. They may not know what beacon calls to them, but they cannot resist—nor do they want to.

Finding a farmer to interview is not easy. Not because farmers don't like to talk; they will happily argue about weather, seed corn, and politics, in that order. Rather, it takes hours for things to calm down enough to get near one. By midafternoon, I catch up with Joe, who is futzing with his tractor, as farmers do.

Joe's family has milked cows in central Wisconsin for one hundred and fifty years. His grandpa stored their frugal earnings in a Bible, preferring the Lord's protection over a bank's iron safe. When asked why, Grandpa would say, "What safer place is there?"

Farmers don't waste time explaining the obvious.

No sooner does Joe start speaking when marchers stop to listen. He does not mind, and continues to chat like we are dairy-men shooting the breeze outside the café on Main Street. The last active farmer in his lineage, Joe has witnessed the tragedy of hard times.

"We're an independent lot," he muses. "When farmers go under, instead of reaching out for help, they pull back." Joe shakes his head in sorrow for someone he obviously knows.

As the audience grows, they are spellbound by Joe's openness, a well-known, and sometimes harsh, trait of farmers.

"Eleven thousand Wisconsin farm families rely on BadgerCare (a program affected by the legislation) for health insurance. A friend just died in a farm accident, and his wife is selling the farm next week. Now she has to worry about insurance? This guy [the governor] thinks he is making things better?"

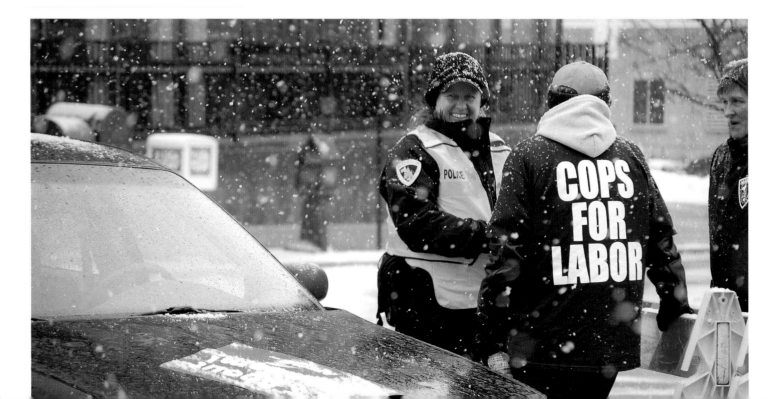

More protesters stop to hear Joe's impassioned words, and my role quickly shifts from interviewing to observing.

"So, what's this got to do with collective bargaining?" asks a man in shiny shoes.

"Eighty percent of Wisconsin raw milk is sold through co-ops," explains Joe. "What's a co-op? Collective bargaining. Farmers work as a group to get a fair price from buyers."

As Joe talks to his new city friends, there seems to be more between them than mutual interest in social issues. Joe is drawing them in, but the reason is unclear. It is not long before protesters are stopping to chat about outwardly random topics.

"Hey Joe. This guy has three Allis-Chalmers he is working on. I thought you might be interested." A farmer's office has no walls.

"Hey Joe. I grew up on a dairy farm, and boy do I miss raw milk. Do you know where we can get a bit?" (I glean that selling unpasteurized milk to consumers is illegal. Joe smiles and gives her the farmer version of "I know a guy who knows a guy.")

"Hey Joe! How many tractors were here today?"

"Fifty-two."

"Wasn't the permit for fifty?" Joe looks to see if I am writing that down.

"Yea, but one was a fire truck. And there was a donkey."

A banker, whose life is filled with rigidity, would have left the extra tractor at home. Not a farmer. Like the scallywag code

in *Pirates of the Caribbean*, the farmer code is "more of a guideline" than a code.

Over the next few minutes, admirers seek details about the plight of farmers, but many simply want to meet Farmer Joe— to laugh with him, to talk about old times, and to thank him for nothing more than being a farmer. Their unbridled adoration of this buoyant young man is fascinating, and a little confusing, until Joe suddenly bounds away, calling over his shoulder.

"I want to show you something."

Reaching under the seat of his tractor, he pulls out a petite brown book. Returning, he opens it to a photo of his grinning blonde daughter on a horse. Next, he turns to a shot of his pretty wife, then to several of his 160-acre dairy farm. On-lookers crowd close to catch a glimpse, taking in each photo as if it were a treasure from some new world far across the sea. Then it becomes clear: *This* is what they were protesting to protect.

Ninety-seven percent of us will never be farmers, but for we electrical workers, gas station clerks, and accountants, farmers are a symbol of what America is, and what it can be. To lose what we can be is to lose what we are.

Leaving Joe to bond with America, I pass a man in a fashionable overcoat staring at a 1935 Allis-Chalmers. He takes off a leather glove, gently sliding his bare hand across the orange body. Today, he could be a farmer. ★

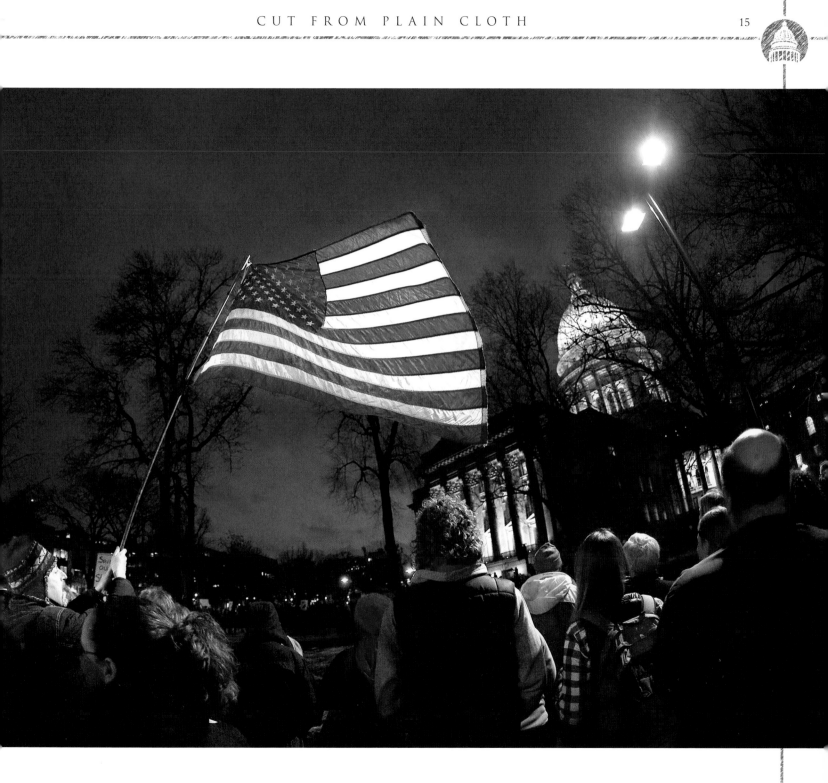

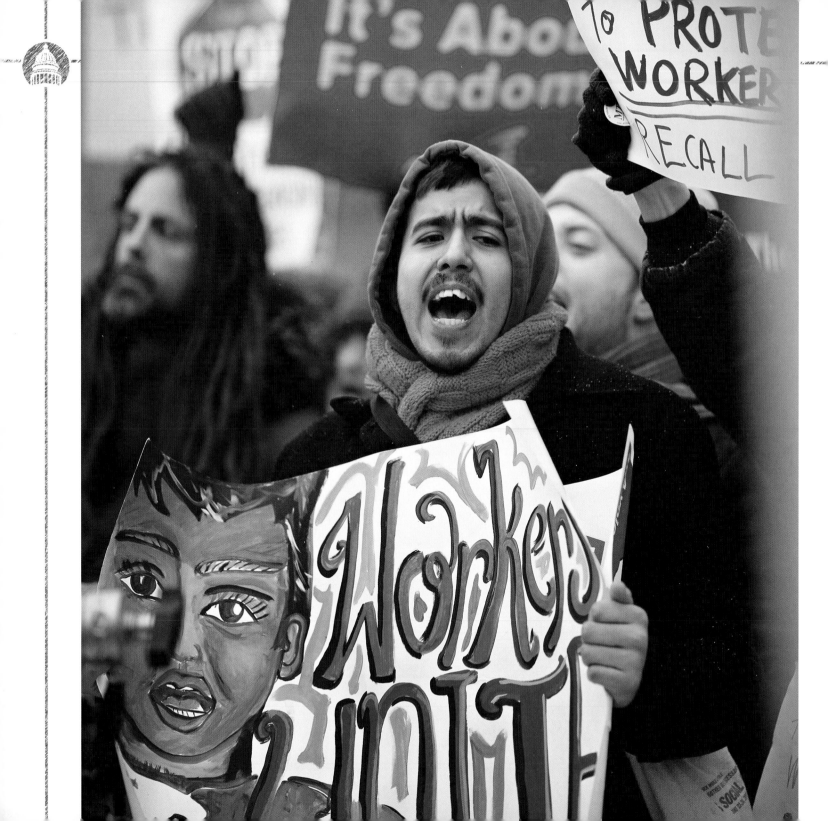

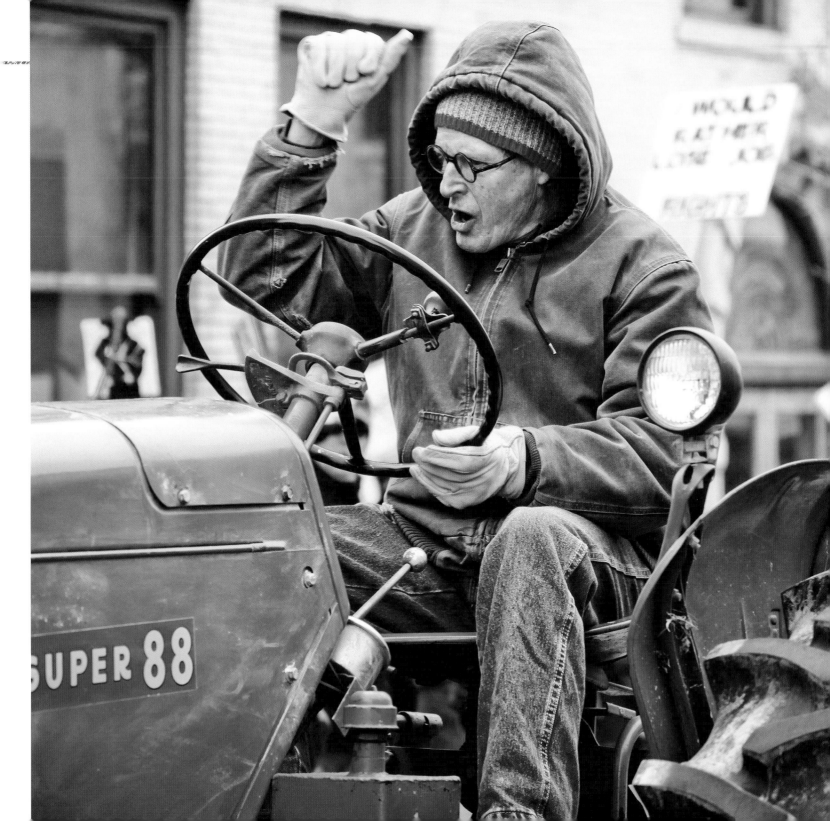

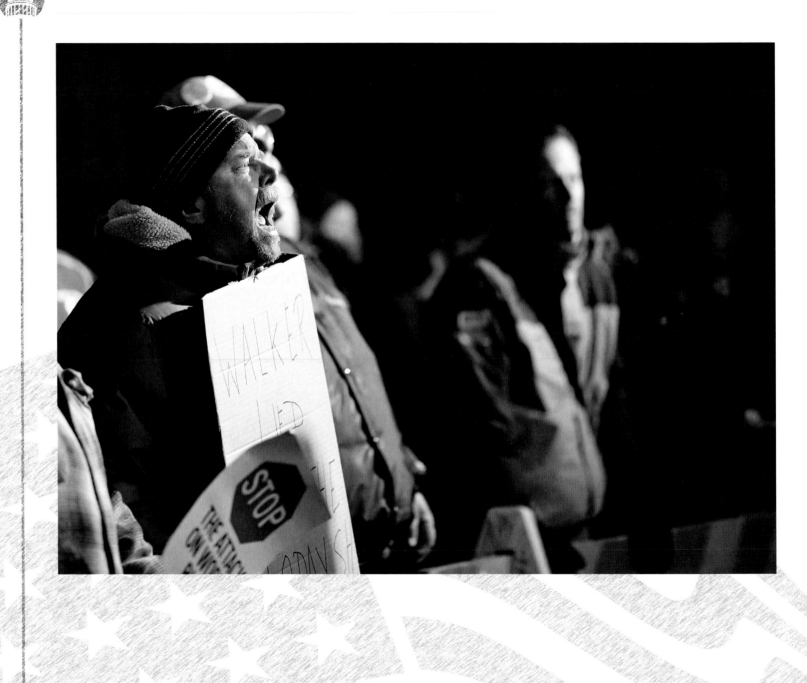

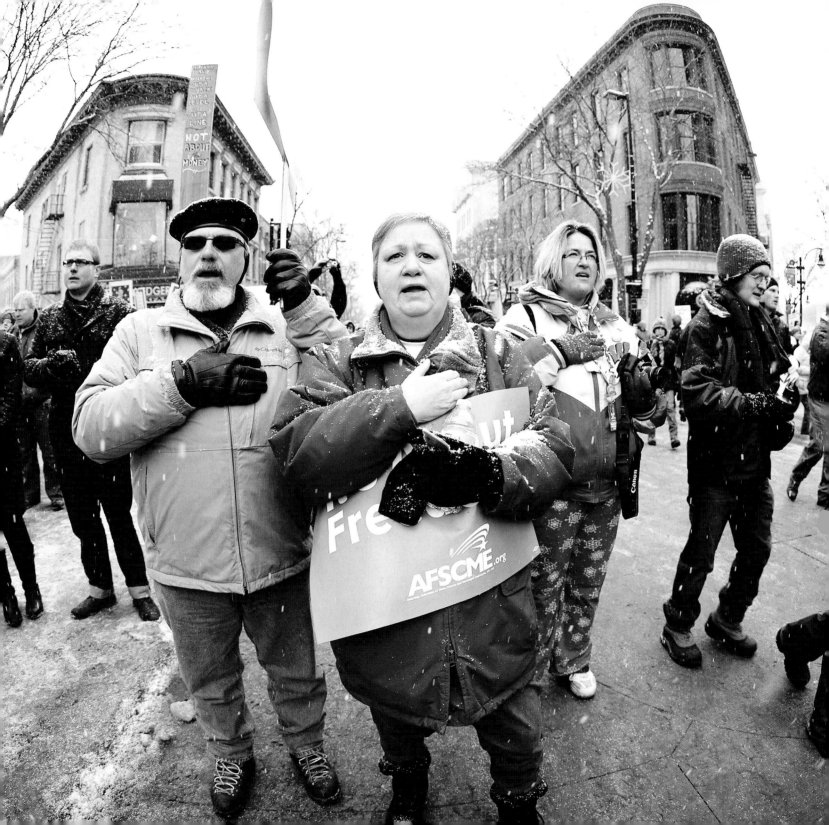

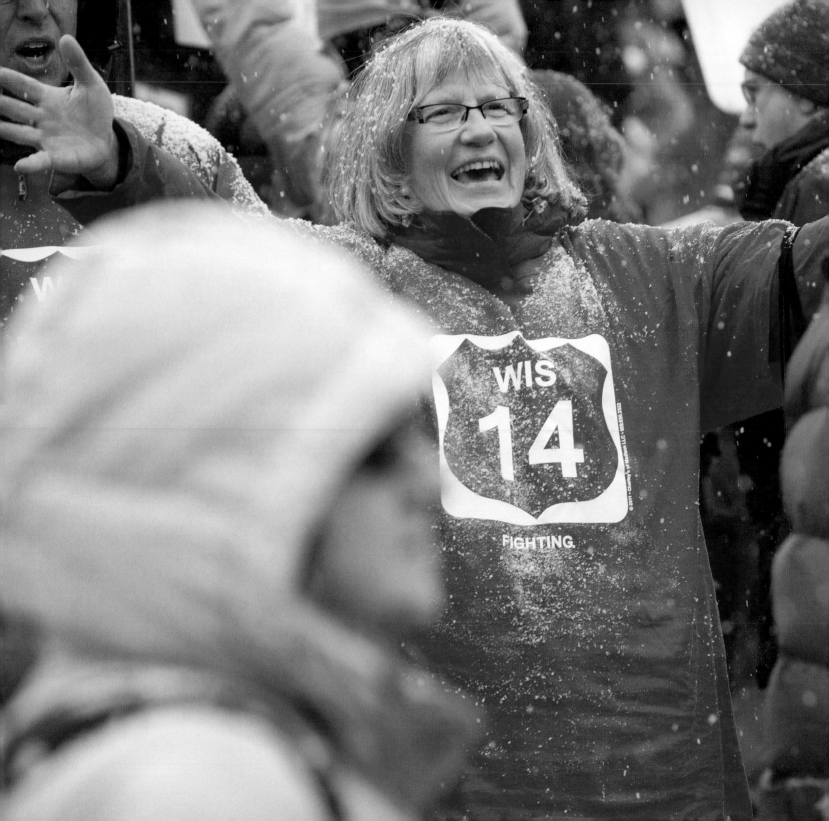

POTATO STEW

The streets are packed with a hundred thousand ecstatic protesters, and the atmosphere is charged. It is rumored that the fourteen senators who took an impromptu vacation in an effort to stall the bill are coming home. I am staked out near the Inn on the Park, which is where my inside man insists that the senators, dubbed the Fab 14, are slated to appear.

After making three calls to my stoolie to find out which entrance the senators will exit, and after moving three times, I plant myself in the middle. While leisurely scanning the crowd, I suddenly freeze, and my heart pounds. Not ten steps away is a large man, dressed in blaze orange coveralls, carrying an NRA sign.

I am about to seek better shelter in which to dodge bullets when the shooter moves, exposing his entire sign. He is there to *support* workers, not take them out.

John represents an interviewing coup, the perfect example of rally diversity, but I am leery of approaching. Yes, this trepidation stems from unfounded stereotypes, but you must understand my history with guns.

My life with firearms didn't start off bad. We had the standard prairie weapons—a 20-gauge shotgun for Dad, a .410 for Mom, and a .22 for the kids. I fancied myself a pretty good shot, but except to a pheasant or two, our stockpile of arms was harmless. Things didn't get rough until after I left home, when a man wearing coveralls (see the connection?) shoved a sawed-off shotgun in my back, impolitely asking for the night's receipts from the pizza parlor I worked at. Years

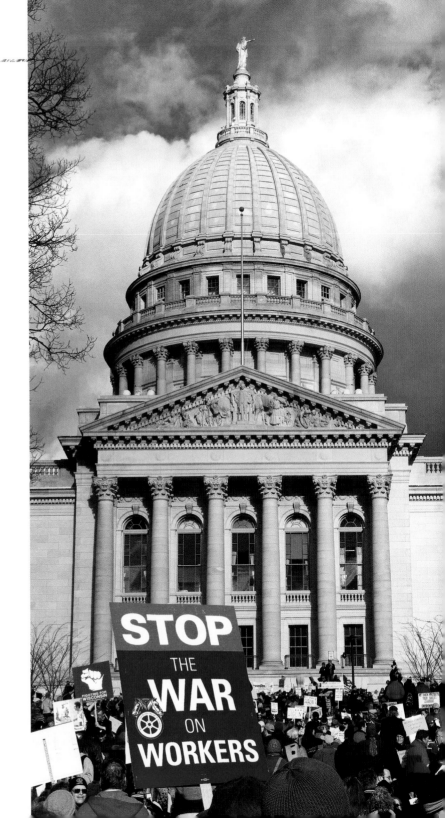

later, while driving home for Thanksgiving, a hunter shot my truck. We heard a "clank" and, sure enough, we found a cylindrical dent the size of a slug in the back quarter panel.

Honoring journalistic tradition, I throw aside those long-held fears and saunter close to John until he is just four feet away. I open the conversation with my best icebreaker.

"Nice sign."

"Thanks," he responds, without drawing a gun.

In the shadow of the impending senator arrivals, our conversation is to the point. John works near Wausau, at a factory that makes French fries. He recites how many pounds of potatoes go through his machine, but it is one of those numbers that is too big to comprehend, like your odds of winning the lottery. Sensing my concern that the interview will be cut short by the senators' arrival, he skips ahead to answer the obvious question.

"Our factory isn't union, but unions set the bar."

In record time, John has conveyed his life and reason for protesting. He is a regular guy with a regular job, expecting to receive nothing more than a regular life. Like many Americans, his values are a mixture that cannot be stereotyped. We are a melting pot of ideals, and like a stew, it is difficult to separate us carrots from them potatoes. In the humble opinion of this author, that is how it should be.

A couple of minutes later, the Fab 14 emerges and all hell breaks loose. I stay close to my new buddy, just in case things get out of hand. ★

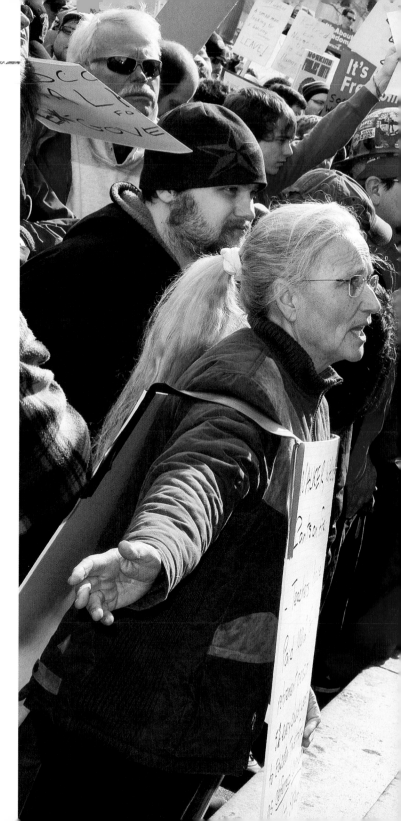

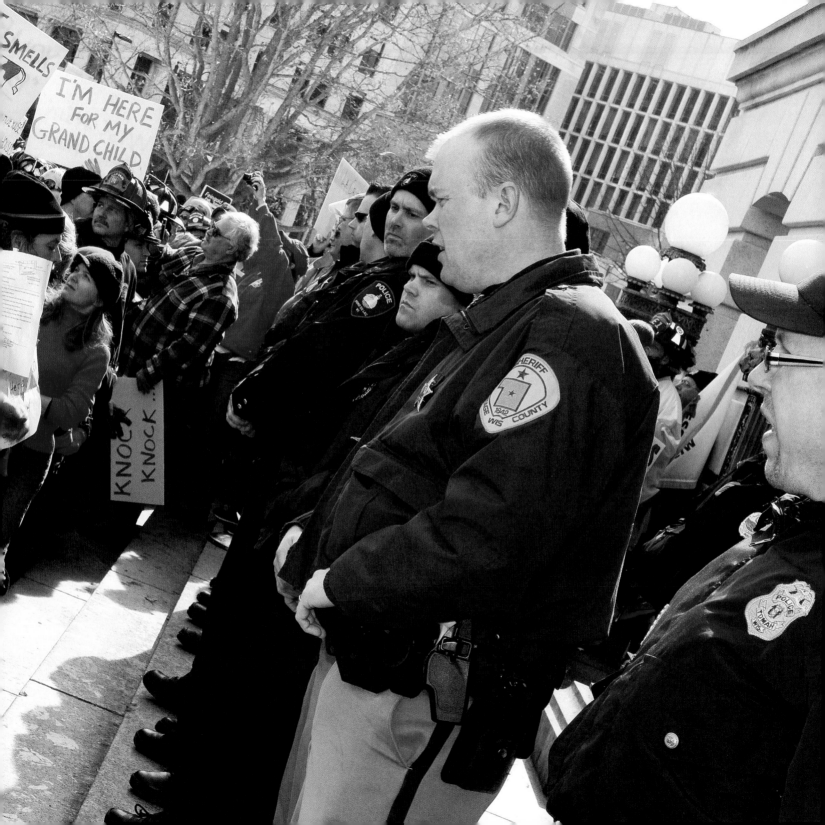

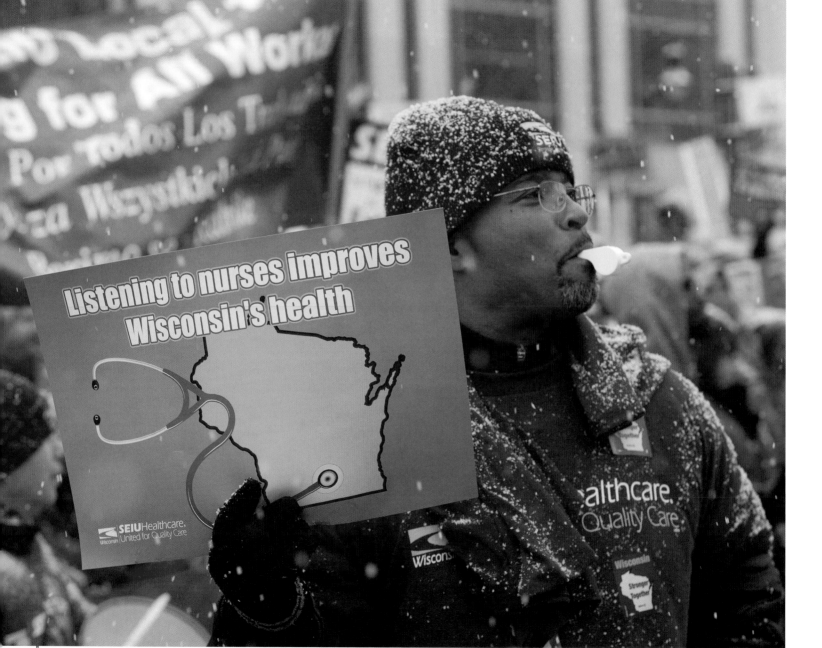

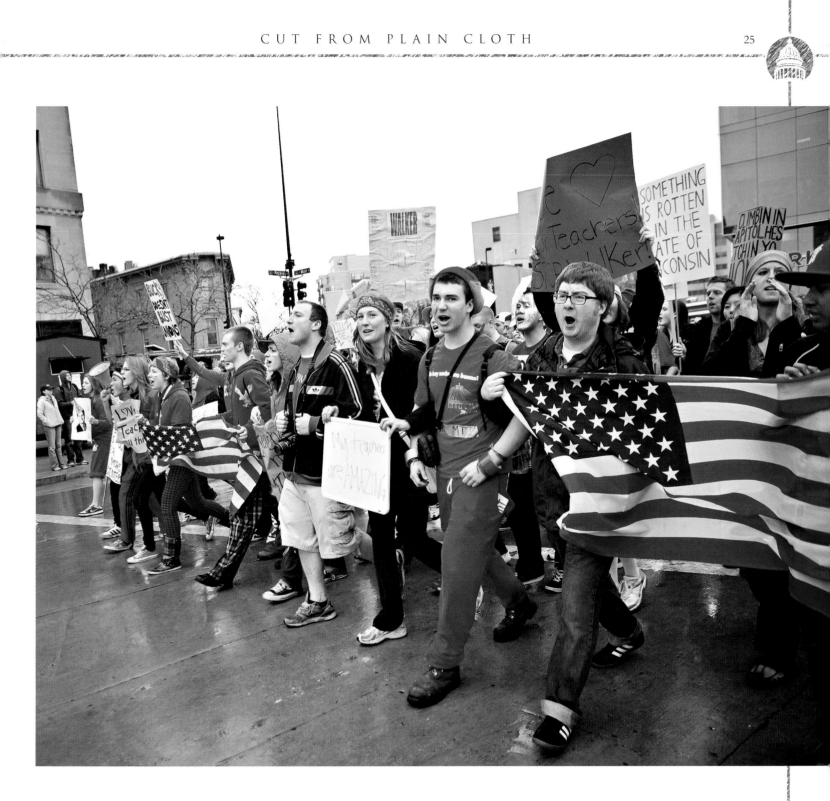

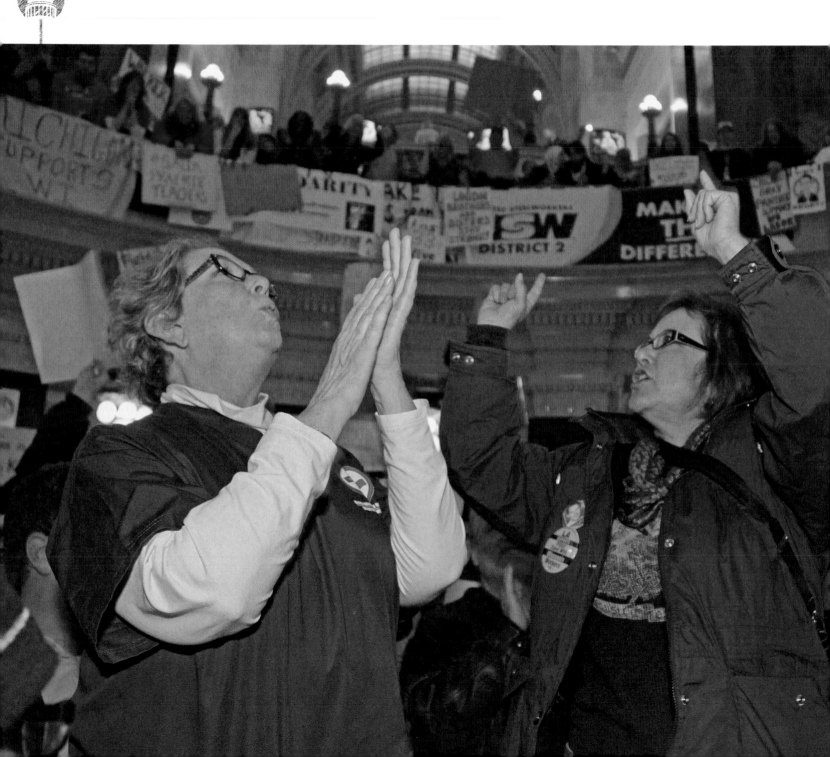

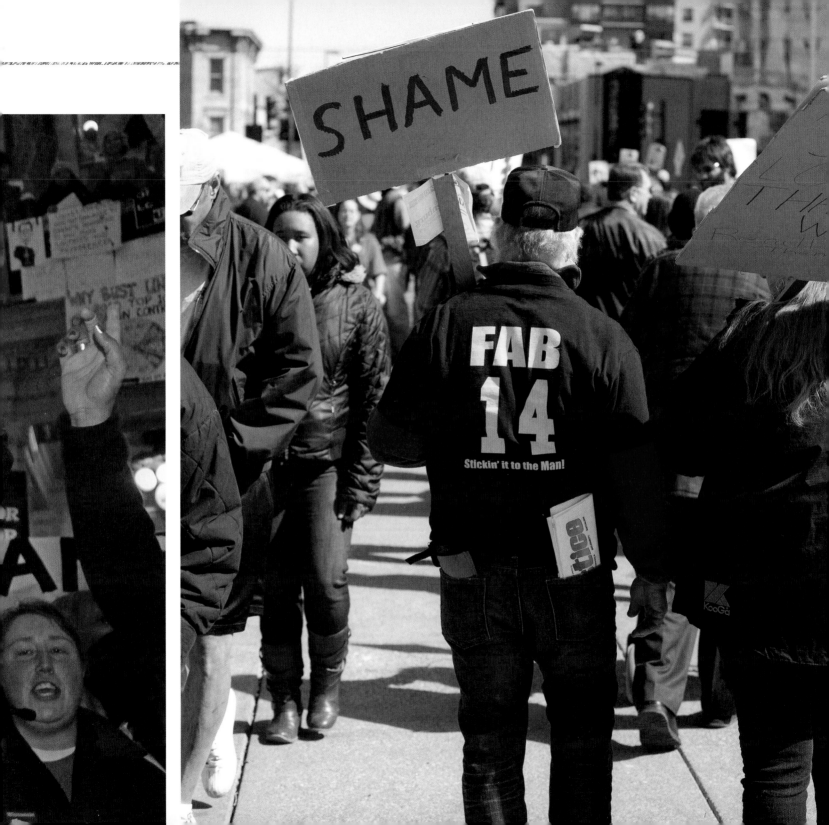

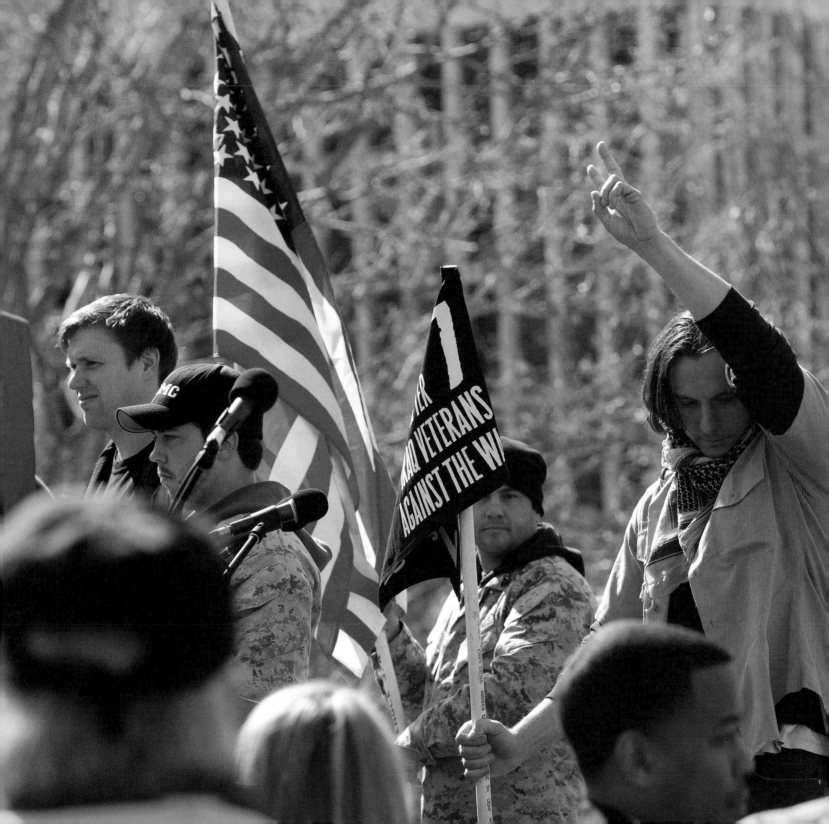

WELCOME HOME, BROTHER

A hundred yards across the Capitol lawn, an Iraq War veteran stands on a low stage, delivering an impassioned appeal about America and unions. It is the eighth anniversary of the Second Gulf War, and a parade of veterans have marched several blocks to join other protesters already circling the statehouse. From the sidewalk on the outer loop of the Square, a tall man listens quietly. His eyes rarely move, but inhabiting his soft stare is a strange serenity.

Dan doesn't look like a Vietnam vet, at least not those in movies. He isn't Bruce Dern, the clean-cut soldier of no regrets in *Coming Home,* nor is he the paralyzed and embittered Jon Voight. If you've seen *Platoon, The Deer Hunter,* or *Apocalypse Now,* Dan is probably the guy listed in the credits as Soldier in Trench, or just Soldier. He seems comfortable out of the limelight, but exhibits the tempered confidence of that unknown trooper you *wanted* next to you when the tracers came sizzling overhead.

Other Vietnam vet stereotypes are equally unsuited to Dan. His hair isn't long and stringy. He doesn't appear gaunt from decades of heroin use, nor does he sport a Harley jacket adorned with an American flag. He doesn't even wear a hat displaying his unit badge. Except for a hand-lettered sign proclaiming veteran support for workers, only his straight posture suggests military service.

29

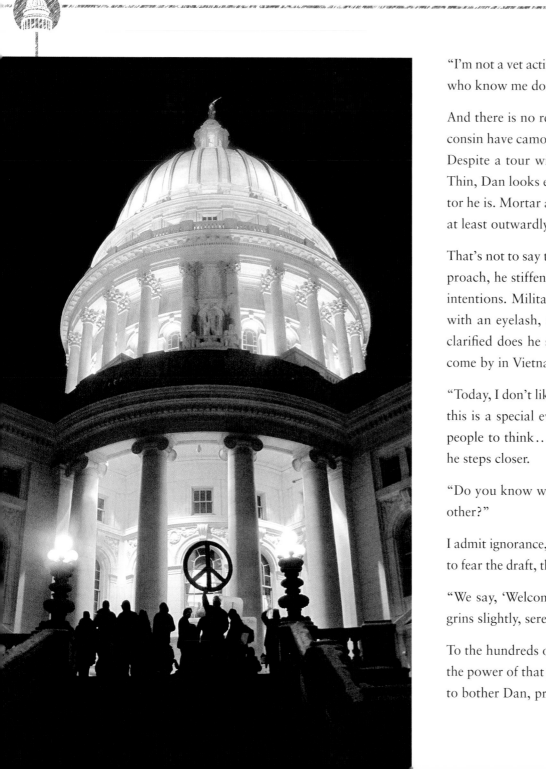

"I'm not a vet activist," he says, his voice steady. "Most people who know me don't know I was in Vietnam."

And there is no reason to. Thirty-five years of peace in Wisconsin have camouflaged him as well as any Vietcong sapper. Despite a tour with the 18th Engineer Brigade at Dong Ba Thin, Dan looks every bit the retired public health investigator he is. Mortar attacks of his youth were overrun long ago, at least outwardly.

That's not to say that Dan has forgotten war. When I first approach, he stiffens and his eyes dart quickly to ascertain my intentions. Military guys are schooled in seven ways to kill with an eyelash, so I don't press. Only after my identity is clarified does he stand at ease. Trust was probably hard to come by in Vietnam.

"Today, I don't like to think about the war," he reveals. "But, this is a special event and if I can walk with a sign and get people to think..." His voice trails for a moment, and then he steps closer.

"Do you know what Vietnam vets say when they greet each other?"

I admit ignorance, for although I was old enough in the 1970s to fear the draft, the war ended before that fear became terror.

"We say, 'Welcome home brother.'" For the first time, Dan grins slightly, serenity again flooding his face.

To the hundreds of millions of us who didn't go to Vietnam, the power of that greeting goes unnoticed. This doesn't seem to bother Dan, probably because it isn't meant for us. It is a

fraternal handshake between those who faced, and still face, challenges only they can comprehend. It isn't just a sigh of relief that nobody is shooting at you today; it is recognition of the hurdles Vietnam vets confronted in war and at home. They fought a vague enemy that looked more like civilians than soldiers. Our country asked for their loyalty, but many citizens asked for civil disobedience against a war that seemed impossible to win and of questionable purpose. For many returning servicemen, there was no hero's reception, only lifelong turmoil. Dan is one of those unsettled warriors.

"For forty years, people have asked me what would make me feel welcome at home." His eyes follow the line of protesters advancing down the sidewalk. "It happened last week, when I came here and saw a hundred thousand workers standing up for their rights."

Dan pauses, as if to savor every moment of his enlightenment.

"This is all I ever asked for. After forty years, I feel like I'm welcomed back."

Welcome home, brother. ★

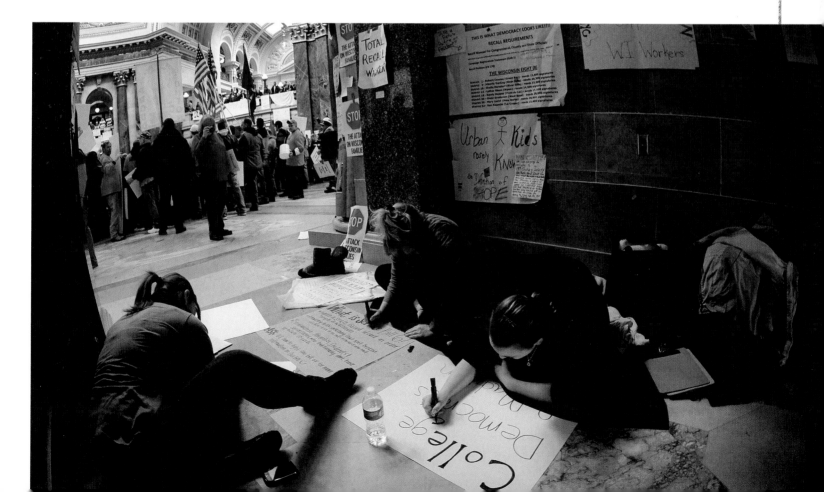

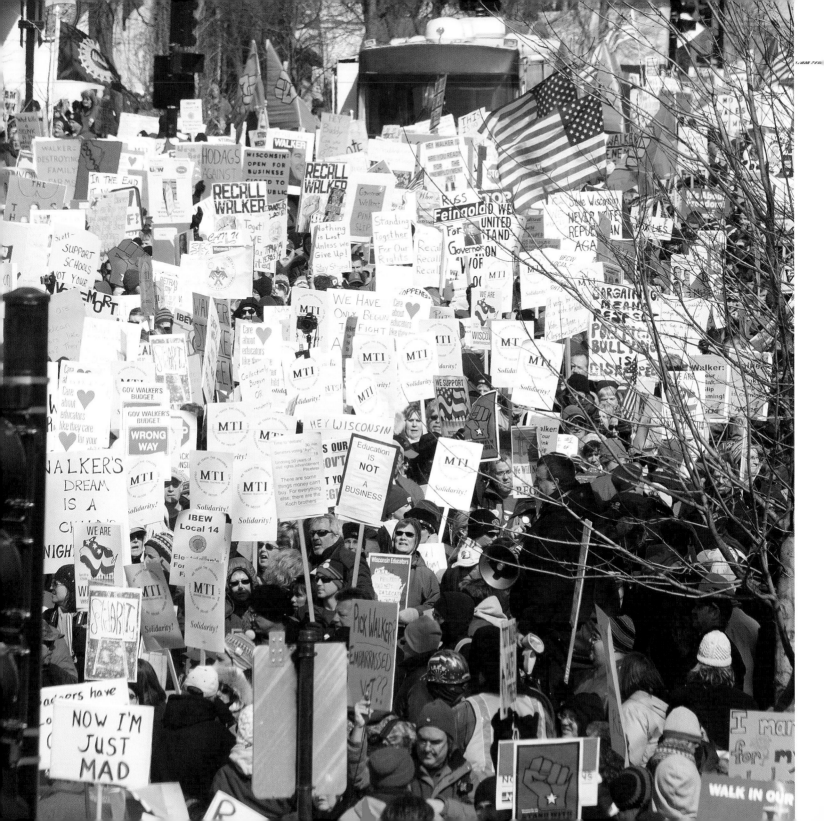

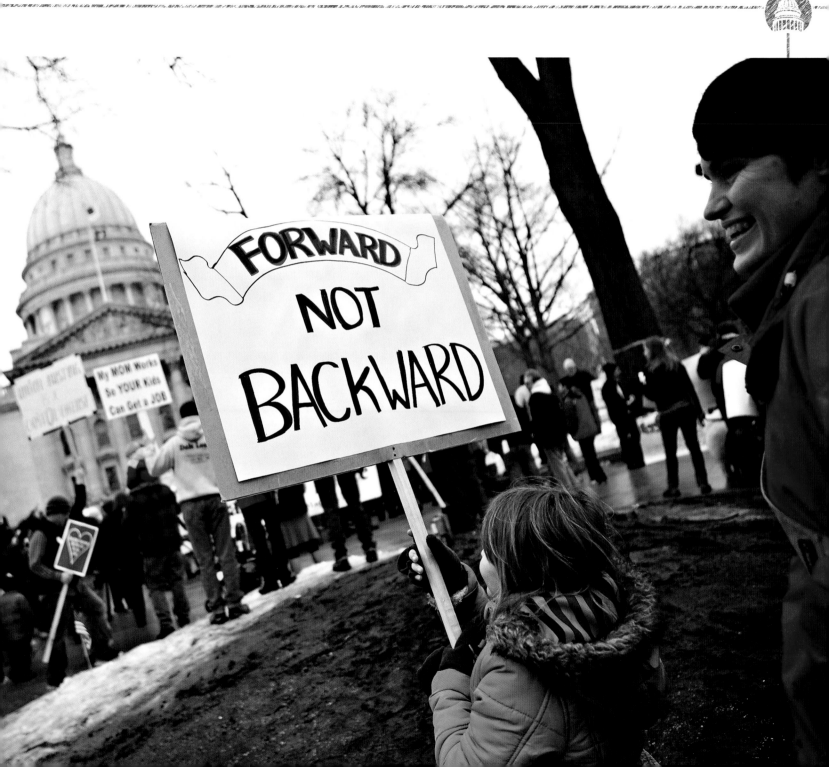

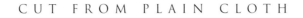

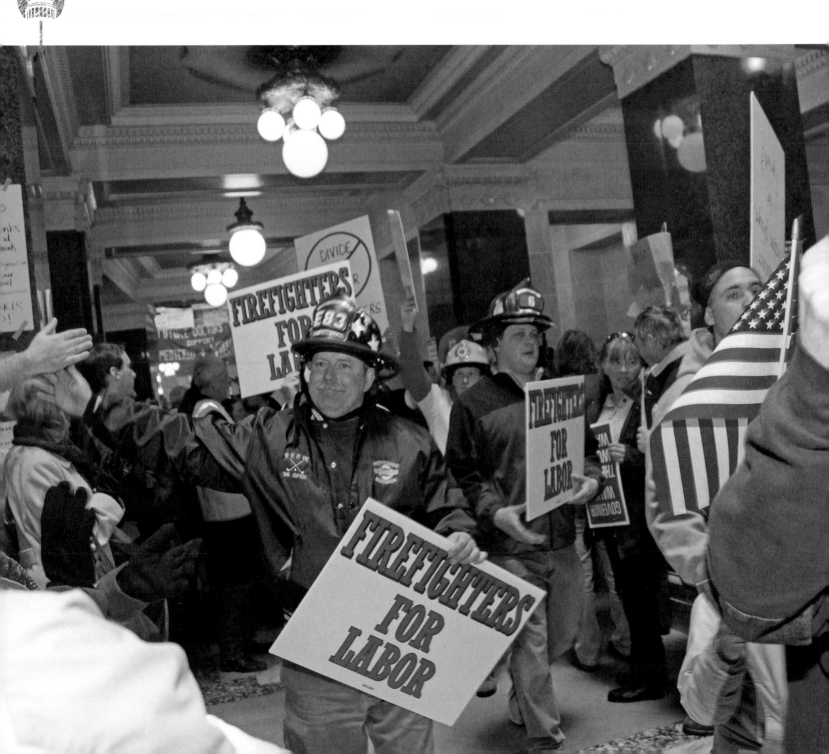

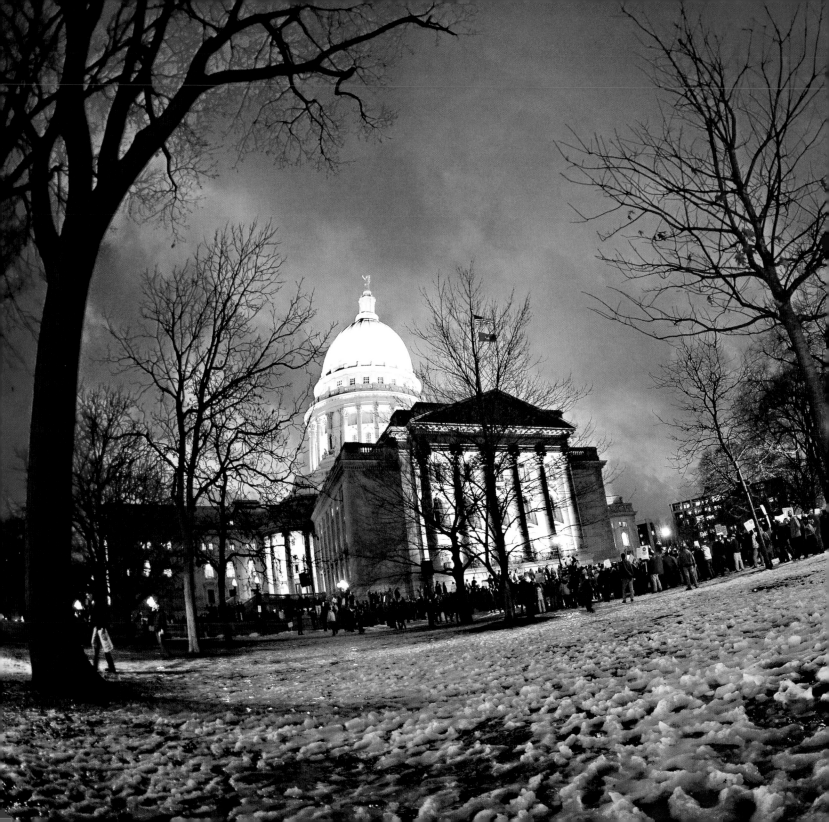

HUGS FOR THUGS

Human courtship is like an ice skating competition. There are the prelims, during which prospective mates unearth details like whether you hang toilet paper "over" or "under." Then comes the long program, a test of compatibility on values. Falter in the prelims, and you still have a shot at the gold. Fall during the long program, and someone else's face will grace the Wheaties box.

Val and Jay met at a student camp during high school, instantly forming mutual crushes. Returning home to different towns, they found their paths diverged. Fifteen years later, they have rekindled that youthful ardor, and are currently going into their long program. For budding lovers, the protests are a chance to discover either harmony or a pea under the mattress.

Jay is tall and a little quiet at first. Val is blonde and vivacious. He wears standard Wisconsin garb. She sports a "free hugs for union thugs" shirt, which has attracted a talkative young man who claims to be union. The man's thug status is debatable, but Val gives him a cuddle anyway. Jay takes it in stride, clearly comfortable with the beauty he is dating.

"We have a long-distance relationship going on," beams Val, referring to the two-hour drive between her home and Jay's.

"No it's not," corrects Jay. "You used to be in Boulder, Colorado—*that's* long distance."

A big smile sweeps Val's face. "You would drive all night to see me.…That's sweet, by the way."

"Thank you very much."

"Thank *you*," she giggles.

Jay is a die-hard independent, refusing to subscribe to political labels because it "takes away personal responsibility for thought." Val is a self-titled liberal who "sometimes wants to just look at something and believe." She is the wind. He keeps her from flying away.

"He is a good grounding force for me," laughs Val, "because I'm all into the love." In return, Jay is lifted by Val's endless optimism and trust in people.

At a nearby pub, we talk for an hour about issues, from unions and health care to the Federal Reserve and manure. At every step, it is a delight to watch the couple find their equilibrium—the glances to assess boundaries, the reassuring touches when they are about to disagree, Val's infectious laugh that melts Jay at every turn.

Having met in Madison for three weekends in a row, the duo has had a chance to explore romance at the protests. Both cite their participation in the tractor rally as a bonding milestone, but there has been an occasional disagreement.

"We got into a big fight," sighs Val playfully.

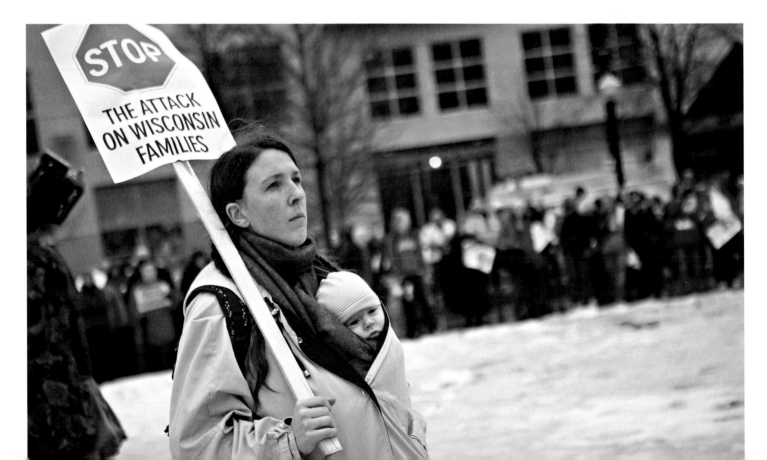

"Did we?"

"I wanted to sleep in the Capitol and he was like a wet blanket."

"I was just nervous," retorts Jay. "I didn't want you to go to jail. *I* didn't want to go to jail. I've *been* in jail."

Out of the blue, my wife, who is at the interview, turns to Val. "If you don't think your guy wants to do it, then it makes you totally not want to do it." Val exclaims it is true. Jay whinnies like a horse. An experienced married man, I keep my mouth shut.

On the day in question, the couple ended up at the Capitol, running into a kind man who loaned them a sleeping bag. It was a night filled with songs, wonder, sharing, and not quite enough sleep.

"He complained the whole time," Val snickers.

"We were sleeping on a cold marble floor!"

Val laughs even harder and Jay melts. "It really was a once-in-a-lifetime experience. I'm glad we did it."

As a waiter brings us more pretzels to snack on, Jay leans close to Val.

"That wasn't a fight, was it?"

Val reaches over to lightly stroke his arm. "We had a good disagreement."

These two may end up on a Wheaties box yet. ★

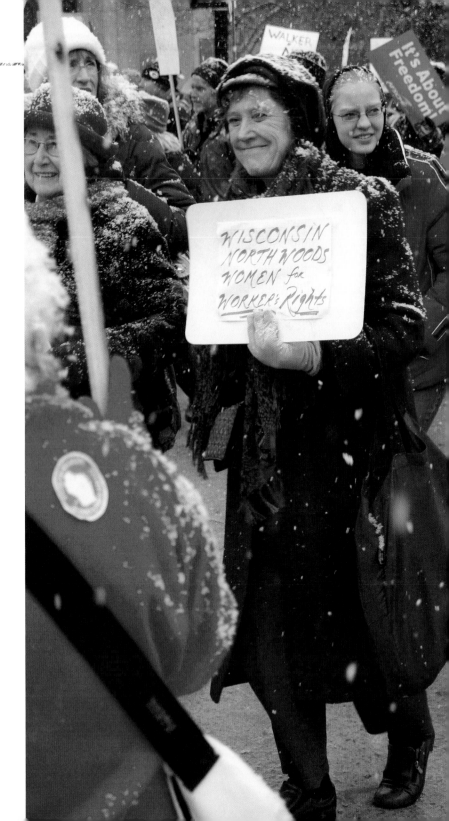

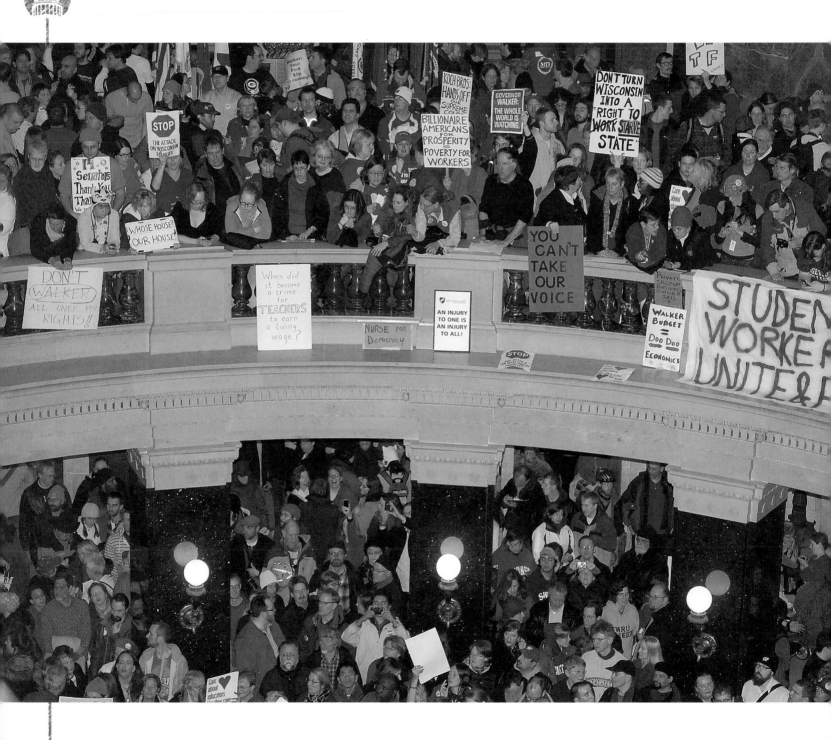

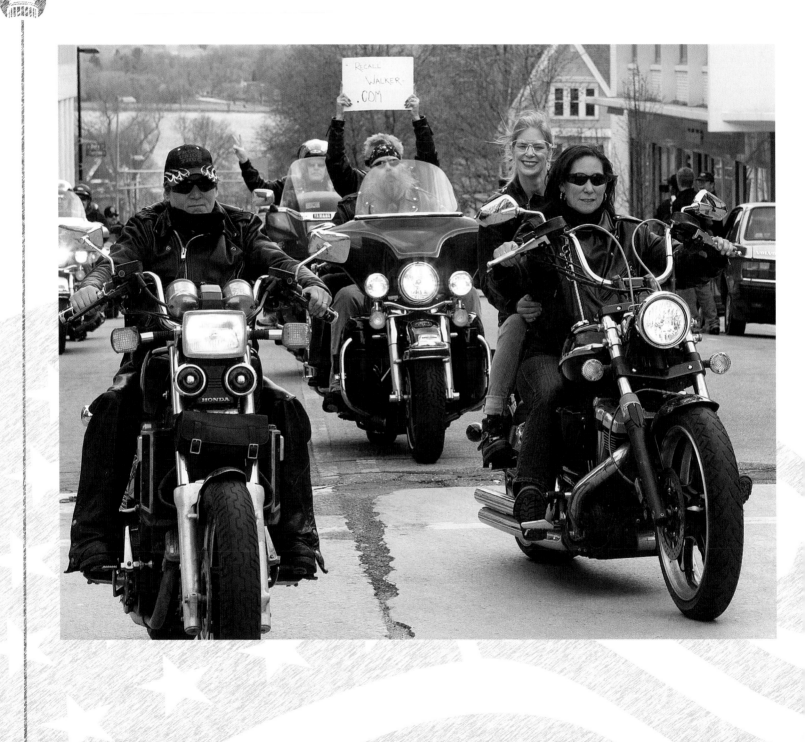

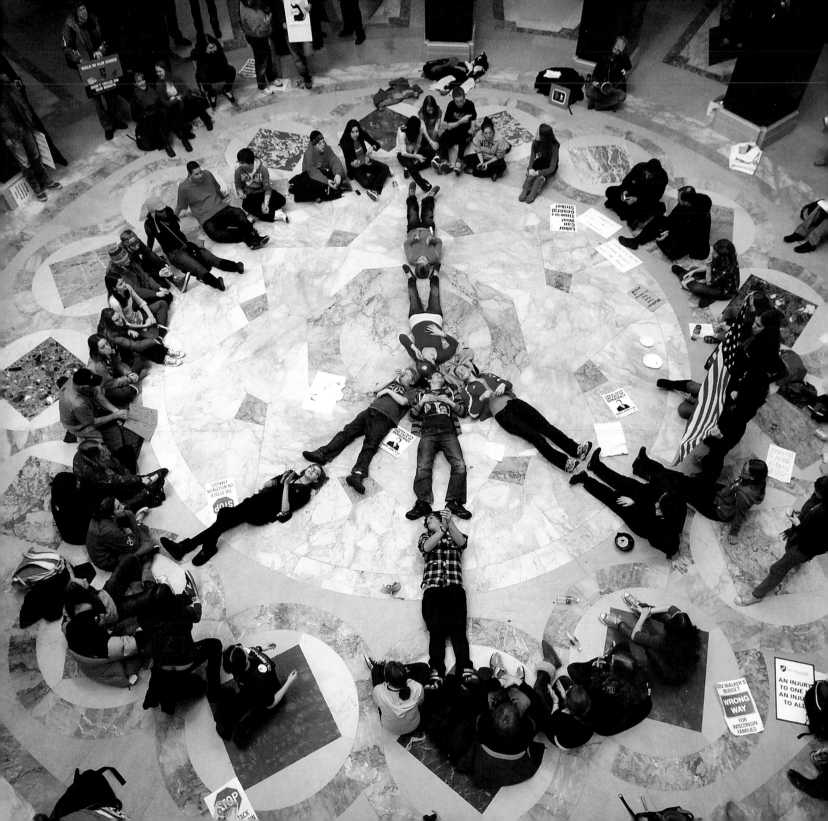

SURVIVAL

It is noon in Farmston, Wisconsin, and the village siren slowly ramps up to alert citizens that it is time for lunch. Old-timers smirk at the out-of-towners, who are easily spotted scanning the sky for the tornado that must be coming. Clocks are prominently displayed at local shops, but the noon siren is tradition, and a reminder to overachievers that God took a rest now and then.

According to the sign at the edge of town, 519 people live within the five- by seven-block village, most of them Norwegian and German. A few Poles and English are scattered about, and a couple of French sneaked in when nobody was looking. Houses and trailers are cast about in a somewhat formal array, bounded on the north by the railroad that spawned Farmston years ago. Outside the city, small farms fight for control of the steep valleys, losing high ground to oak trees, but digging in wherever a cow can walk with relative safety.

Nestled in the abandoned elementary school at the center of town are the police department, city office, community center, and village library—8,000 books, three computers, and an $18,000 budget. The librarian is Kay, a pleasant woman with a soft, honest laugh. Usually an omnipresent fixture at the library, today she is taking a vacation day, joining colleagues in Madison to speak to elected officials about the governor's proposed funding cuts for libraries.

"Farmston is typical rural Wisconsin," says Kay, without apology. "We celebrate Farmston Days in the summer, and just

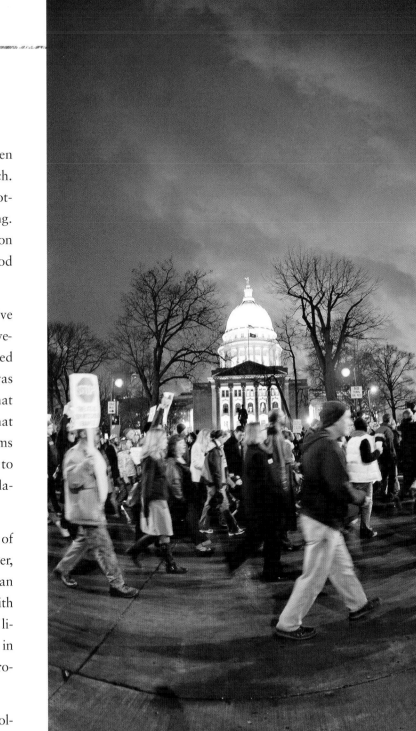

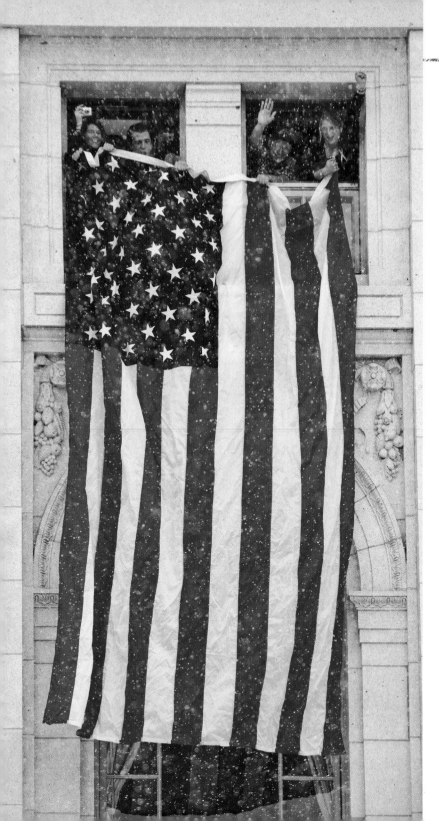

built a veteran's monument at the park. There isn't a lot of business. Other than bars, our main industry is a sand mine."

Indeed, times have been tough for Farmston, which endures a 20 percent poverty rate. Through the hardships, though, the city has held on to its library.

"There is a great spirit in our town," swells Kay. "Not many communities our size have a library."

Closing the library would be a tragedy, considering the town already lost its school. Every morning and afternoon, students hop buses to and from another village in the consolidated district. School closings are a common tale in rural Wisconsin, but the consequences go far beyond a long bus ride.

"Schools are the social hub of a small town," Kay laments. "Everything happens there. Now, the library is the remaining cultural center. Anything that affects the library will affect the town."

Losing the school isn't the only change straining Farmston and its library. Years of technological advances have chipped away at small towns. Faster roads make it easier for people to shop in bigger cities. Industrial automation means fewer local jobs. Now, a change in the way businesses go about their hiring puts further pressure on the already overburdened library.

"For an increasing number of jobs, you have to apply online," notes Kay. "We have the only free Internet in town, and patrons use our computers to send job applications. It isn't just that people can't afford Internet service. Out in some valleys you can't get satellite TV or even cell phone reception, so there is no other way to get online."

Despite the impending budget storm Kay remains surprisingly positive, as small-town residents often do in the face of their many adversities. "Our library will probably weather this better than big ones. We rely more on donations, and those people still believe in us."

Though Farmston may come through relatively unscathed, Kay sees a bigger picture, and good reason for making the three-hour drive to Madison. To her, libraries are not just an essential part of the community; they are important watchdogs over government.

"A librarian's job is to ask questions. If a patron comes in and wants to know about sage, we have to figure out if they mean the plant, color, or software. Librarians are questioning this bill, and I see government shirking its responsibility to the people."

Kay is uncertain about the future of Farmston and its tiny hub of activity, but a visit to the library website verifies its continued place in the community:

> The WiFi is always on and should reach to the parking lot, if we're not open. If we're open, come use your laptop or fancy phone in our comfy chairs.

As it does so often, the porch light glows brightly in a small town . . . and always will, if Kay and others like her have any say in the matter. ★

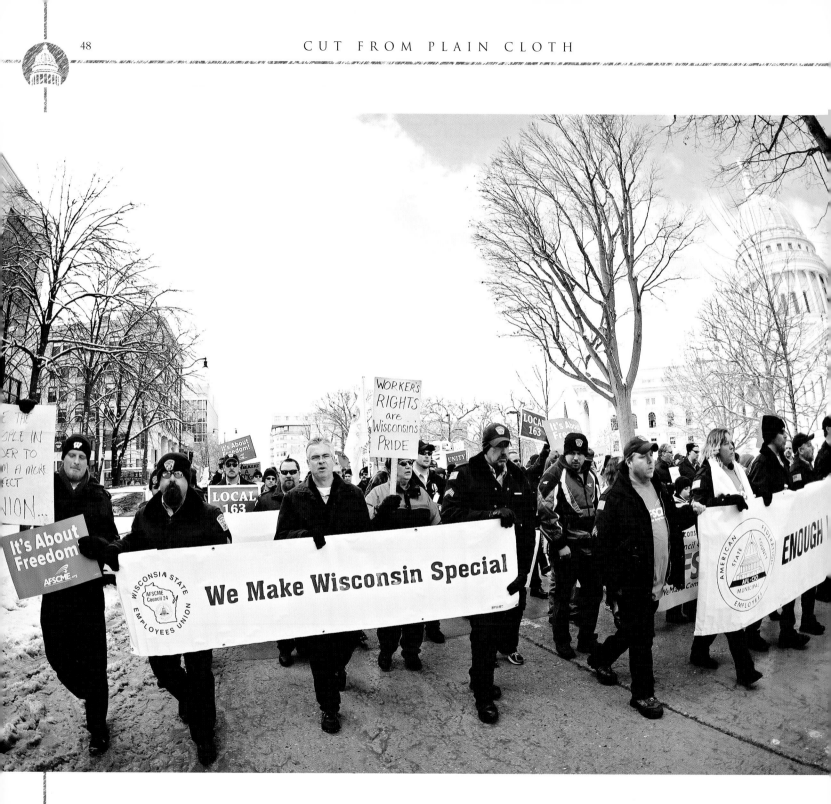

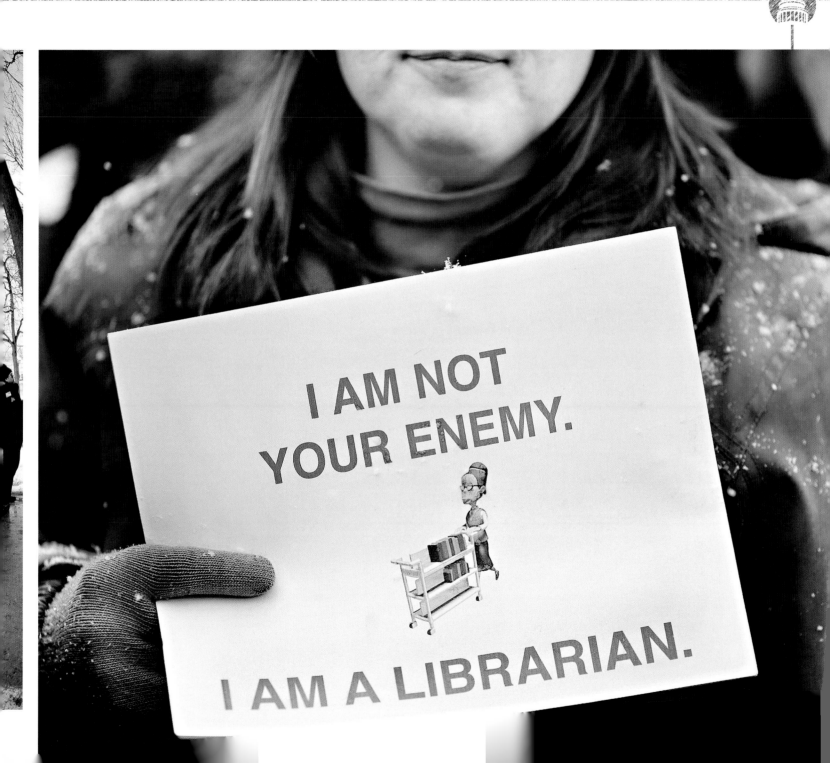

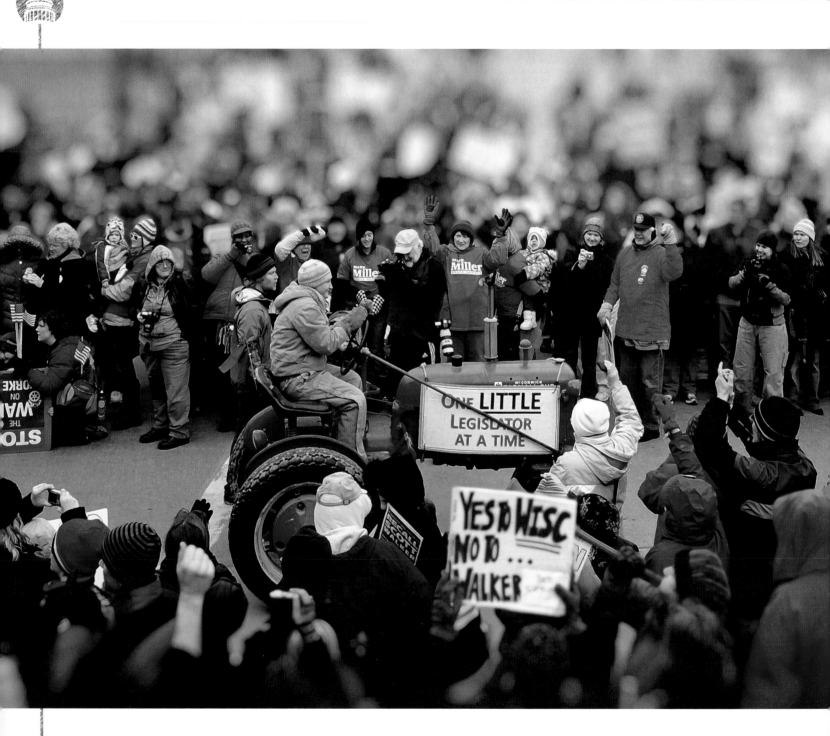

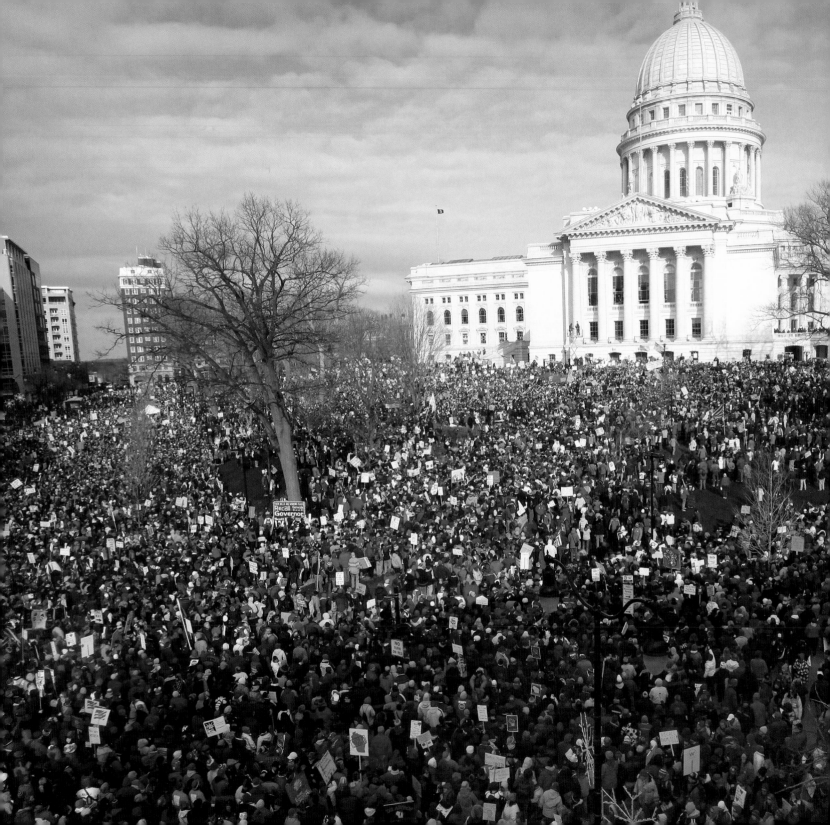

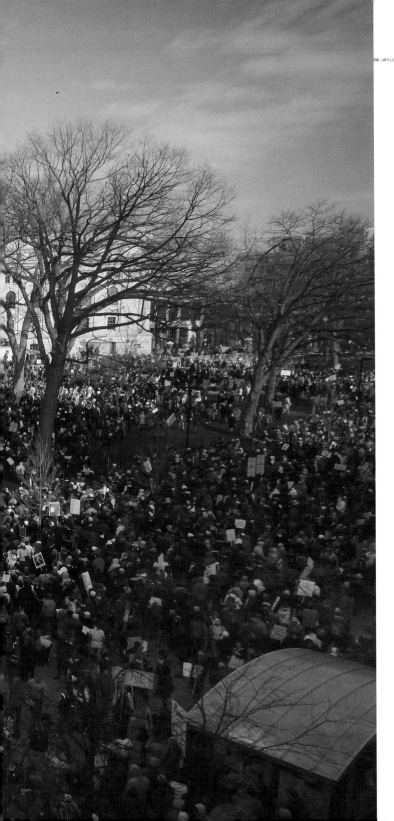

FORTY-FOUR DAYS

It is January of 1937 in Flint, Michigan. Winter has set in, the Great Depression is on, and tensions are high as fledgling unions begin to take on the auto industry. At Fisher Auto Body Plant #1, a man is holed up with hundreds of workers engaging in a sit-down strike, bringing the plant to a standstill. At an open window, the man's young son and wife, a member of the Women's Emergency Brigade, secretly pass in much-needed food for the strikers. Suddenly, from within, men begin to yell and dash about.

"Run! Run, and get away!" calls the frantic husband to his family. The woman and terrified boy quickly toss the remaining supplies through the window and dart away, ducking behind a snowbank just as mounted police arrive.

Attempts by the company to break the strike fail, and after forty-four days of occupation, workers emerge with an agreement naming United Auto Workers Union as the exclusive bargaining agent.

Seventy-four years later, another union battle is being waged. Amy, Gary, and their seven-year-old son join countless others making treks to Madison to fight for unions, but their journey is special. That worker who risked everything in 1937 was Amy's grandfather.

"I first heard the strike story when I was nine," recalls the winsome brunette. "For a little girl, it was exciting—tear gas, riots, and police horses that scared my uncle [the boy] to

53

death. Thankfully, most of the violence took place away from Grandpa, in Fisher Plant #2."

Amy and Gary currently hail from a working-class town four hours to the northwest of Madison. As it is for many young couples, finances are tight, but both have been well schooled in the value of a dollar.

"Grandpa's frugality was legendary," laughs Amy. "One time, Dad found a car for a hundred and fifty bucks, but knew Grandpa wouldn't let him spend that. So, he told the guy he would give him fifty that day, and when he brought Grandpa, they'd just pretend the price was a hundred."

Gary's thrifty ways come from surviving on Aid to Families with Dependent Children while his mother toiled to get out of a bad situation. For both families, union jobs paved the way to better times. Gary's mother was hired by the state and was able to do without public assistance. Amy's grandparents went from a tiny house with no indoor plumbing to sending their kids to college—something Amy attributes to those forty-four days in 1937.

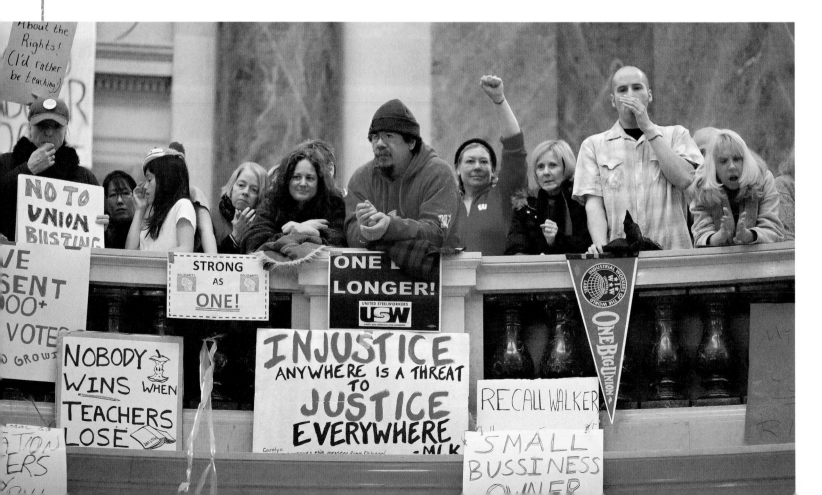

"I always felt my middle-class life came from Grandpa's union job."

Of the two young protesters, Gary is the stronger supporter of Grandpa's preferred protest tool—a strike. Frustrated with the ongoing personal attacks on his mother, who, in his words, "went from being called a welfare queen to a big, bad, public employee," he has begun holding meetings with neighbors to discuss issues he categorizes as the "privatization of public space."

"If you've got money, you can buy what you want—an education, clean water, books. The majority of families in our community rely on public space—a pubic school with quality teachers, public natural resources, a library free from profit motive."

Response at the meetings has been high in a county that many might expect to be a tough sell for protest issues. Gary explains the turnout.

"It is cathartic for people to meet and say 'Damn it, this is how we feel.'"

"It's not like Madison up there," interjects Amy. "People don't drive around with their politics on the bumper of their car. You have to talk to them." She smiles proudly at her husband. "I didn't know how much he was going to put his money where his mouth is."

Not to be outdone by his parents, even their child seems involved in the cause, casually drawing a picture of a stick figure carrying a protest sign on the sidewalk as we talk. The sign says, "Yes, Yes, Yes, No, No." Nobody is sure what it

means, but Amy is convinced the boy is on his way to becoming another Grandpa.

"He recently refused to do something we asked, informing us that he was standing up for his rights."

When asked what her grandfather would think of today's protests, Amy breathes sadness and curiosity. "I wish I could talk to him about this....He would be thrilled at all the people. But, he might say it's time to strike."

For a moment Amy looks far away, perhaps contemplating how that conversation would go. When she speaks again, it is with the honesty of a granddaughter having a chat with her grandfather.

"At a labor memorial in Flint, there is a statue of police dragging away a woman by the collar....I hope I would be brave enough to be in the Emergency Brigade."

Suddenly, it is 1937. There is Grandpa Gary, willing to put it all on the line for a strike. Grandma Amy stands beside him, not quite sure she is Women's Emergency Brigade material, but stocking up on food just the same. And there is the boy, who will one day share this story with *his* grandchildren. ★

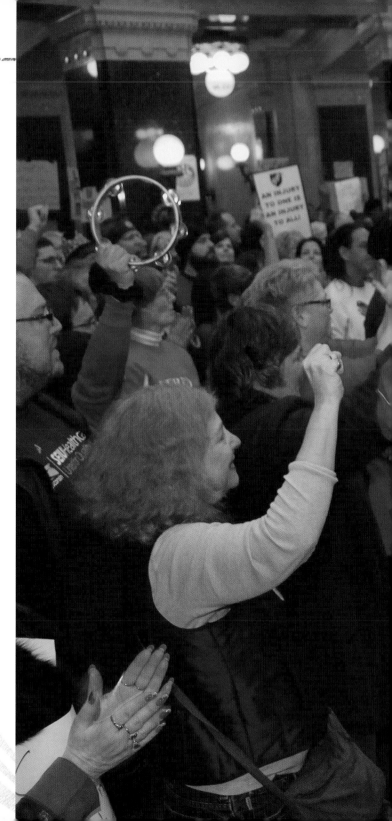

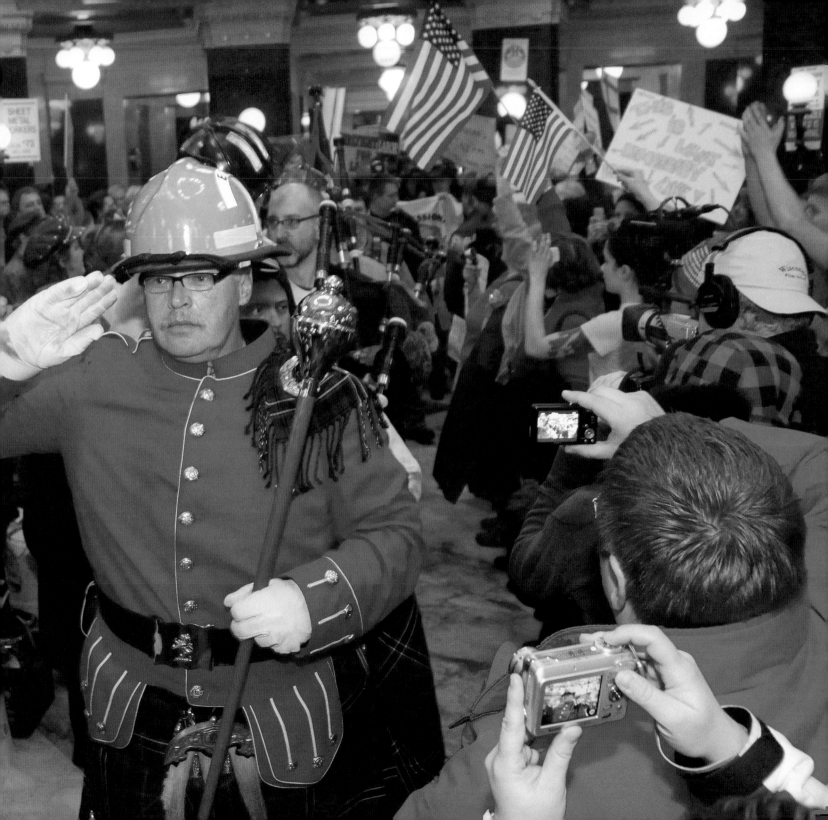

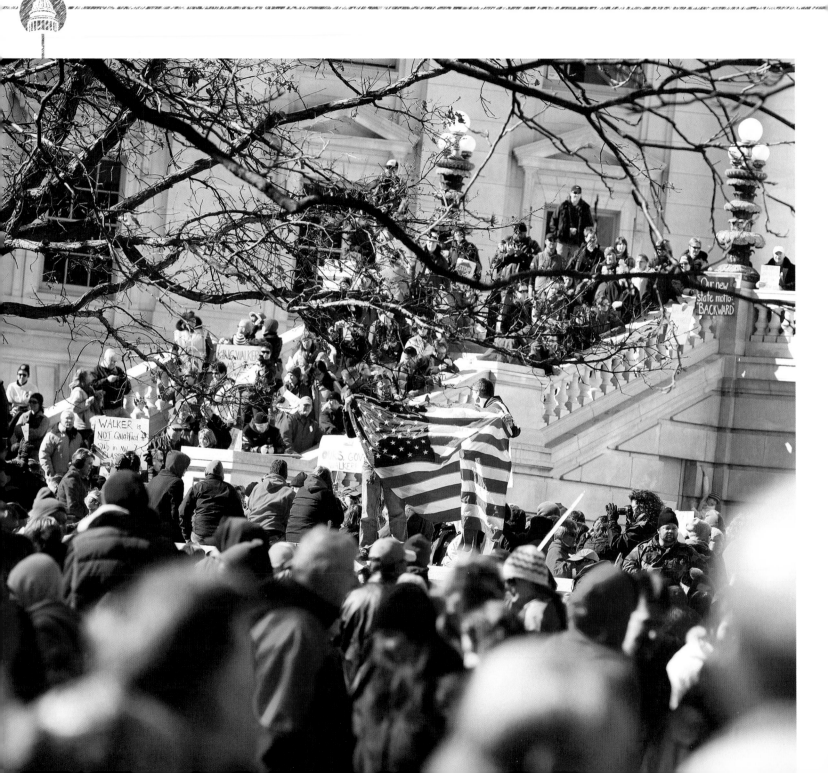

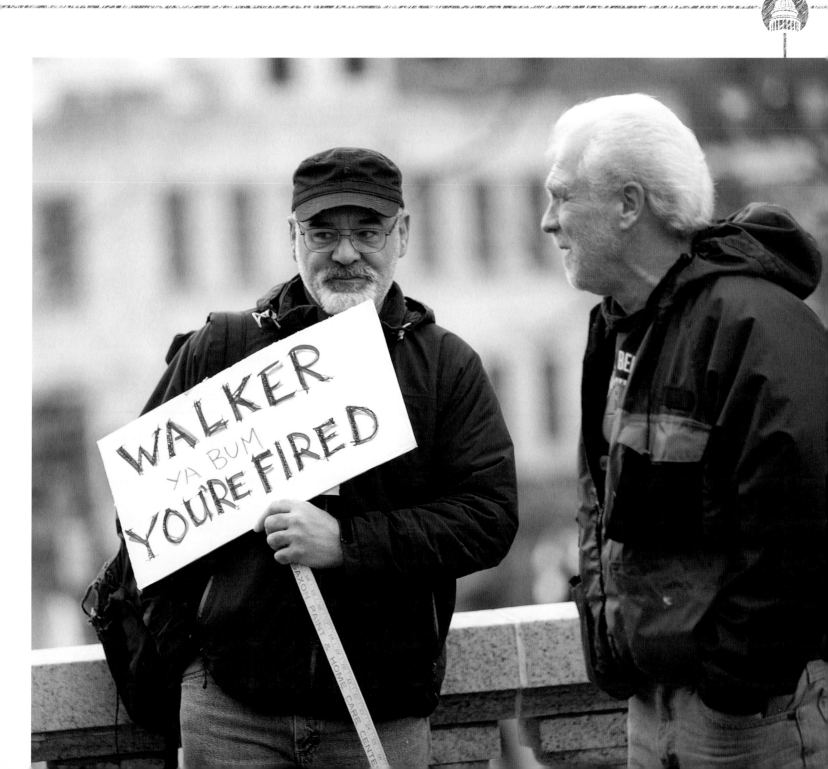

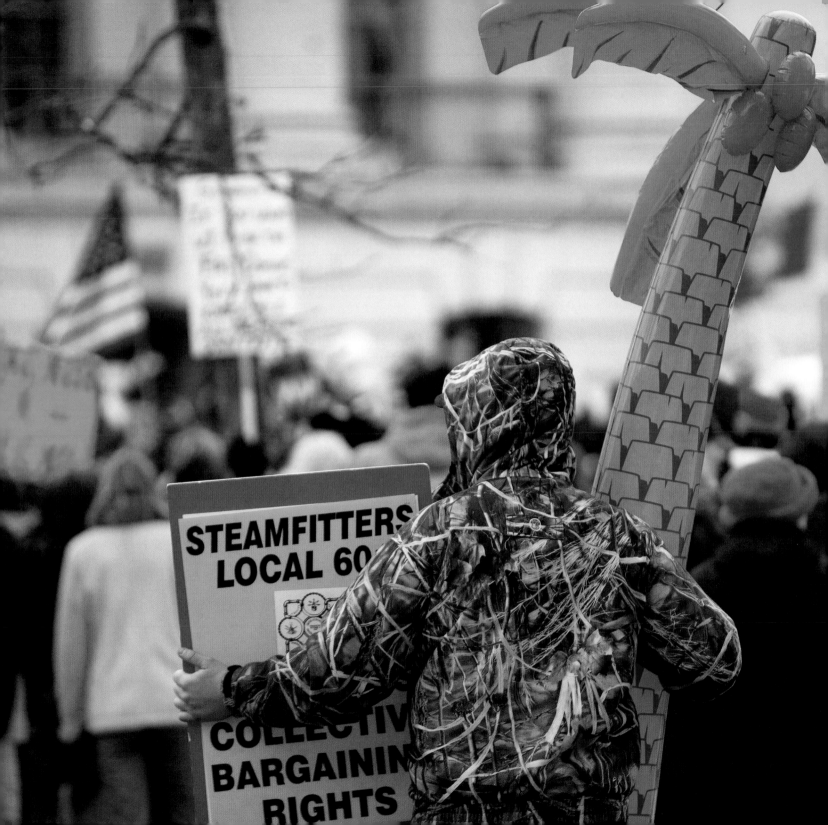

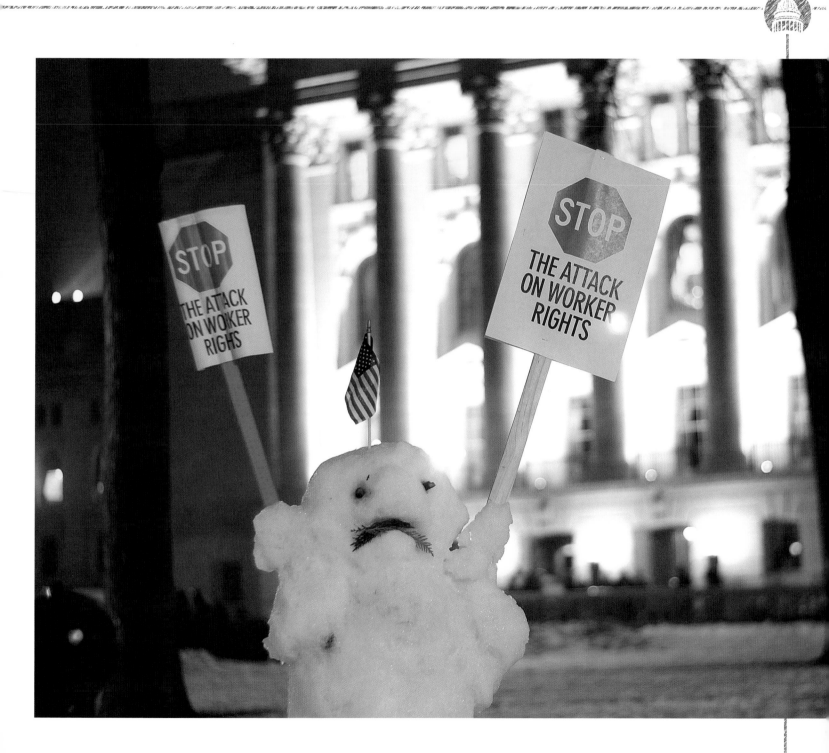

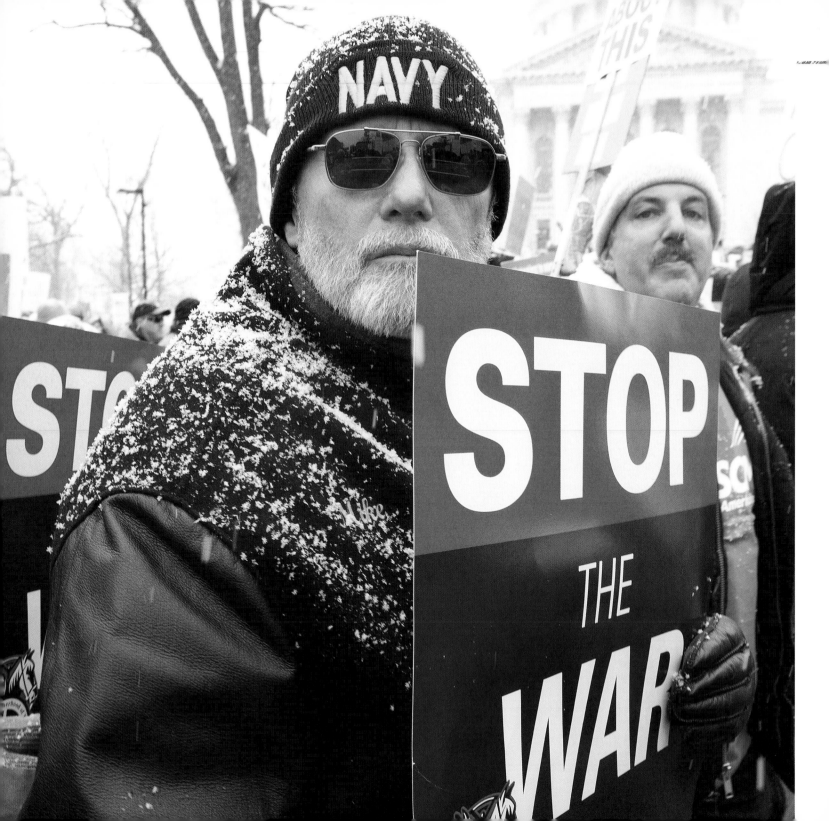

LOCAL BOY

Bobby grew up in a Madison suburb long before its fresh streets were lined with plastic-coated houses. The son of a cement contractor, he literally earned his spending money watching cement dry. Full-timers never wanted to stay late to protect the new pour, which, according to Bobby, is a crucial job. As evidence, he offers the story of an in-line skater who blatantly ignored numerous "wet cement" signs, zoomed through a narrow gap between two protective barriers, then face-planted into a pile of semi-set gravel and mortar.

"He's lucky I was there," laughs Bobby, "because if he didn't have any broken bones, he sure would have if the other guys had been around."

Bobby is ex-Navy—nuclear sub Navy—which, based on the exploits he proceeds to tell, is shorthand for, "I drank all night, hounded your daughters, and walked away from a flying Jeep wreck (not in the line of duty)—but I'm respectable now, except when I party with my Navy buddies."

His wife concurs, telling the story of a massive Marine who once flirted with her. In a deep voice laced with Semper Fi confidence, her would-be suitor asked in what branch of the service her husband served.

"He's on a nuclear sub."

The muscular Marine slowly shook his head as he backed away. "Those bastards are crazy."

Bobby hugs his wife, grinning with the satisfaction of a man who has found his mate for life.

Not quite ready to leave Bobby's rousing tales of the past, I ask if he spent his entire career on a sub, or whether he had also been stationed on a boat. With obvious disdain for my ignorance, he corrects, "A *sub* is a boat. A *boat* is not a ship."

You have to be *in* the Navy to understand this.

Using his GI Bill to pursue an education at the University of Wisconsin, Bobby now works at a local software company, has two kids, and owns a home just a couple of miles from where he grew up. His company isn't unionized, so I ask what he is doing at the protests. Conjuring up a Navy reference, as Navy guys do, he explains.

"On a sub, everybody does their job, or you die. If the pilot drives into a submerged mountain, you die. If the nuclear re-

actor boys miss something and it goes Chernobyl, you die. If the cooks feed you spoiled food, you die, or get sick enough that you want to die."

Seeing that I'm not getting it, Bobby scratches his graying goatee and connects the dots.

"I listened to a man at today's rally, and he spoke with great passion about community, how we all rely on each other. For the first time, I think the people here are starting to see that just like life on a sub, we are all connected. If one of us doesn't do our job, we die."

Bobby eyes me for a reaction, and I grunt in agreement. He's on to something, I think. Either way, I'm not arguing with the nuke submariner. Those bastards are crazy. ★

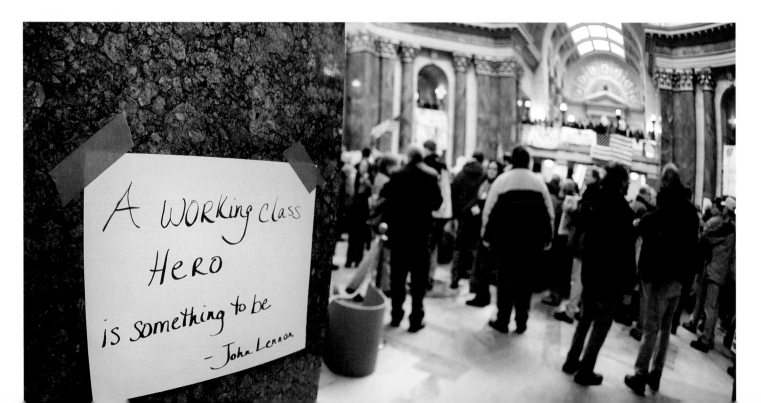

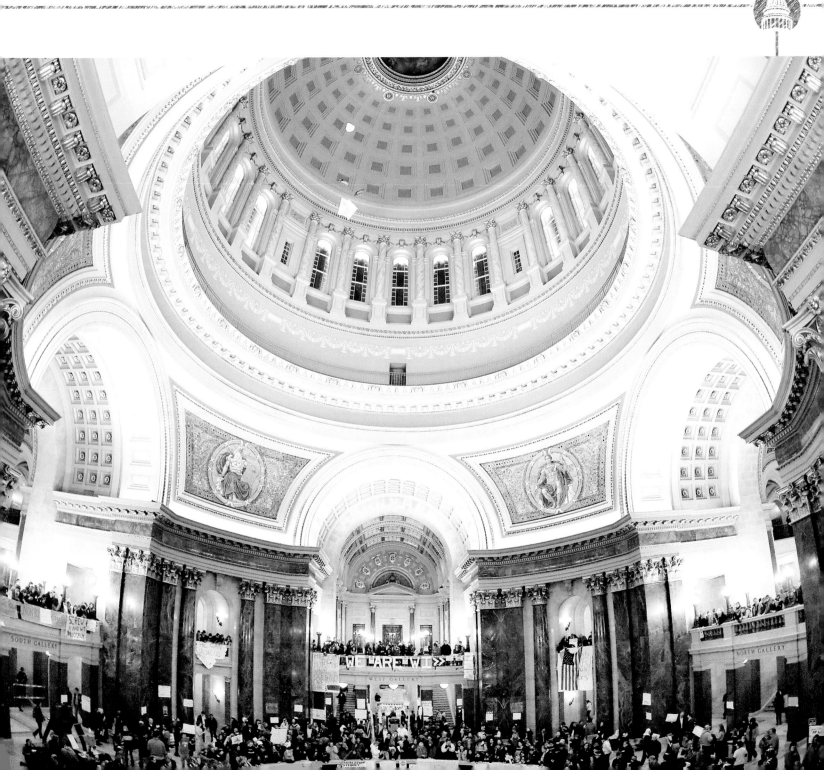

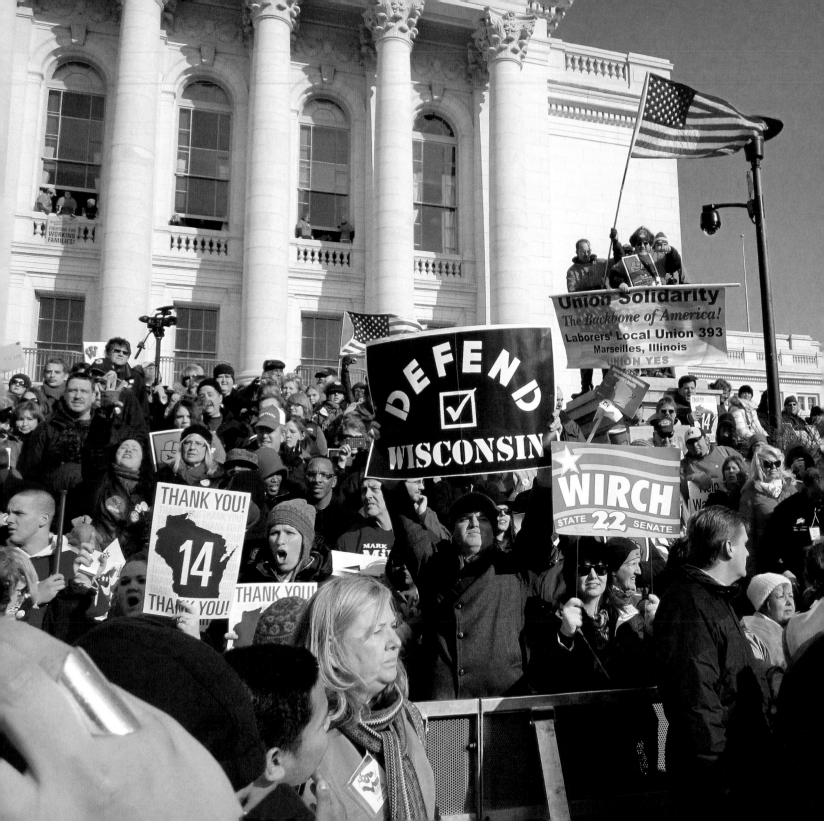

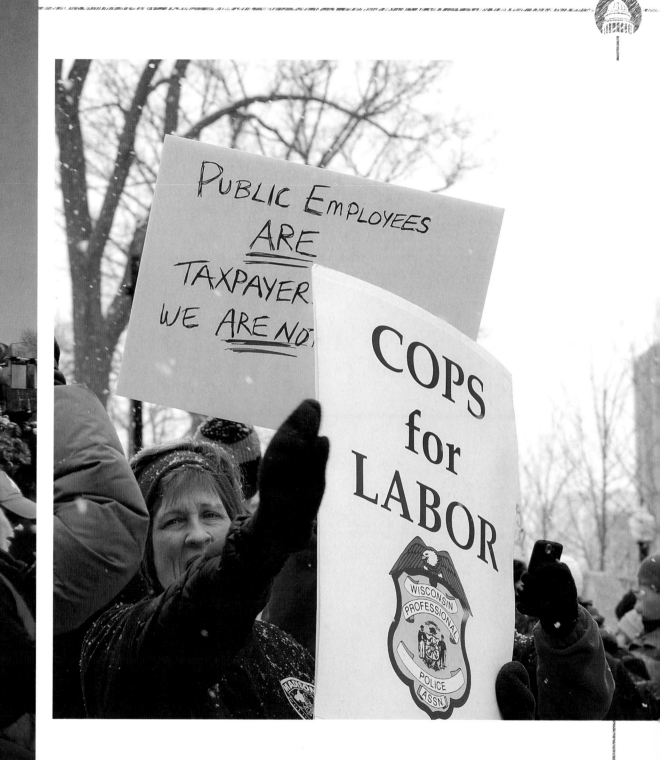

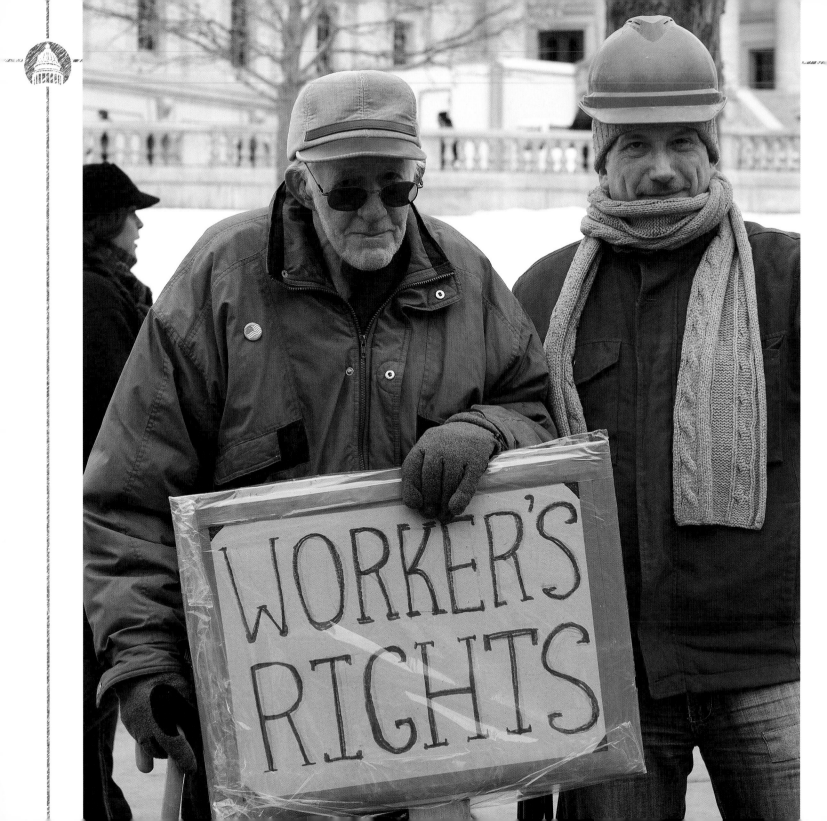

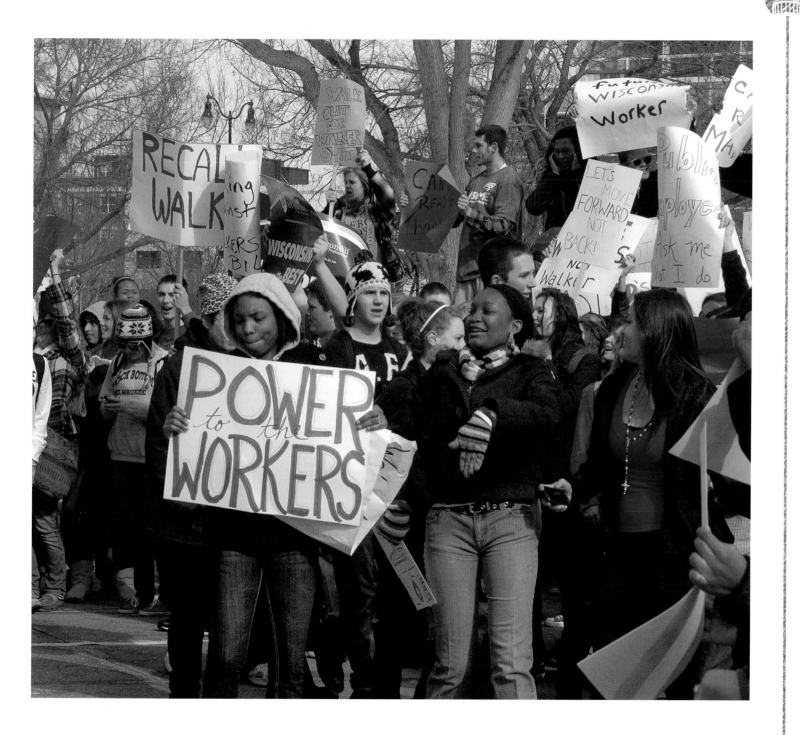

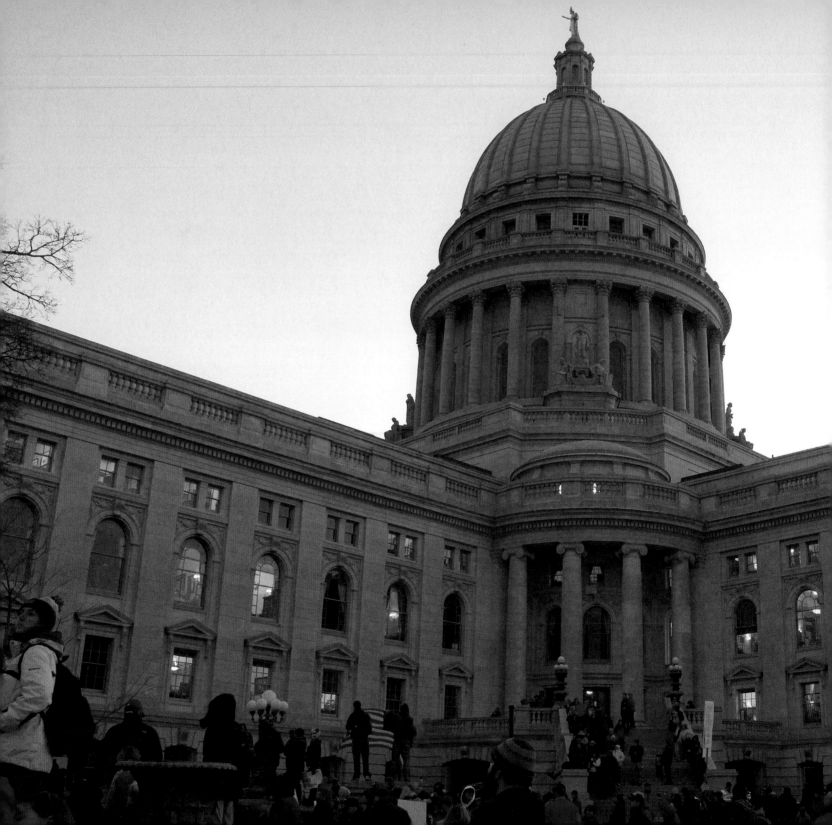

SONS OF IRELAND

If there is drinking, fighting, or fun to be had, chances are an Irishman is in the middle of it. Few other ethnic groups have such a celebrated history of rabble-rousing, or are more deeply rooted in American labor. It is only fitting that in the search to find a firebrand at the rallies, it led to the bastion of mischief—the Irish.

Staring down from the public gallery at the state assembly hall, Larkin briefly scans the group of legislators waiting to speak. These are his people, men and women supporting public employees like him. Surveying the high ceiling, he harks back to his first day on a picket line at the governor's mansion. It seems so long ago. Since then, he has protested an hour every day, all he can spare away from his family.

Down below, a flurry of activity grabs his attention. Legislators begin scrambling madly to get back to their seats, but it is too late. In a matter of seconds, the assembly leadership calls for, and closes, the vote. Only those favoring the legislation that Larkin abhors are able to push the buttons that decide his future. There will be no more discussion.

For a moment, Larkin is unable to move. Slowly, his hands clench until his chiseled face glows red. Jumping to his feet and throwing a pointed finger toward a fellow Irishman below, he hurls the ultimate insult.

"The Sons of Ireland will remember this!"

Outside the hall, Larkin has second thoughts about what he did. Maybe it was too harsh—his temper can get the best of

him—but he believes someone had to say it. Someone had to say, "You're Irish. I'm Irish, and you just went against our heritage."

To the non-Irish, Larkin's epithet may seem soft. We Germans could have loaned him some nastier-sounding words, and Italians toss heftier insults like pizza dough. But, to the Irish, a snub to heritage cuts deep, and to call someone out for such an offense is serious.

The heritage Larkin defends so vehemently was spawned in desperate times. Every school child learns the story of peasants fleeing potato famines in Ireland for a better life in the United States. America welcomed strong Irish backs to build

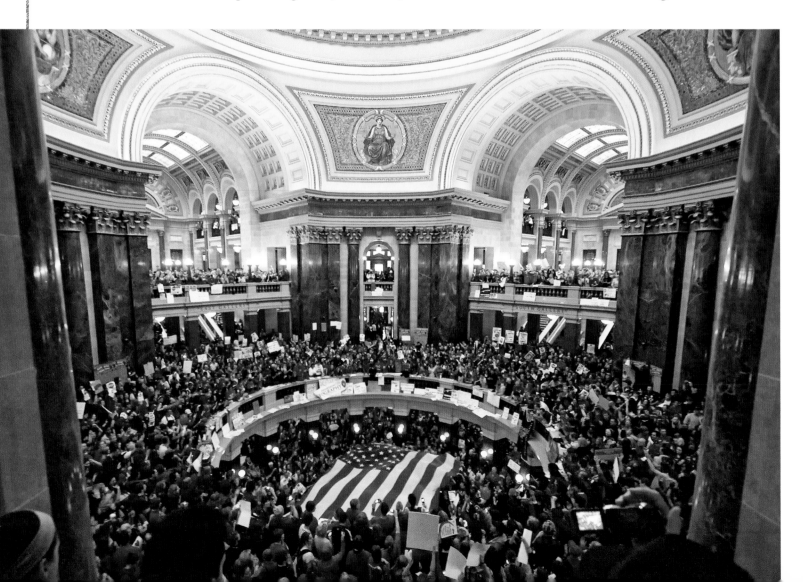

canals and railroads, but not the Irish themselves, who some considered unworthy of citizenship. In response, the Irish pushed back—hard. They were determined to become Americans, and if they had to fight their way in, they would. With calloused hands and a few bruised knuckles, the Irish proudly ascended the steps of working class.

In many Irish households, "labor" is synonymous with "heritage." It pays homage to ancestors who fought to rise to the middle class. For men like Larkin, labor history is more than a lesson in a book; it put food on the table for seven brothers and sisters.

It does not matter that Larkin looks anything but Irish, with his Australian outback hat and Midwest accent. Being Irish is about heritage, and in Larkin, there is unmistakable Irish fervor—or more correctly—Irish American fervor. Irish immigrants did not fight to create a new home for Ireland in America, but a place for Irish in their new home.

Walking away from the Capitol, Larkin faces a difficult choice. Some say the strength of the protests is in peace and courtesy, but is that enough to satisfy the Irish in him? Is it time to hold his tongue, or time for a pint and a good rumble? ★

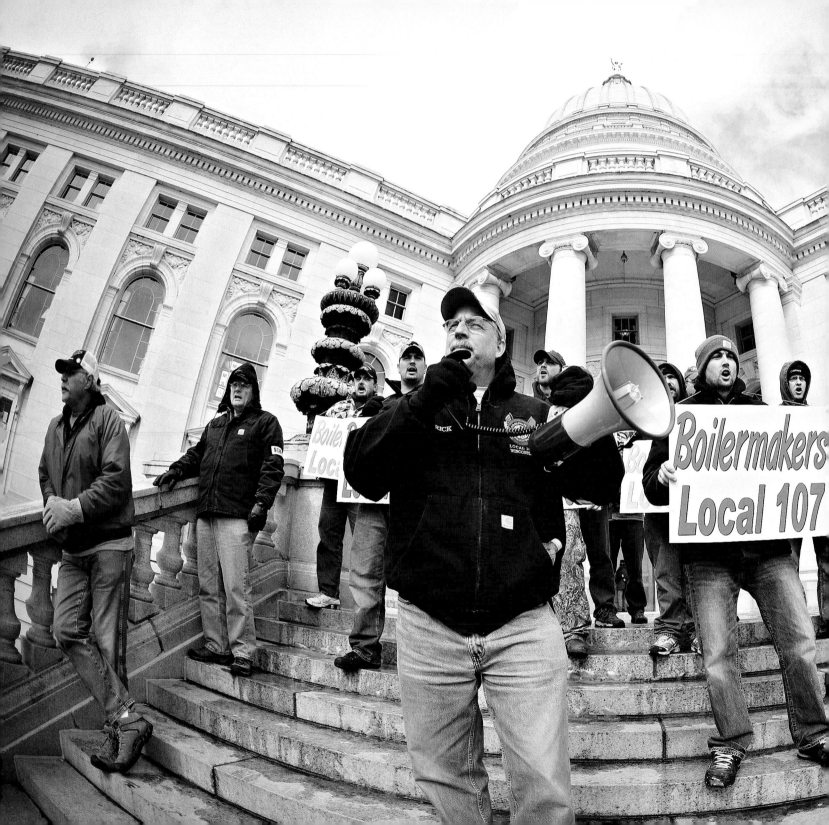

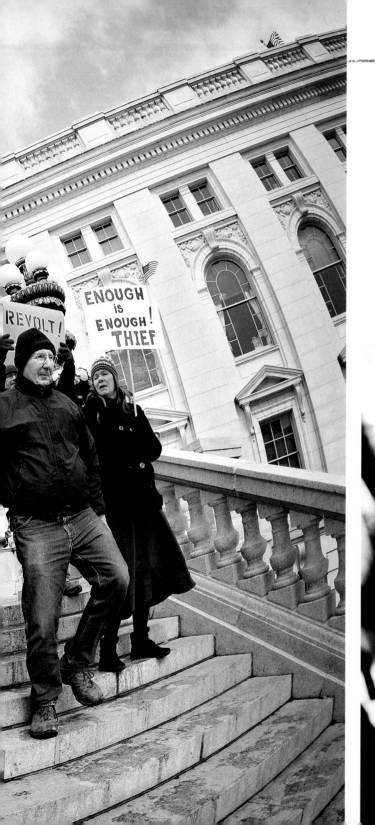

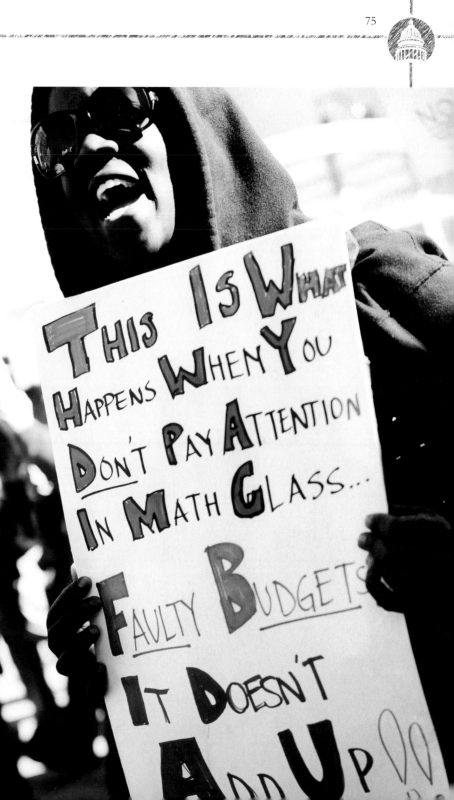

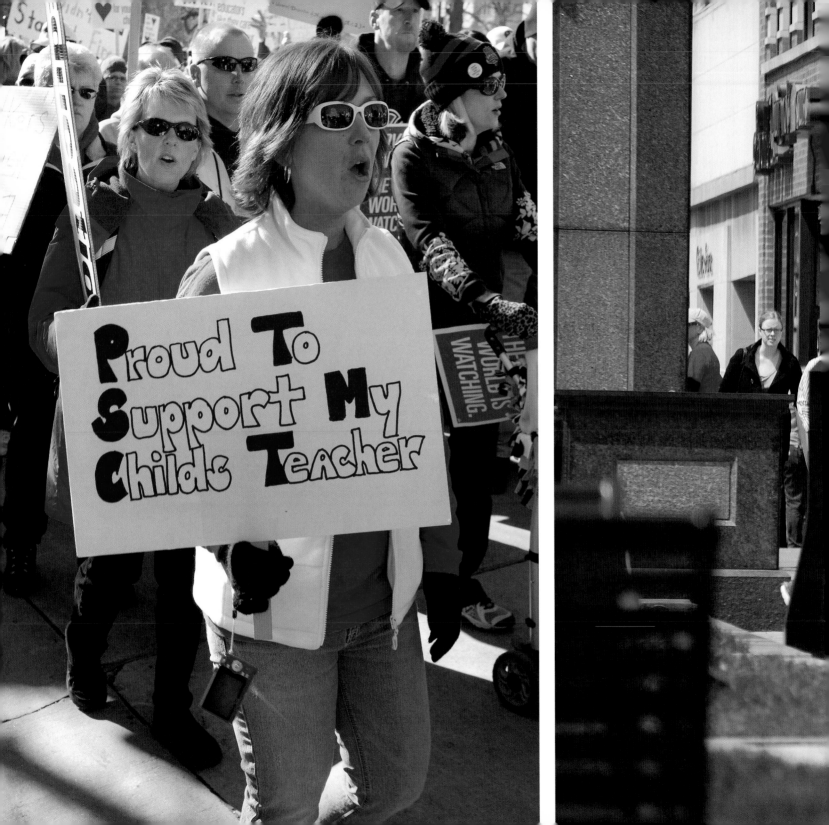

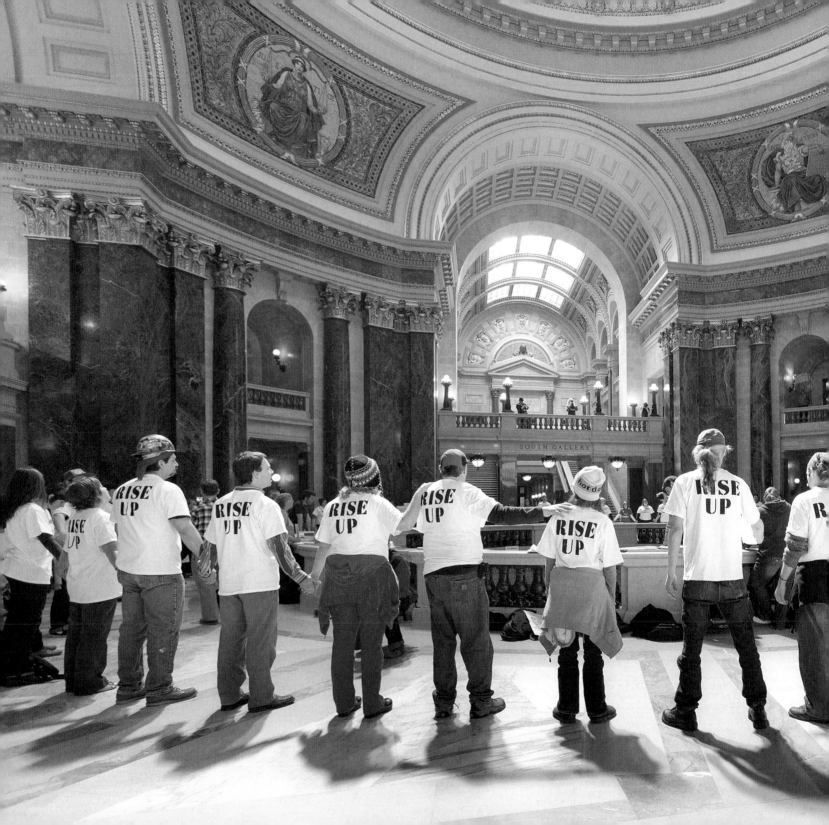

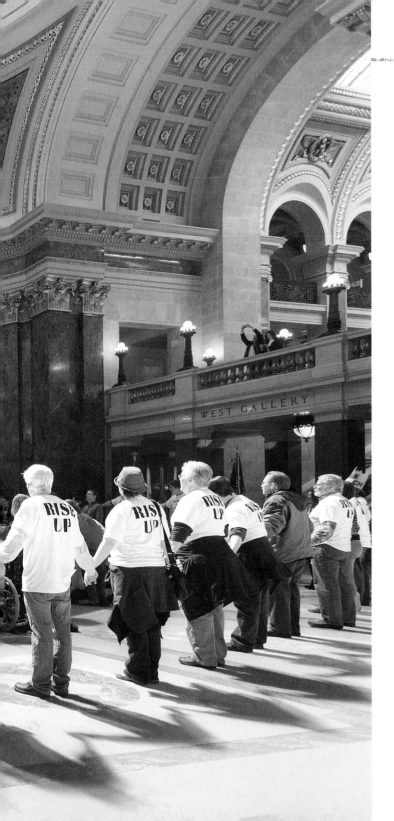

A DIFFERENT WORLD

Driving a city bus has all the components required to induce a massive coronary—rush hour traffic, diesel exhaust, and impatient passengers trying to catch a transfer. Therapy sessions ought to come with the job, but for Steve, guiding a twelve-ton box through crowded streets *is* therapy.

When I first notice Steve, he is standing alone, peering at a huge flag being unfurled across the south Capitol steps. It is hard to tell what emotion lies beneath his bearded face. Fixed eyes suggest contemplation, but his posture is relaxed and approachable. I do not intentionally interrupt his moment, but when my glove falls to the ground, he looks my way and we exchange greetings.

Steve spent several years on the East Coast, but in most respects, he is Wisconsin. He grew up on a dairy farm not far from Madison, enjoys helping his elderly neighbor raise vegetables, believes his children should value hard work, and is dedicated to his family—the latter almost costing him his job once when he took off work to care for an ill relative.

A Madison Metro driver for fifteen years, Steve is affected by the legislation sparking the protests, but on this day, his interest is cast elsewhere—at a young bus passenger he just saw. For some time, Steve has driven the campus route, shuttling students to and from classes. During slow times, he gets a chance to visit with riders.

"I love talking to the kids, especially those from other countries. For the past three weeks, they can't talk about anything

except the rallies. They are in awe, because many can't protest in their own country. They would get beat down."

Steve takes a quick look at the flag fluttering on the steps.

"These foreign kids tell me that the greatest thing about America is that we are able to question our government with-

out fear. And I have seen some of them at the Capitol today. They have nothing to gain, but they still come—just to experience a freedom they may never know again."

Looking me square in the eye, Steve nods.

"Makes you think we take things for granted, doesn't it?" ★

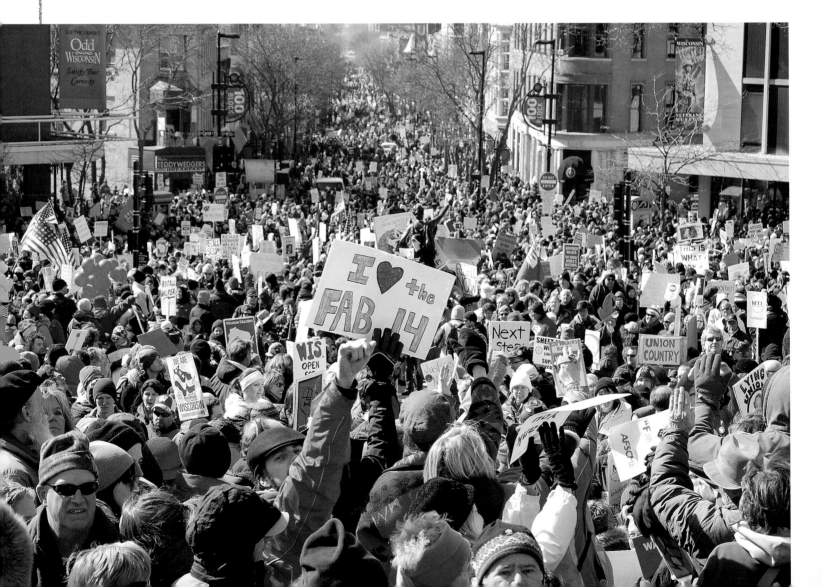

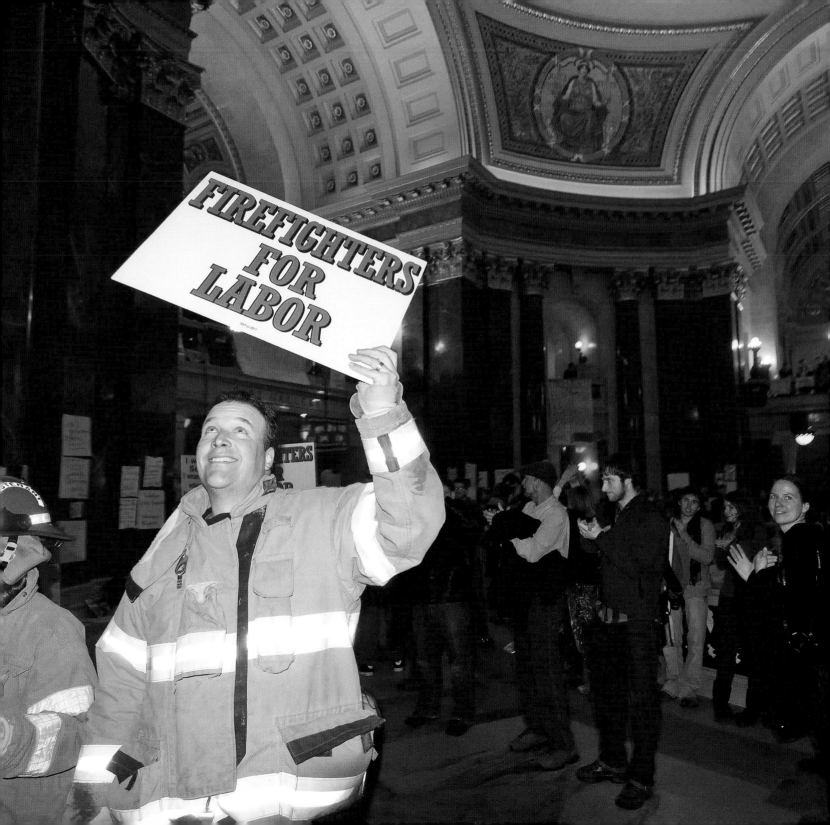

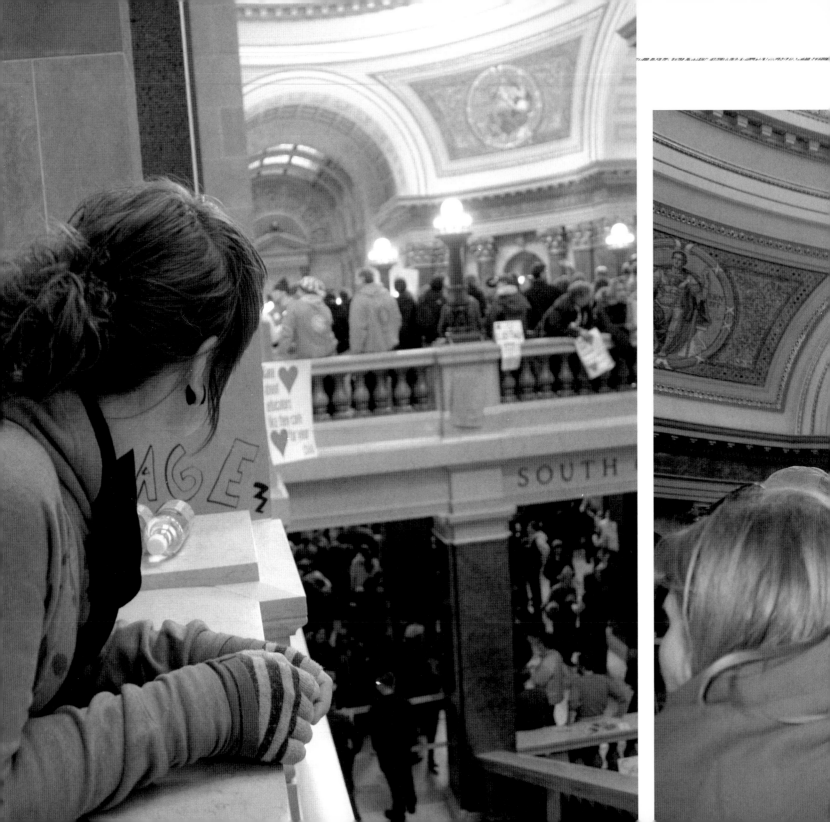

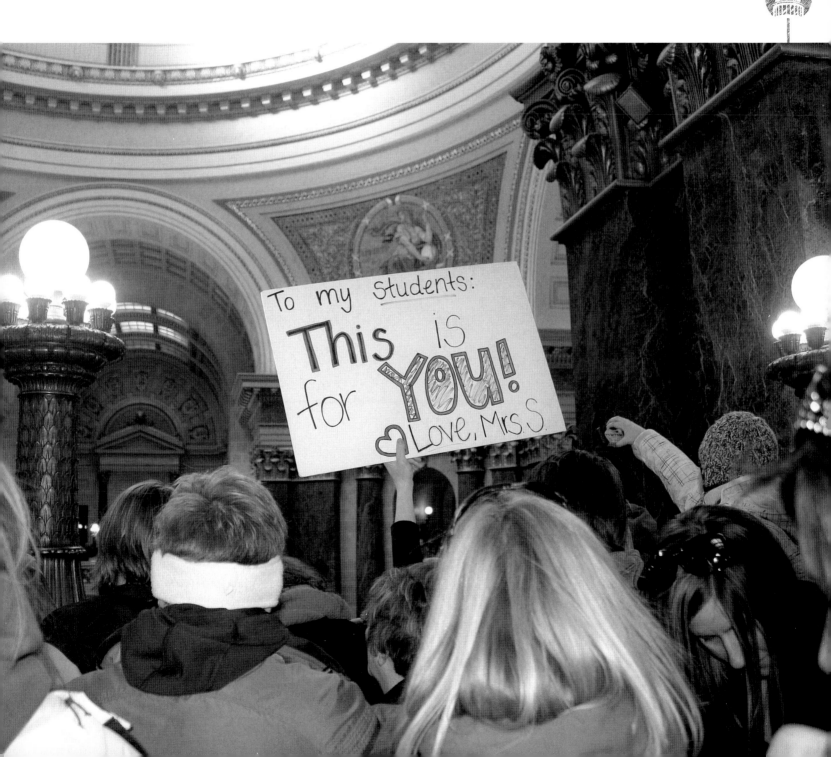

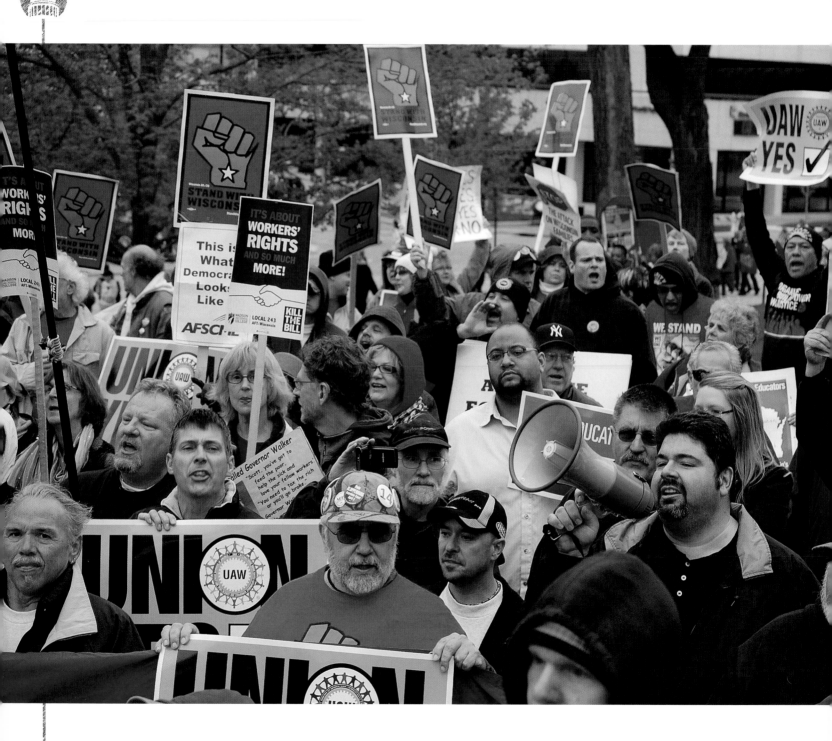

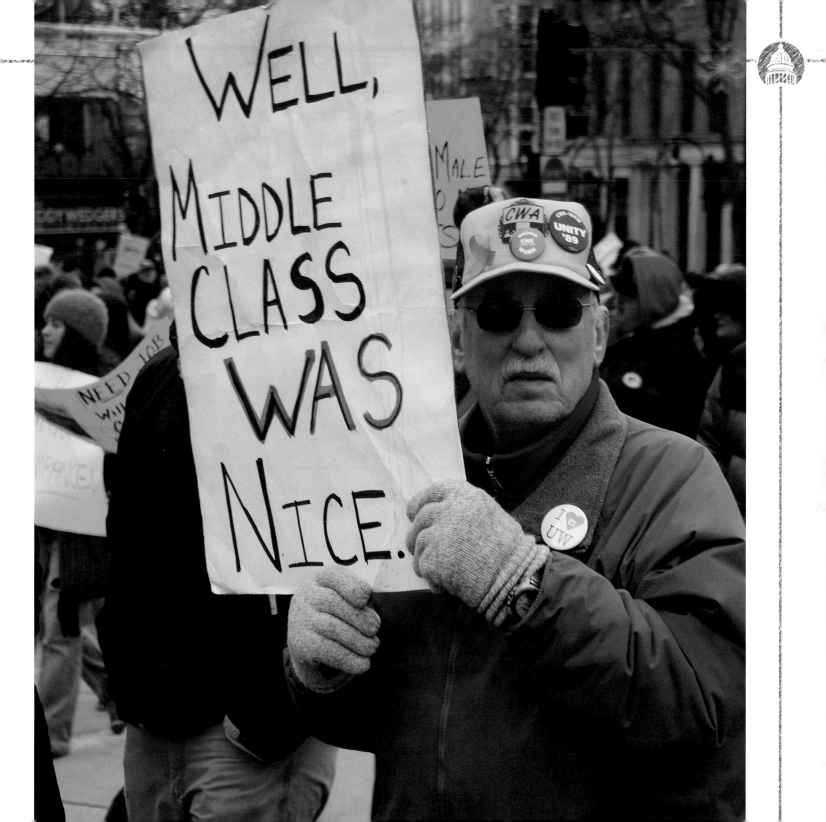

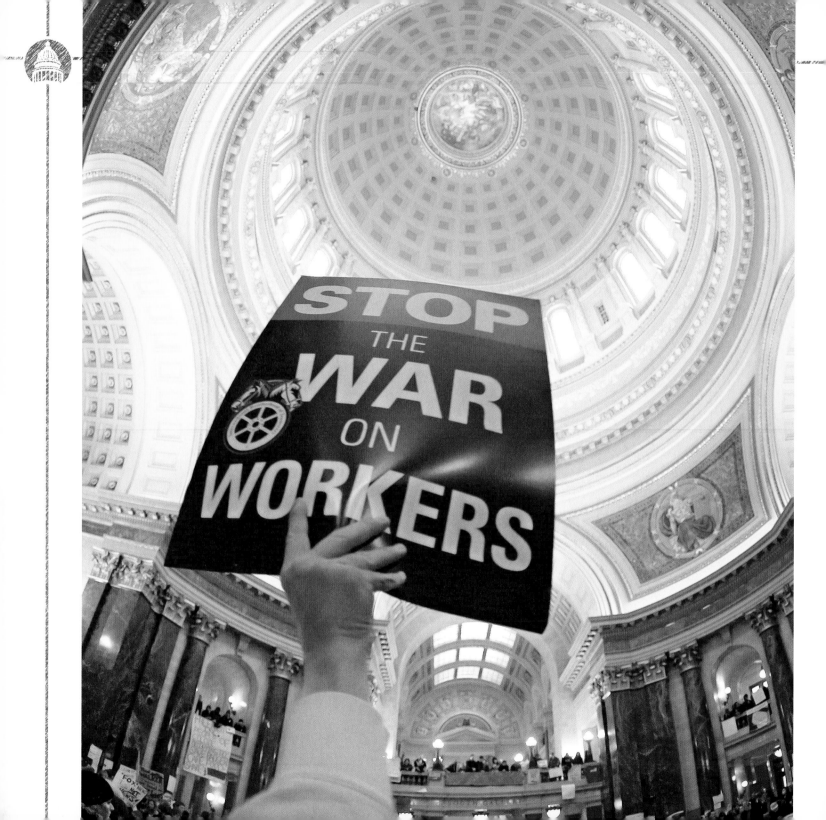

FAMILY AFFAIR

For a protesting parent, life trudges on. Kids must be shuttled to piano lessons (some voluntarily, some in handcuffs), the garbage must go out on Thursday, and the oil in Junior's car must be changed before pistons and cylinders decide to tie the knot. Just because Mom and Dad are out trying to change the world doesn't give them a get-out-of-jail-free card from family responsibilities.

Usually, protests are not thought of as family events. Some are powder kegs just waiting for a match. Not so in Madison. The air is so peaceful that parents often bring young children, some little ones toting signs displaying the simple, elegant logic of a four-year-old. "This bill is yucky," with "yucky" sketched in preschool penmanship. Or, "Liar, liar, pants on fire." You can't go wrong with the classics.

Nonthreatening normalcy is a signature of the rallies. You never have to walk far to overhear conversations that regularly occur in a Wisconsin driveway or over a cell phone in a restaurant. "Billy, for Pete's sake, just look! The spaghetti is on the second shelf of the fridge, in the container marked *spaghetti*." Families think no more of walking the Square than they do a shopping mall, often breaking up and heading in different directions, meeting up again later. And, like at a mall, the protests are another stage for the ongoing pageant of parenting.

Beth looks to be about forty, and is just saying goodbye to a neighbor as I walk past. She seems friendly, so I ask her how it is going.

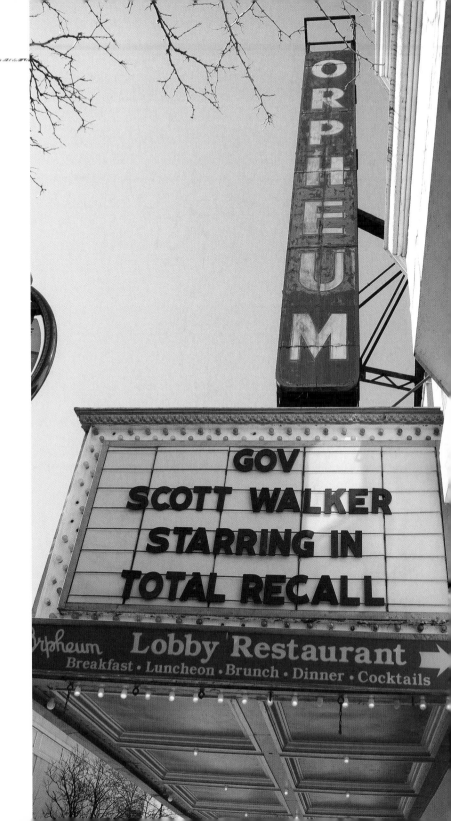

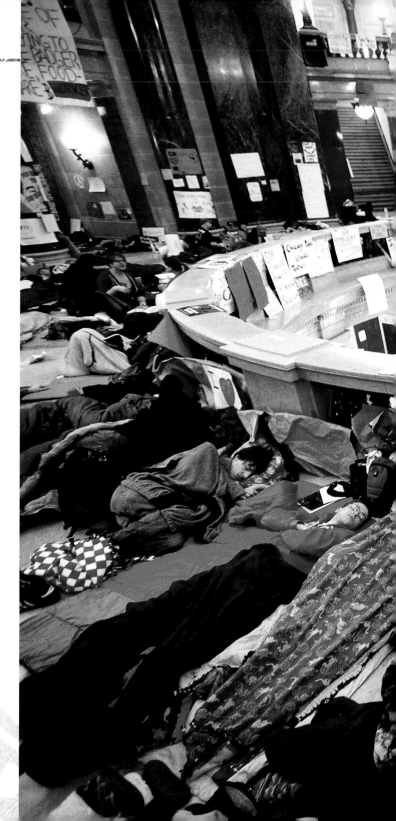

"Excellent!" she says with the exuberant freedom of a parent without children nearby, or rather, *her* children nearby. "I was supposed to work today cleaning houses, but I just had to be here. So, I called up a couple of clients, explained the situation, and asked if it was okay if I did their places tomorrow."

"How did they react?" I inquire, curious whether her clients supported a leave of absence.

"One said okay, but didn't seem real excited. She tends to be a little snooty, though. The other said, 'You go girl!' So, I did."

Just then, an attractive young girl carrying a sign approaches with a willowy boy in tow.

"Hi, Mom."

Beth eyes the boy's hands, which seem to be placed strategically on a part of the girl's body that would not draw attention, but indicate a certain level of familiarity.

"Hi, dear."

"This is Tony. You've met him."

"No, I haven't."

Life goes on. ★

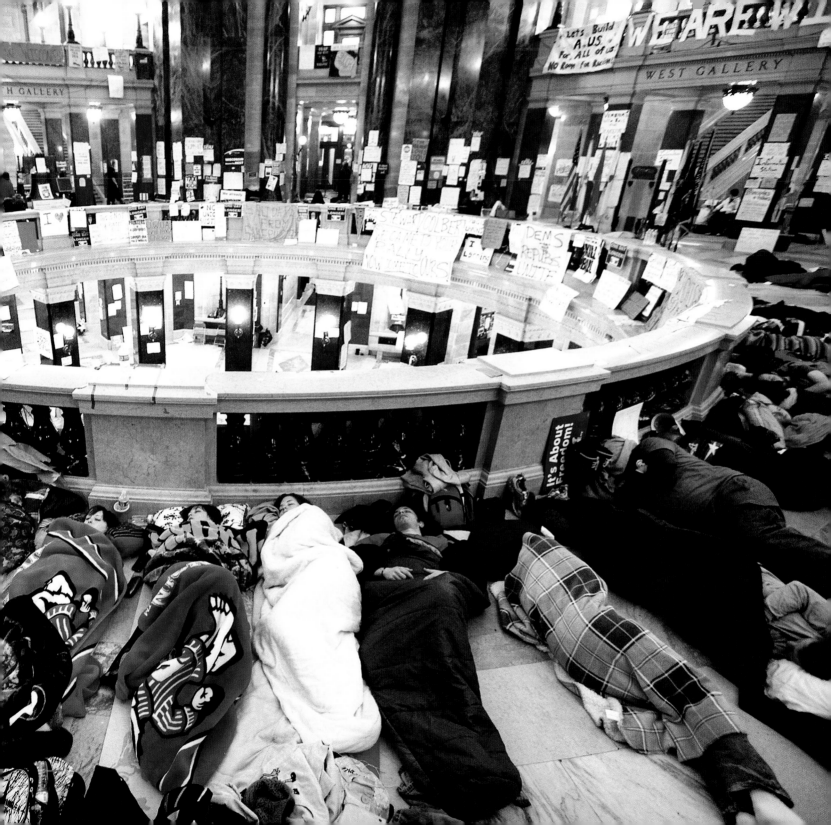

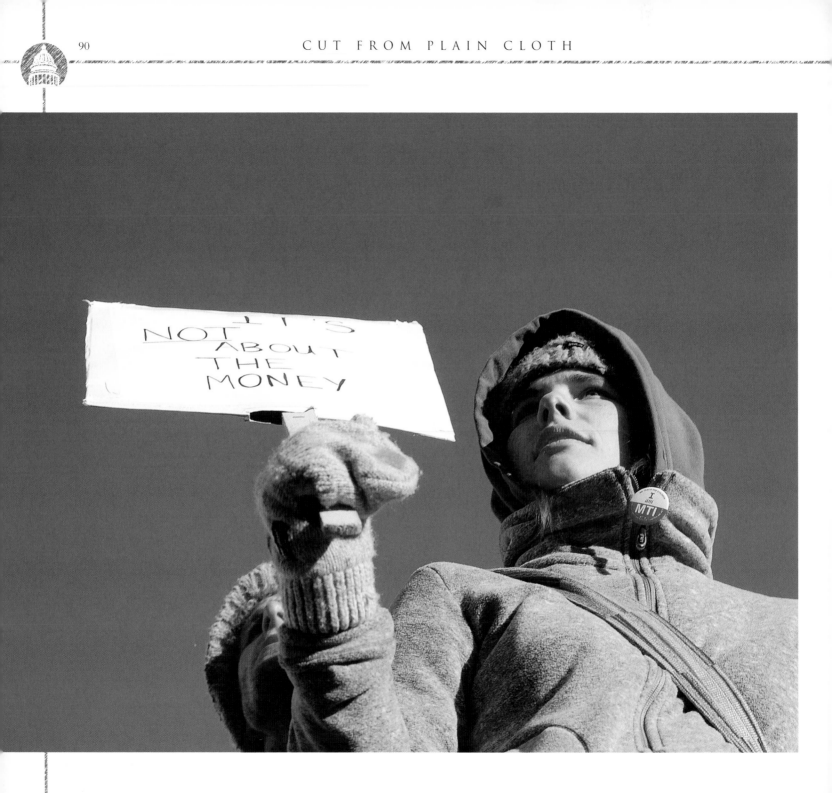

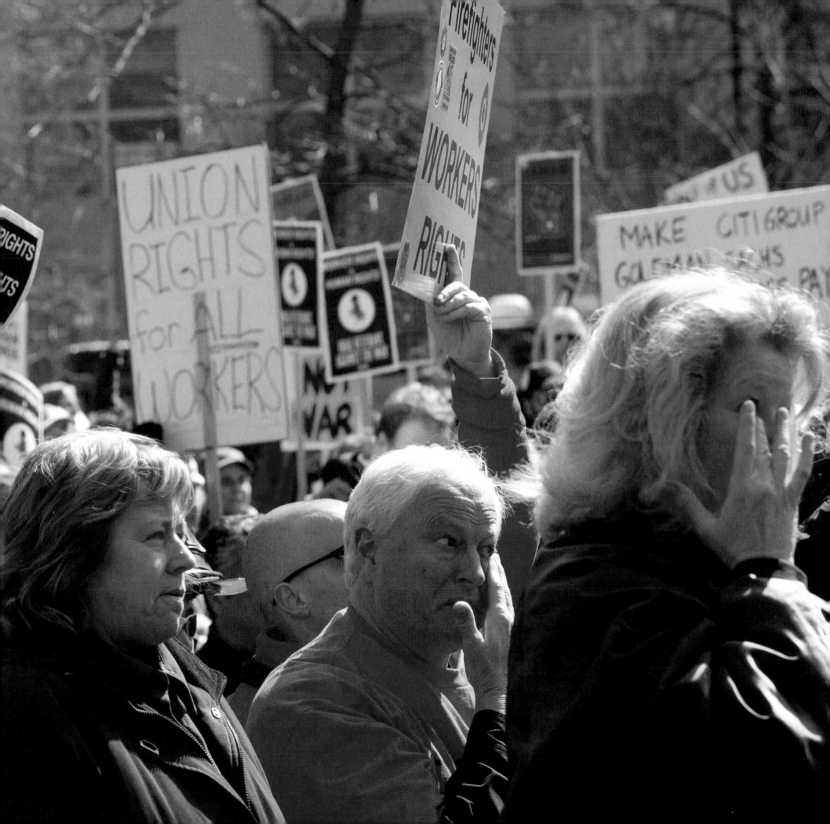

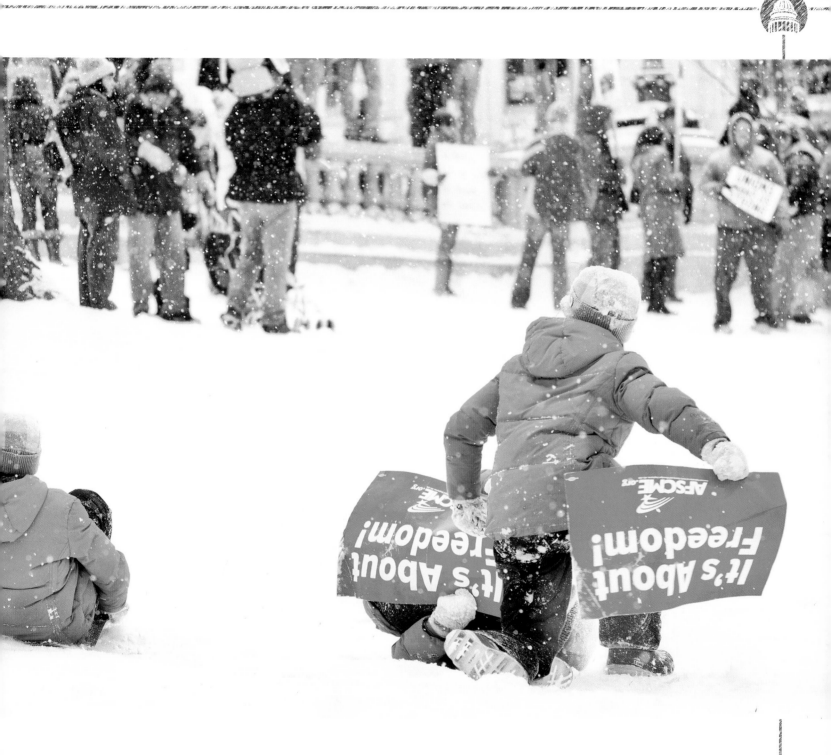

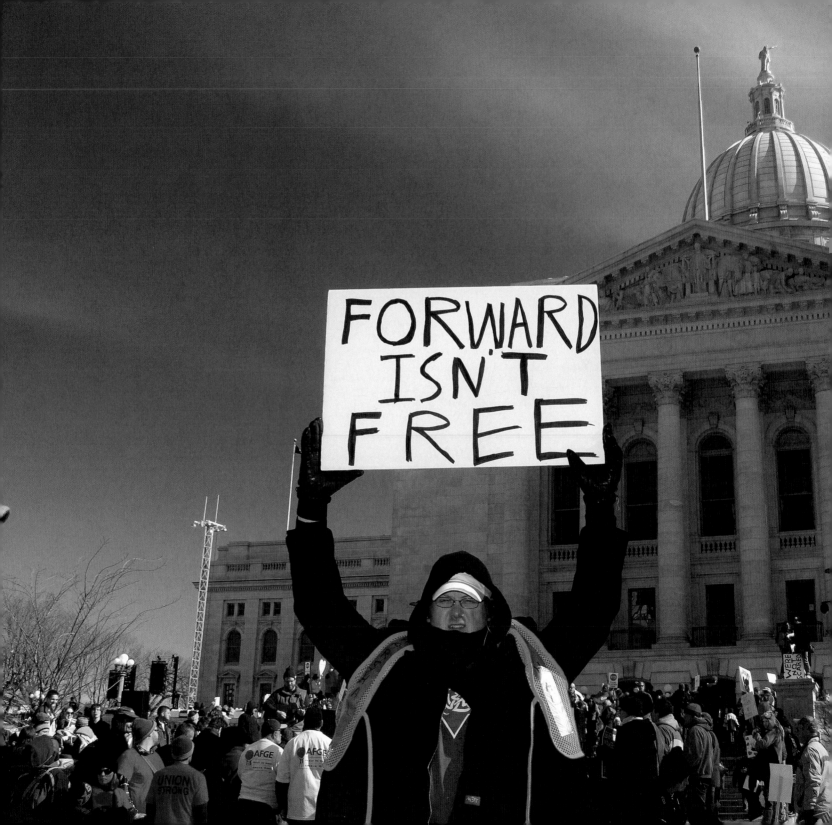

SACRIFICE

For two weeks, the statehouse has been the core of the protest reactor, occupied day and night. By day, the roar of protesters in the rotunda is deafening. Almost hourly, parades of visiting supporters are led on marches of honor, snaking through the jammed building, hailed with cheers of "Whose house? Our house!" By night, the floors are stacked with sleeping bodies, recharging to fight another day.

Sifting through this afternoon's crowd is Jen, a volunteer marshal whose job is to answer questions, keep things moving, and act as a buffer between protesters and police. An unequivocal success, marshals are heralded by Madison police for helping keep the protests more peaceful than a Badger football game (especially after knocking off Ohio State). The system is genius, because whether at a concert, football game, or protest, people are naturally defensive when approached by police. In contrast, when a pretty blonde asks a bunch of guys to please make way, they part like the Red Sea—and then thank her for asking.

Jen has worked the rallies every day, and has yet to tire of seeing starstruck protesters enter "our house" for the first time. Newbies come in, widowed from hope, and leave on a honeymoon. But, after two weeks of occupation the matchmaker is about to shut down. The legal mechanism that has kept the building open at night is no longer in force, and anyone refusing to leave when the building closes could be arrested. Marshals like Jen have been given the job of notifying protesters. It is a day she has dreaded.

95

Circulating counterclockwise through the rotunda, Jen relays the news, informing those who wish to engage in civil disobedience to proceed up one floor. She has been at it for an hour when she comes upon a middle-aged woman sitting alone on a bench in an alcove, staring into the crowd with big eyes and a delicate smile. The woman is friendly, and politely listens to Jen explain what is happening.

"Will I be arrested if I stay?" she asks.

"I'm not sure," replies Jen. "It's possible."

"Oh. I just don't know what to do."

"Well, if you need transportation, there are buses outside." Not wishing to press, Jen says good-bye and begins another pass around the floor.

Half an hour later, Jen again comes to the alcove, and there sits the woman, still intently watching the chanting throng

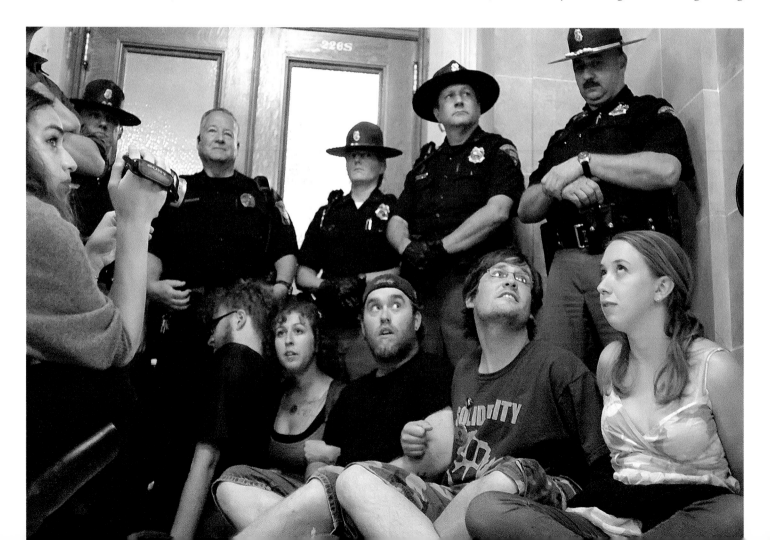

on the floor. Before approaching, Jen studies her for a moment. The woman has a soft innocence, like a country kid who has come to the big city for the day and is taking a mental picture of every exciting detail.

"Still haven't decided, huh?" smiles Jen, raising an eyebrow and tilting her head.

"No. I guess I don't know if I'm willing to be arrested."

"Yeah, that's a tough one. Just so you know, you've got about twenty minutes left…."

"Thank you."

Jen is supposed to repeat her instructions, but chooses not to. In the tension that is mounting as the exit deadline nears, there is something soothing in the woman's quiet composure. It is as if she sees something that nobody else does.

A few minutes later, after finishing an excited conversation with a protester who decides to move upstairs and take her chances, Jen takes one more lap around the floor. Curious, she pauses to look into the alcove. The bench is empty.

Spinning around, Jen scans the floor, but the woman is nowhere to be seen. For a second, she thinks about going upstairs to look for her, but instead turns, slowly walks to the alcove, and sits on the bench. ★

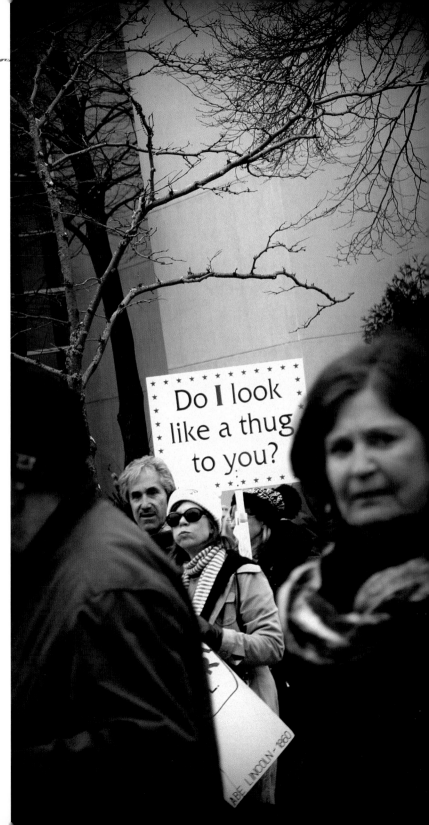

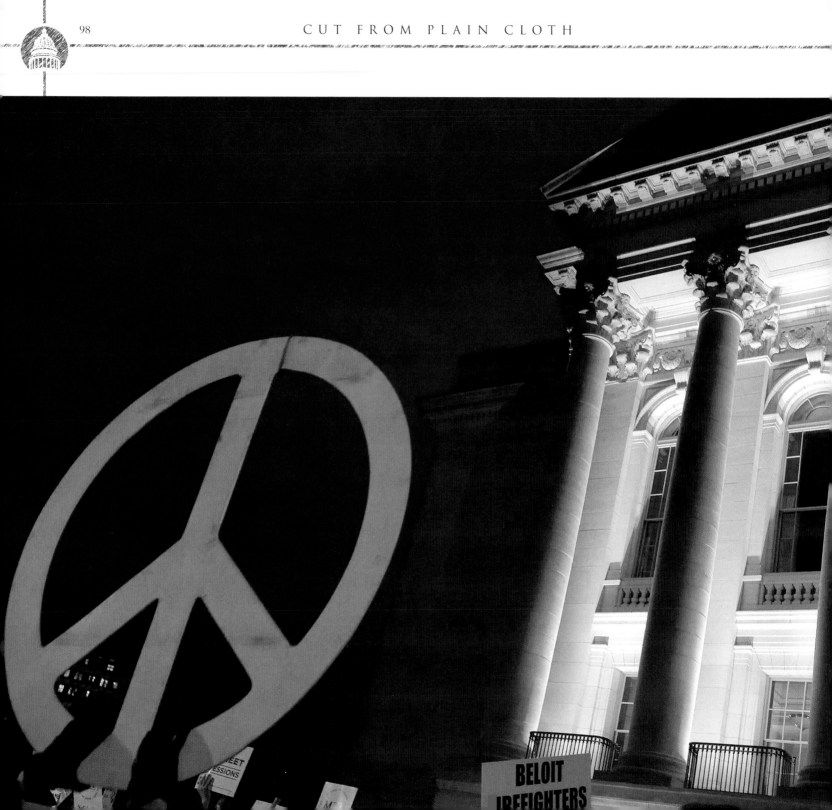

BELOIT
IREFIGHTERS

THIS IS WHAT
DEMOCRACY
LOOKS LIKE

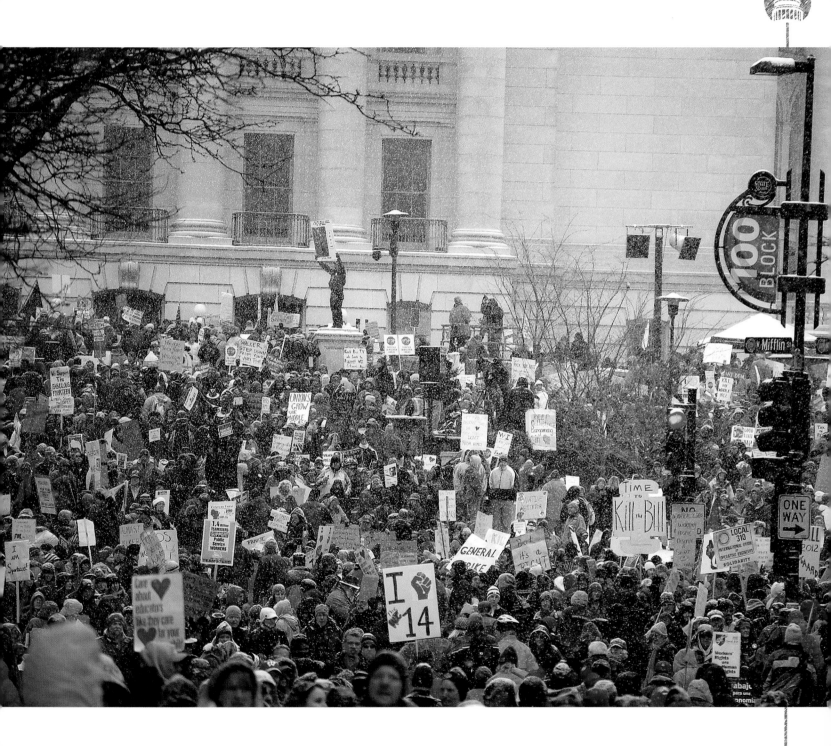

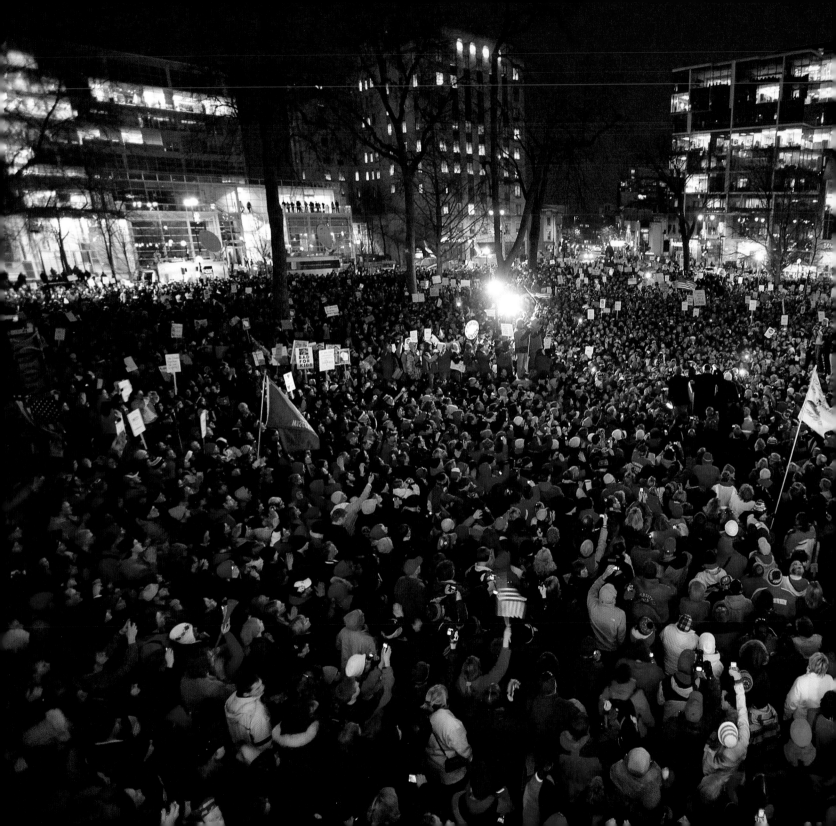

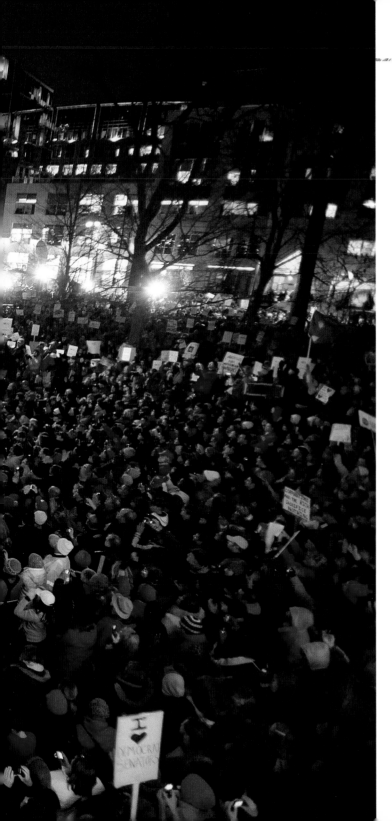

NEIGHBORHOOD WATCH

Seventy-nine-year-old Greta sits on a bench flanking the sidewalk, struggling to stay cool in the heat. It is June, four months after the rallies began, and the temperature is climbing into the nineties. Opposite a protest sign leaning against her bench sits a man who keeps reminding Greta to drink water. Just off her shoulder stands a woman who occasionally asks if she is getting too hot.

"These are my neighbors," Greta explains. "I live in an apartment near here and try to get out to protest once a week, but have had health problems." She waves an unsteady hand. "*They* wouldn't let me go alone." The neighbors just smile protectively. Friends of Greta's for some time, they are used to her enchantingly spunky disposition.

Greta's independent nature is embedded in history spanning two continents. Born in the United States in 1932, she was transplanted to Germany soon thereafter when her father took a job near Berlin. Getting caught up in WWII, she experienced much of what we have read about those times, but not necessarily in the way we have heard.

"My father had Polish prisoners working for him. He treated them well, even making it possible for one prisoner to visit his family at Christmas. Of course, this was not approved," she says matter-of-factly.

During the war, Greta befriended a Jewish boy who had no family. Though she was only a little girl, she became an

"agitator," helping other kids who needed empathy during bleak times. After hostilities ceased, Greta ended up in the Russian zone of a divided nation. There, the Russians got a taste of her scrappy nature.

"With U.S. citizenship, I became a nuisance to the Russians, so they expelled me." Greta does not elaborate what "nuisance" means, but one can imagine a spirited young Greta easily earning the title.

As we speak, Greta's friends continually encourage her to stay hydrated, even resorting to trickery. The man raises his water bottle, asking her to toast to "peace and the future of our world." Greta sips, but clearly knows it is a trick.

Coming back to the United States in 1948, Greta continued her independent ways.

"I went to college at a time when the only accepted education for women was home economics. When they asked me to take a decorative stitching class, I said *no way*." Again bucking societal convention, Greta transferred to the literature program. Until her retirement, Greta spent her life with the novels she read in college, working as a book collections coordinator. I get the impression she still does not do decorative stitching.

When asked what she thinks of the budget bill, Greta answers simply, "It's terrible." I prod for details, but she seems comfortable that her first statement covers it well enough.

It isn't long before we are joined by two more friends, both of whom are carrying foam containers. "It's time to eat now," one of the women cajoles Greta. "You need to have some food."

"Everyone makes such a fuss," says Greta, running a hand through her white hair, but taking the meal.

Standing up to create space for one of the new arrivals, the man who has been sitting on the bench turns half to me, and half to the group. "Greta is such a great lady. Her determination is what gets us down here. She is our teacher in activism and how to have a great life."

Everyone nods in agreement.

Heading off to find a snack of my own, I glance back to see Greta surrounded by her affectionate neighbors, intent on seeing to her lunchtime needs. I'm sure she is telling them that she can do it on her own, but maybe a little solidarity now and then isn't a bad thing. ★

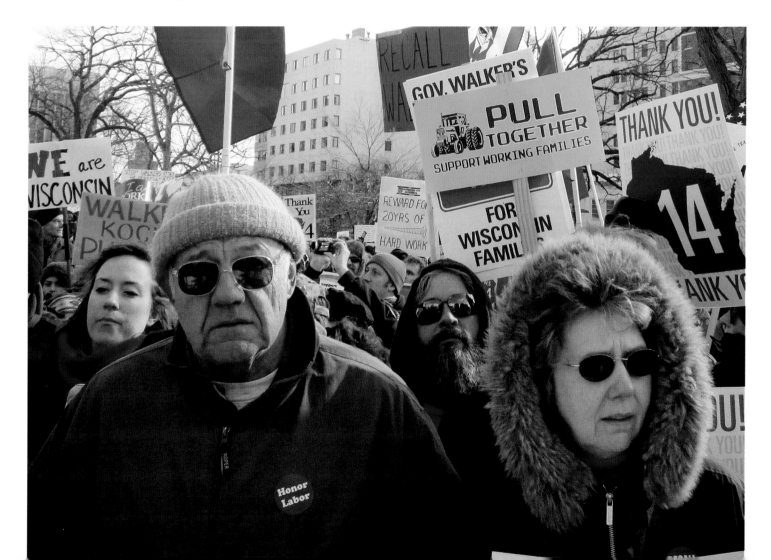

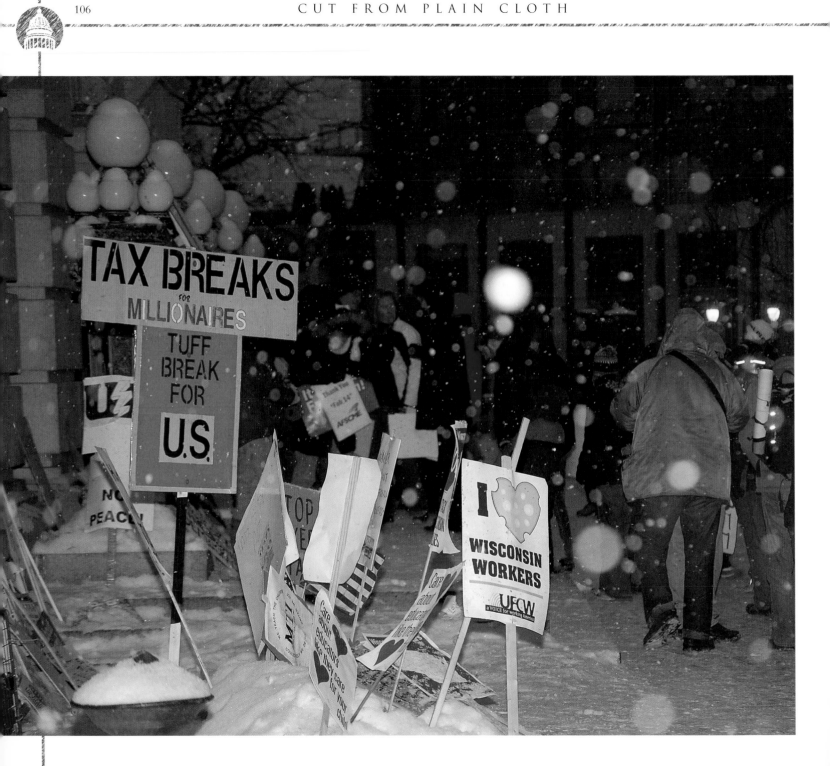

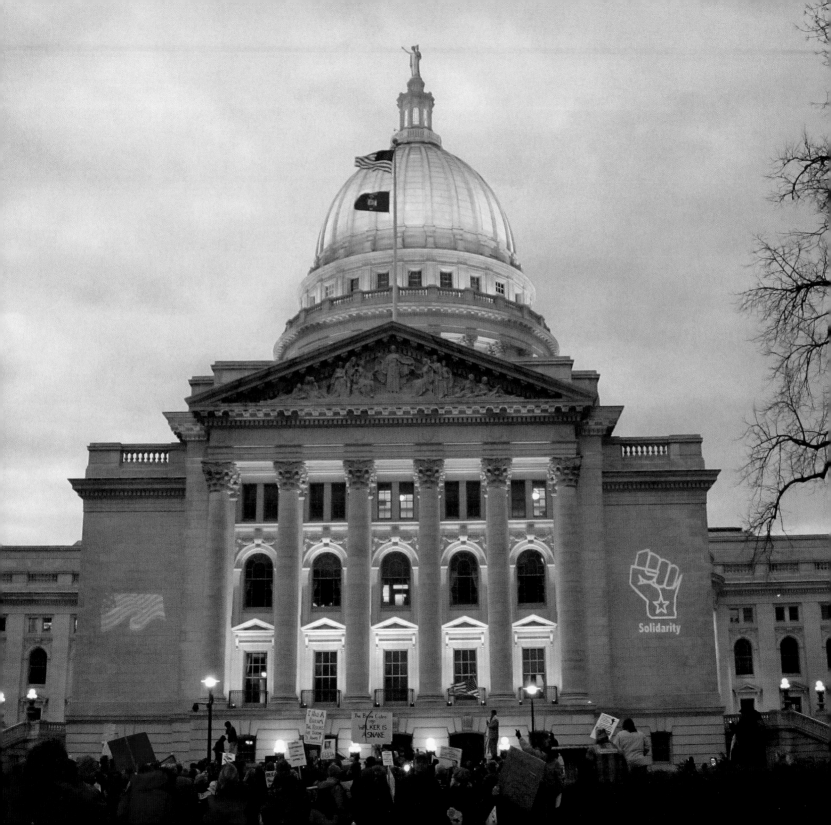

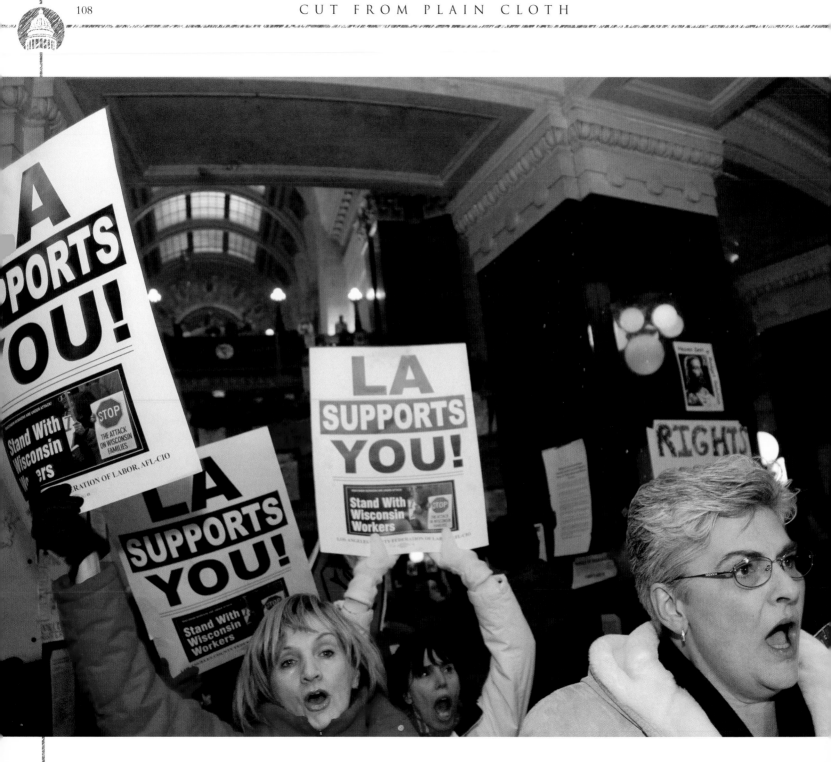

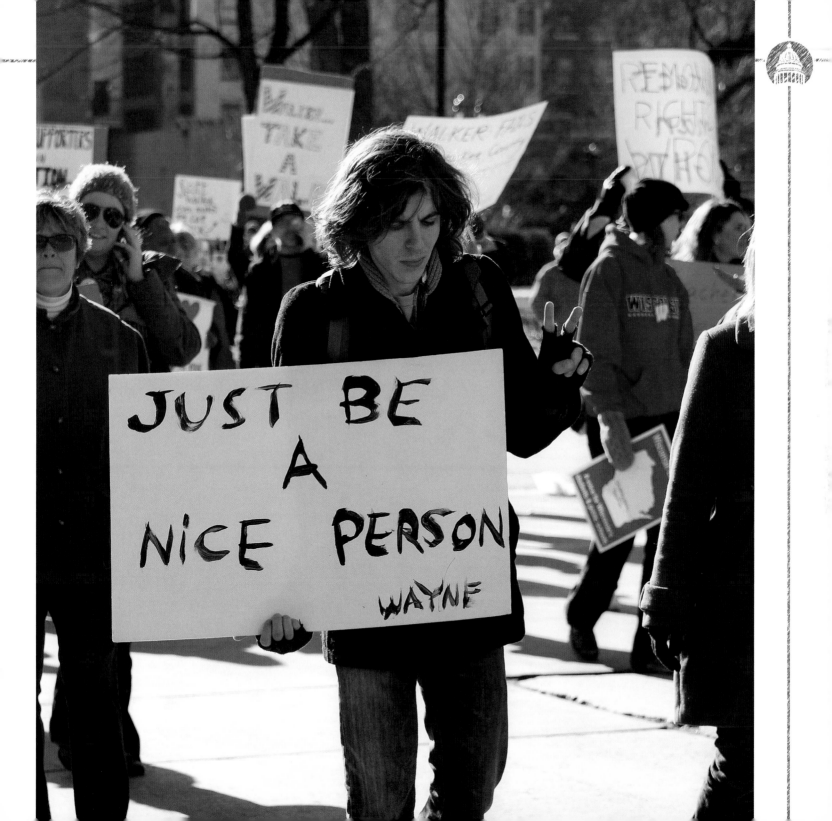

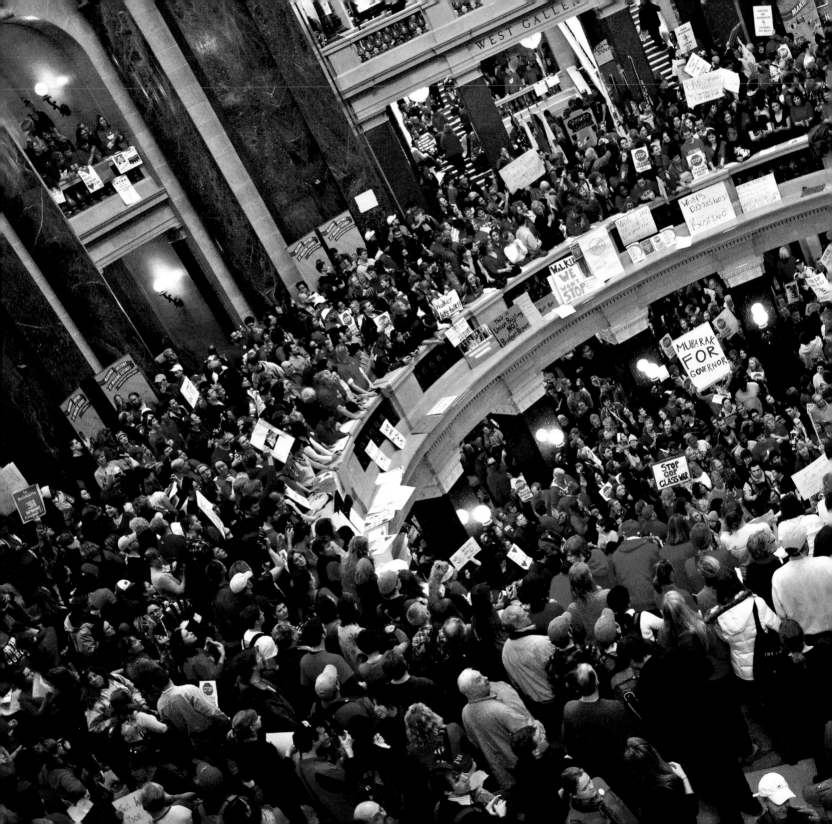

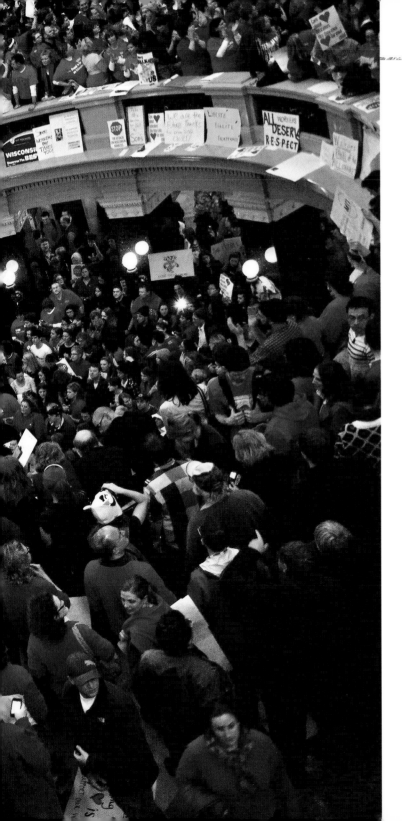

A FEAST FOR EVERYMAN

The most recognizable name of the protests is not a politician or celebrity, but a little pizza joint on State Street. Located just a block off Capitol Square, Ian's never intended to become a universal symbol of the protests—but a simple act of kindness swelled into a wave that swept it into a worldwide phenomenon.

Like an earthquake far below the ocean, the trigger for the Ian's tsunami was barely perceptible. On day two of the protests, the father of a former employee was inside the Capitol, waiting with others to testify against the bill. As proceedings dragged into the night, he called Ian's to ask if they might bring up their leftover slices to feed hungry people waiting to speak. Always concerned about reducing waste, the manager on duty happily agreed, and even made sure to include a few more slices than normal. The pizza arrived to wild cheers at three o'clock in the morning, and within minutes, a blogger posted the event to the *Huffington Post*. The wave was on its way.

The next day, Ian's fielded its first order to deliver donated pizza to protesters, but there was no outward sign of what was about to happen. It didn't take long for the surge to hit—three days later, the store was inundated with so many calls from donors that it had to shut down all deliveries except for those going to the Capitol. The following week, donations streamed in so fast that on most days, Ian's had to cut off orders by mid-afternoon. Even with long shifts and extra employees brought in from other stores, it just could not make enough pizza to satisfy all the donations.

During the peak of contributions Ian's consumed three tons of flour in a week, manned phones like a telethon, and delivered up to a thousand pizzas per day. The press picked up the story, and Ian's delivery drivers became instant celebrities, shadowed by *The New York Times* and Associated Press. One driver tells what it was like to be famous:

"People gave us victory signs and thumbs-up. You would drive twenty pizzas to the Capitol and when you got to the column of circling marchers, three or four would jump out of the crowd and create a space like we were an ambulance—'Ian's is coming through!'"

Drivers repeat many tales of surprised and grateful protesters. Sometimes the emotion of meeting an Ian's driver was almost too much to handle. One driver tells of a woman who approached him outside the Capitol as he was preparing to return for another run. She handed him a hundred and forty dollars, asking that half go to pizza, and half to employees. Choking up, she explained. "My son has been in there for ten days and has eaten nothing but Ian's pizza. You're keeping my son alive."

Back on State Street, those manning phones speak of similar interactions with callers. "People want to tell you their

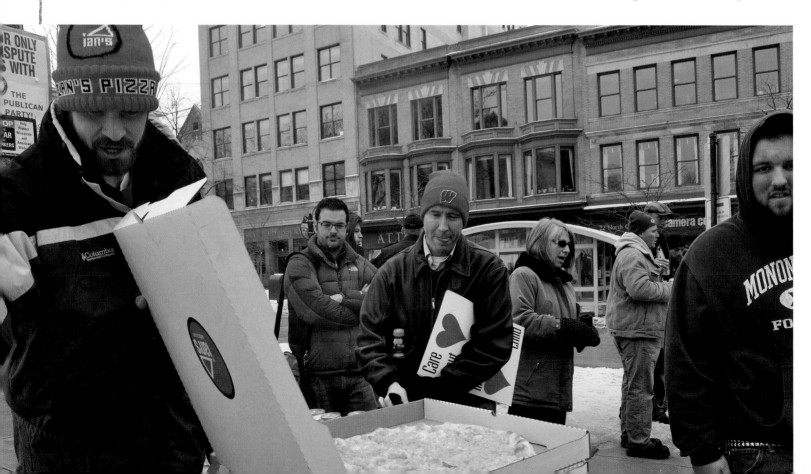

stories—why they are calling from the Czech Republic or Hong Kong." There is Charlotte in California, an elderly woman in poor health who is sorry she has only a few dollars to donate. There is Kevin in Kenya, and a woman deeply concerned about an Ian's driver who sprained his ankle during a delivery. There are calls from the unemployed giving whatever they can, there's a five-hundred-dollar tip, and there's the caller who suggests that Ian's shirts be changed to say "Hell yeah!"—which is what an exuberant employee said when asked if it was possible to order "Protest Pizza."

Early on, someone at Ian's erased the chalkboard normally used to list daily specials and began to record the states and countries from which calls were received. A girl named Emily is the most likely suspect, although everyone seems to take credit in some way.

"I built the board."

"My protozoan ancestors provided the chalk."

As the chalkboard list of locations grows to include every state and continent, so does its fame. Protesters wait in lines stretching a block just to get a glimpse of the celebrated board, and to eat the pizza of dissent. At the Capitol, protest placards made from recycled pizza boxes become the sign-making material of choice, hosting messages for the world, and extolling new idioms such as "Powered by Pizza," "This Is What Democracy Tastes Like," and "The Pizza Rebellion."

Why pizza? According to an Ian's manager, the answer is closely aligned with those protesting.

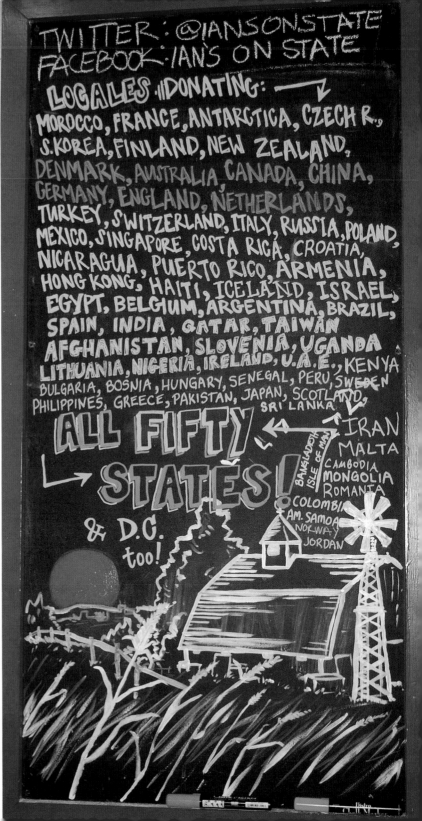

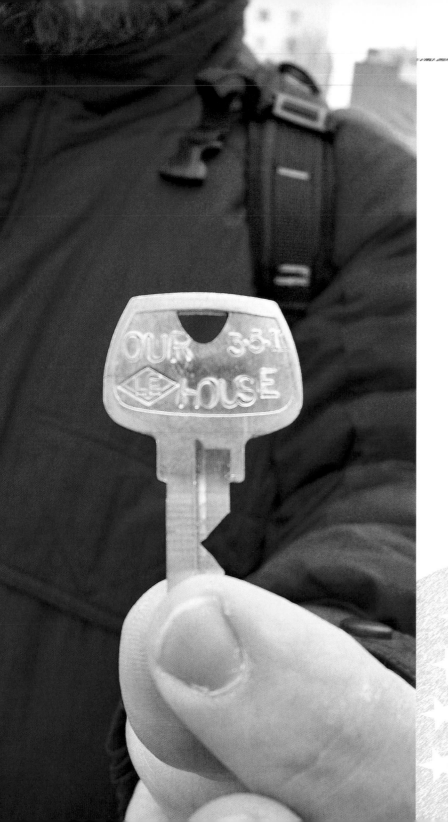

"A pizza is an everyman food. It is very accessible, emotionally and physically. You can eat pizza and do just about anything."

During the last two weeks of February, callers donate $180,000 for pizza. Only they can truly explain why, but perhaps a sign hanging inside the Capitol helps decipher their intent. It says, "Jay would be here if he could, so please add him to the count." For the Jays across the world, sending a protest pizza via Ian's is a means to be counted.

Maintaining political neutrality throughout, Ian's just wants to be known for "serving good food by friendly people at a reasonable price," but will forever be aligned with the rallies. Any protester will tell you, "This is the Pizza Rebellion"—a protest of the everyman. ★

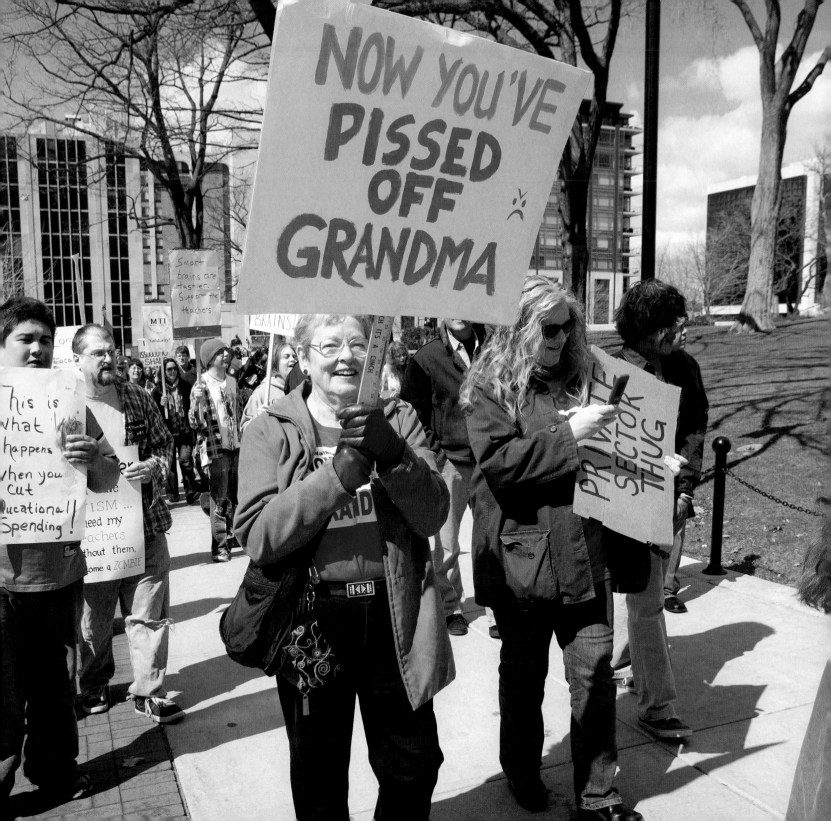

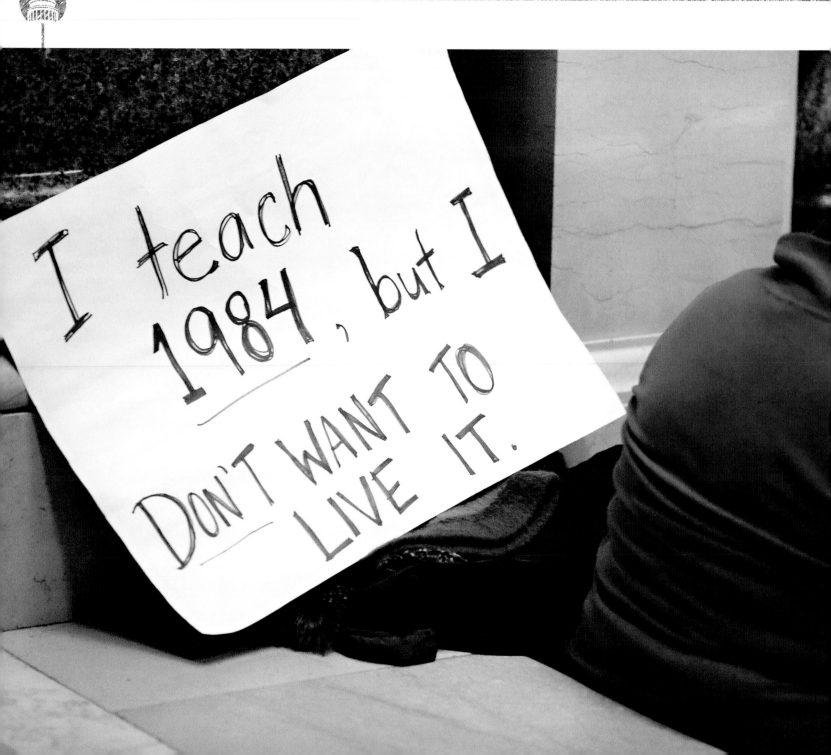

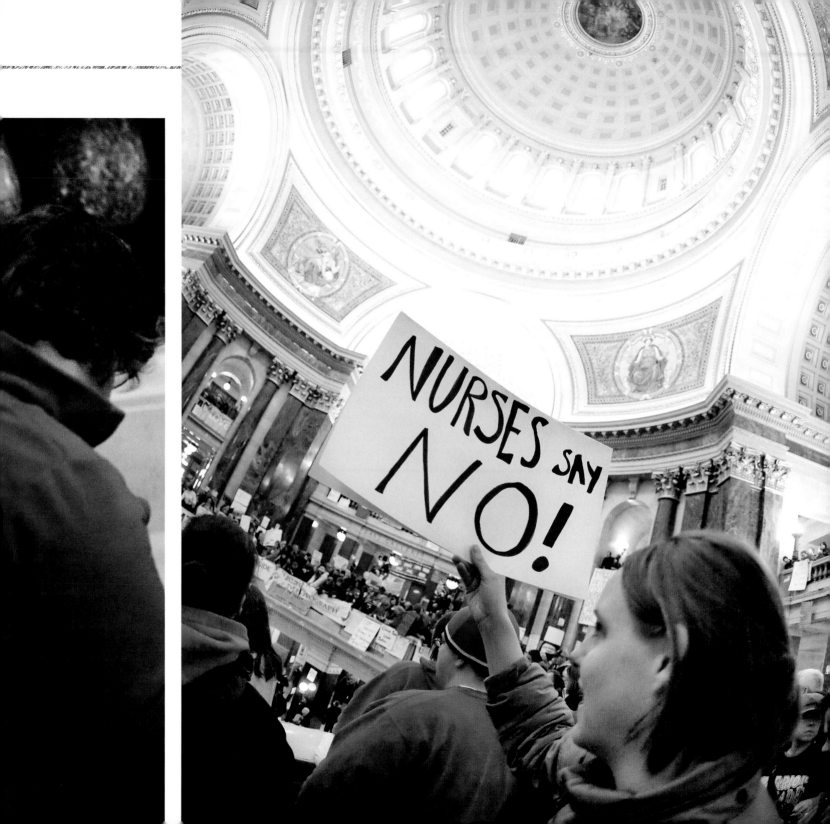

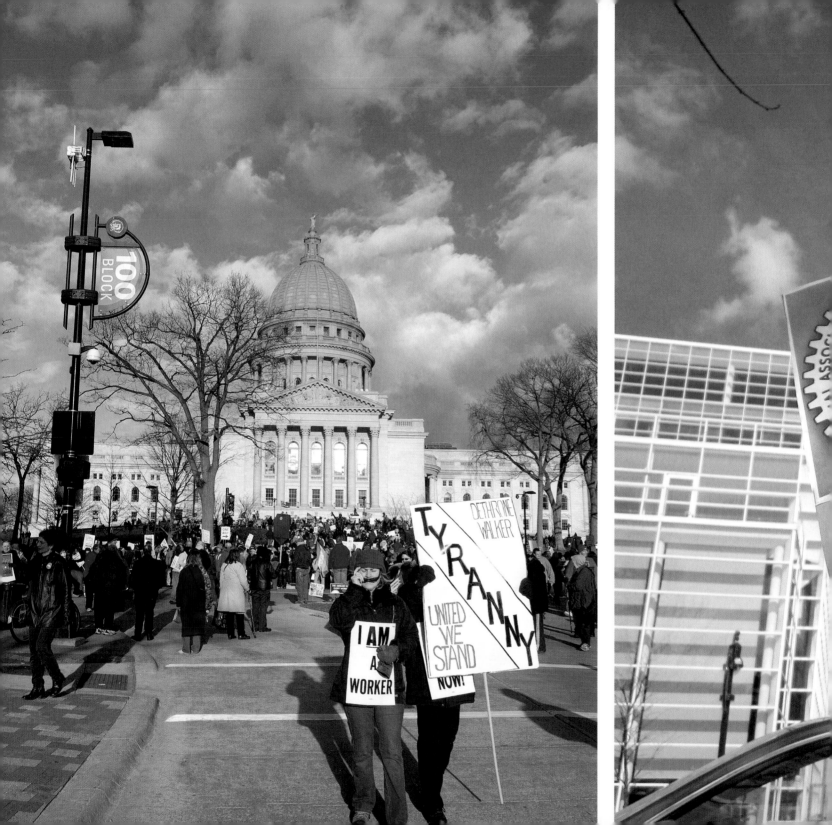

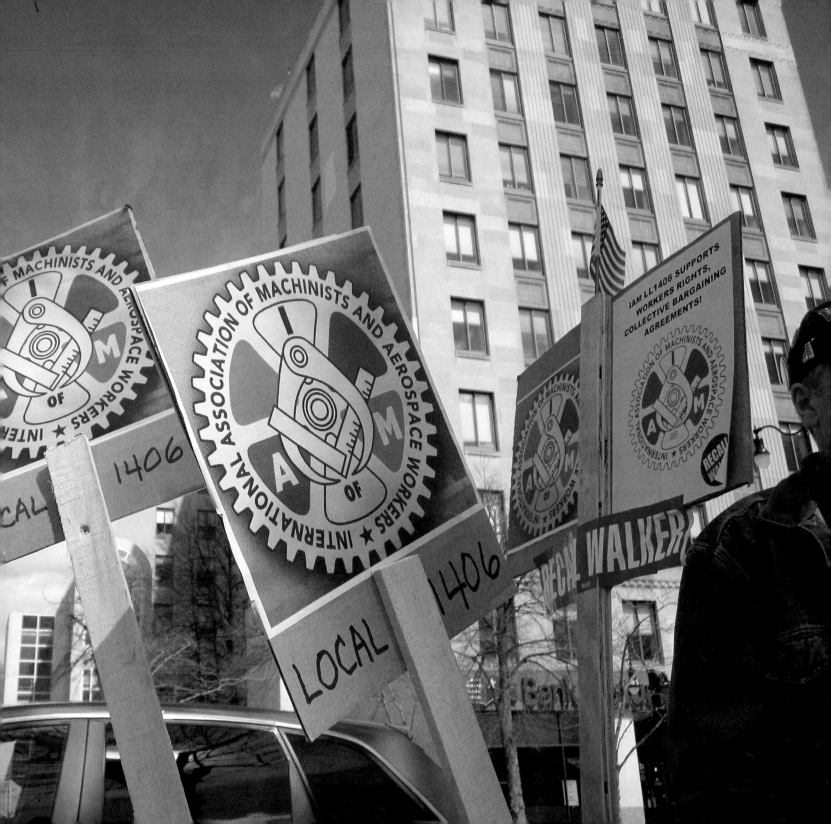

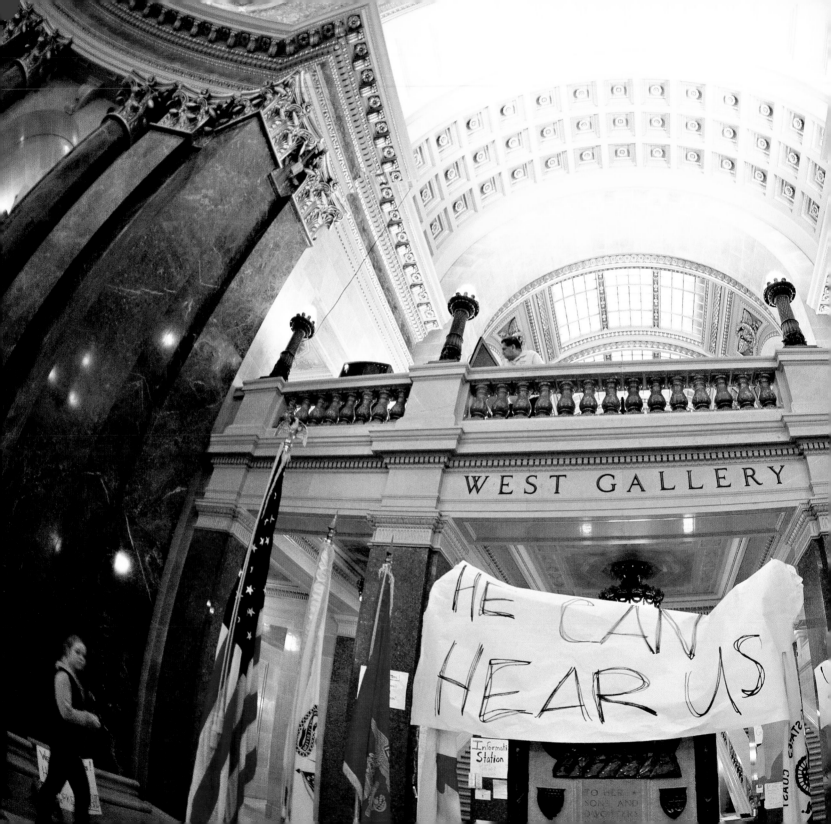

ARISE AND BE HEARD

The workers' rights rallies will undoubtedly be remembered as some of the most creative demonstrations in history. The protest signs alone are worthy of a book. In fact, the Wisconsin Historical Society collected many for posterity, and even the Smithsonian National Museum of American History wanted some. As entertaining as the signs were, it was hard to beat the zombies. The weather had finally broken, the tulips were poking through the ground—and so were hundreds of protesting zombies.

I honestly attempted to interview a zombie, but nobody would break character. Desperate, I copied down a common zombie chant and entered it into an online zombie translator (seriously, you can do this). It came back, "Hate to be a bother, but if I could nibble on you that would be just tops."

Although creativity may first appear to be nothing more than a little fun, a wise onlooker explained its true value.

"Laughing gives people an outlet to channel their anger…and we really need to laugh."

There certainly was laughter—some of it tasteful (zombie humor), and some of it a bit morbid. Either way, protesters smiled more, walked slower, and for just a little while, had a hard time remembering what tomorrow might bring.

Exactly. ★

A few zombie sightings of the day:

- A man surrounded by a family of zombies is dressed in a University of Wisconsin hockey jersey that says, "I thought they said Zamboni."

- Three college zombies, obviously still attending classes in the underworld, are engaged in a heated philosophical debate: "But wait, would zombies walk for a *specific* reason?"

- Bystander one: "Are they going to do a loop around the Capitol?"
 Bystander two: "You never can tell with zombies."

- Mother and daughter zombies are resting on a bench. The mother tells me, "I just want my girl to have a better afterlife than I did."

- A zombie being interviewed for television: "Some of us were political before we died."

- Two young female zombies are talking about a wild night and birth control. An onlooker is confused. "Did she eat a pregnant lady?"

- A woman enjoying the parade shakes her head, then cracks a sly smile. "Don't mess with the creative class."

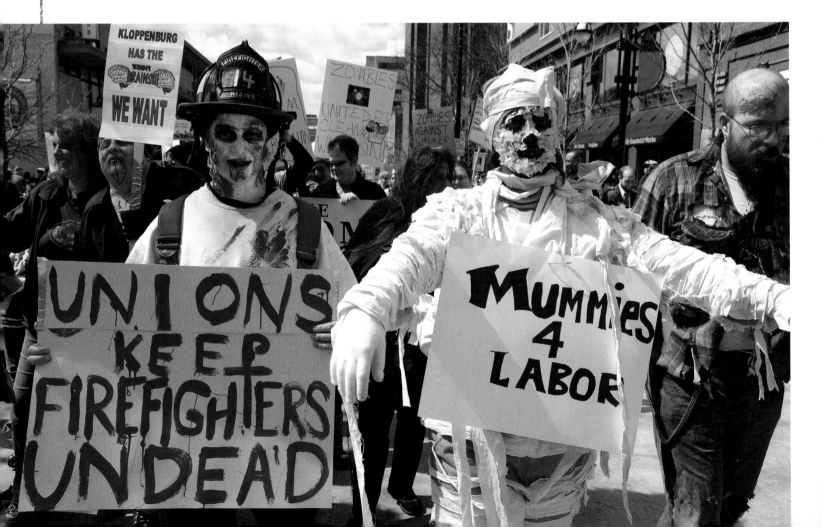

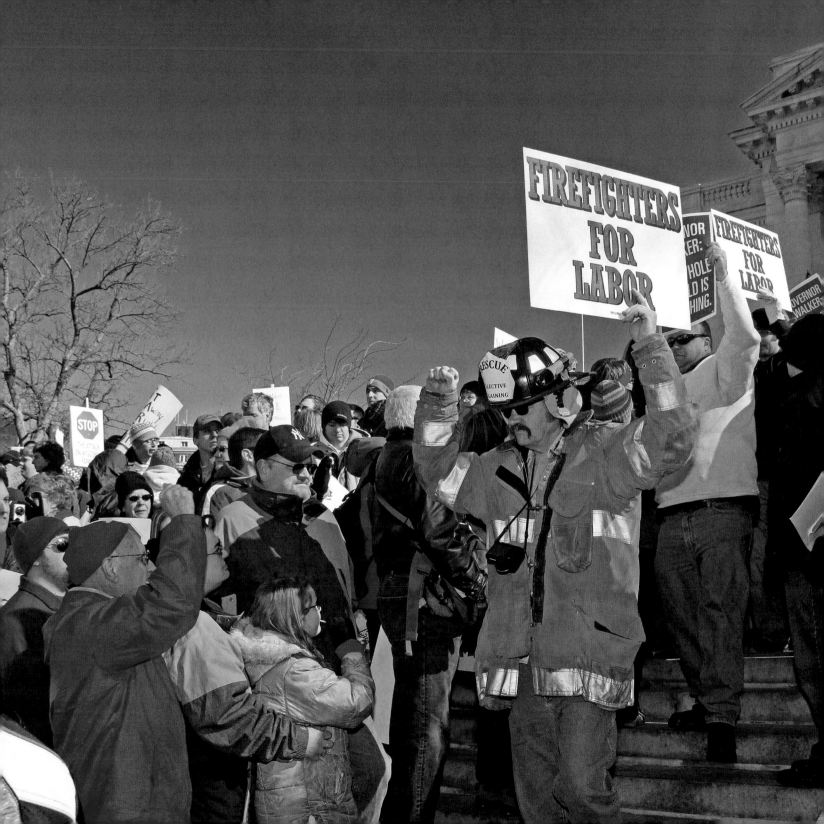

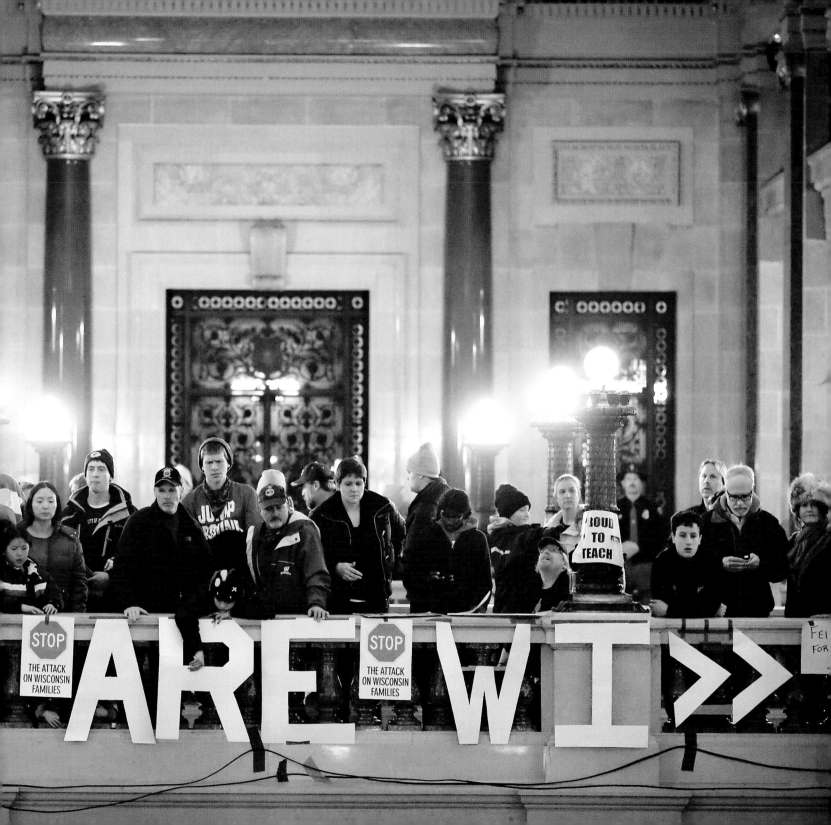

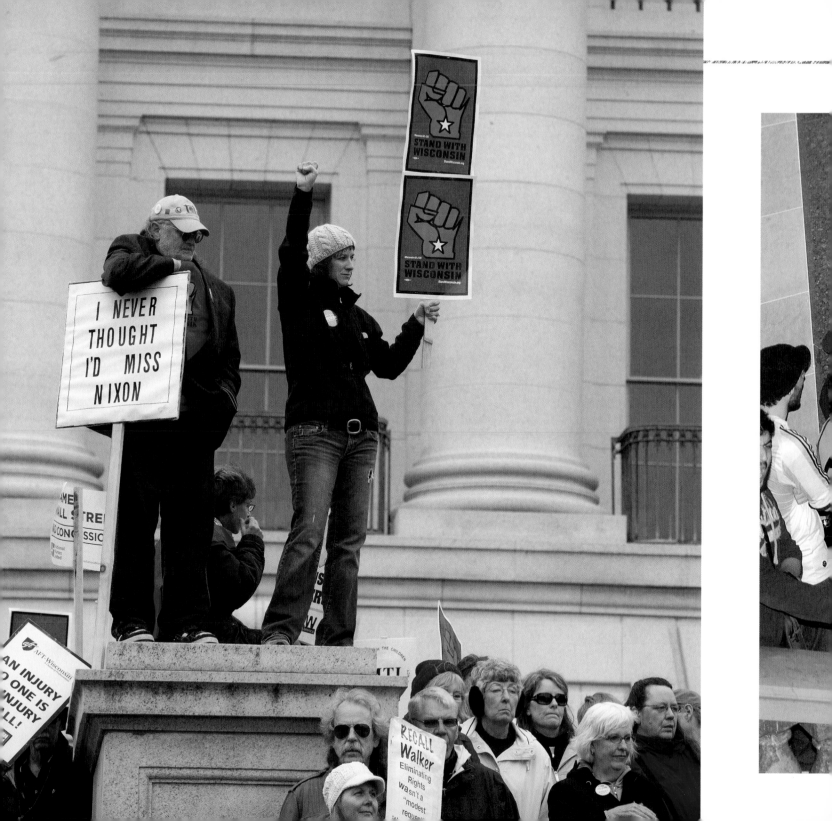

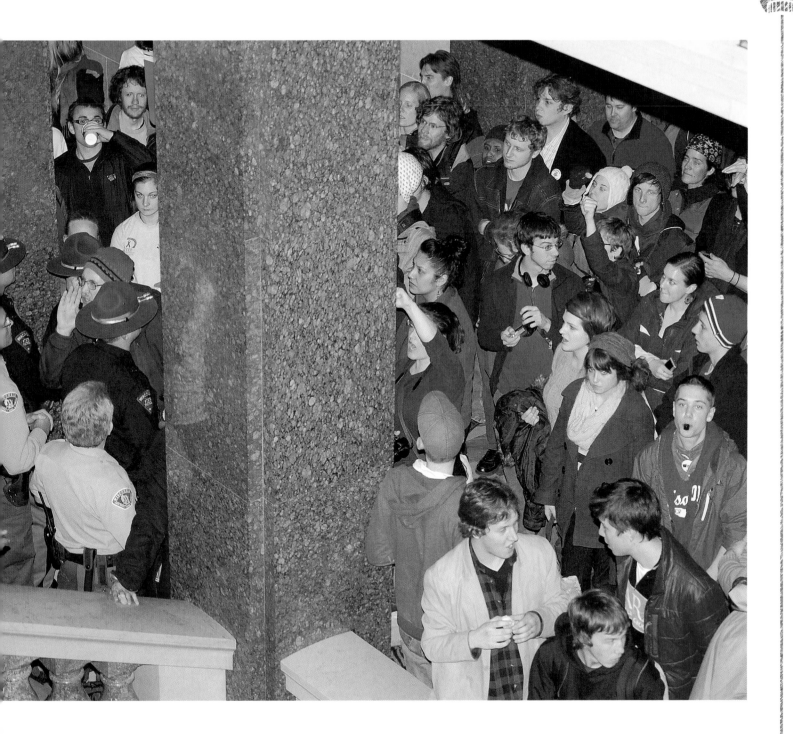

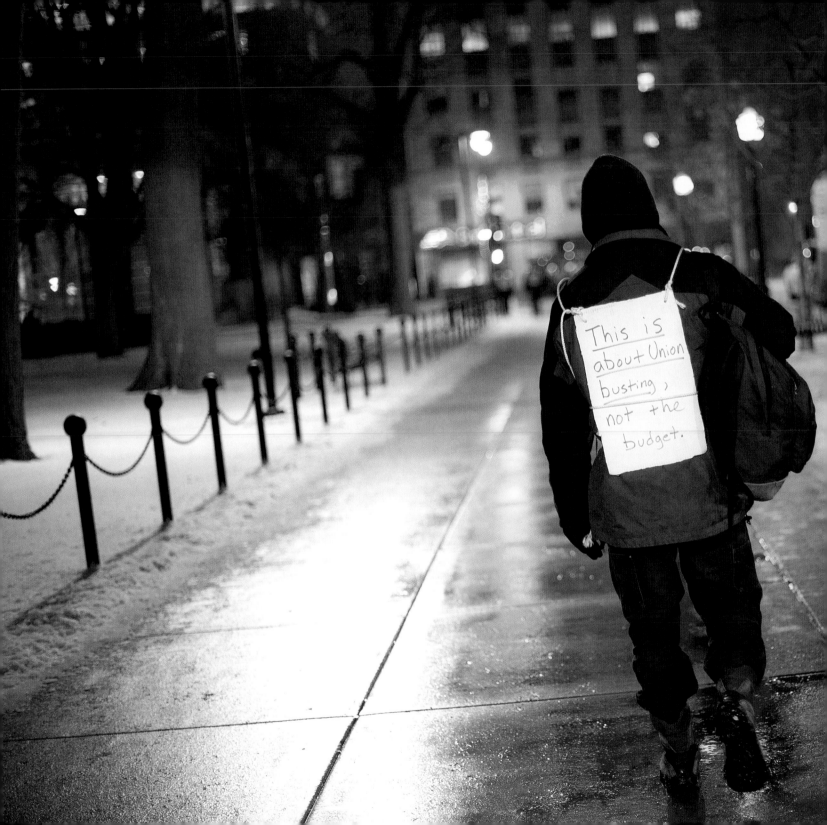

ROGER WILCO

For a boy, there are four desirable career paths—football player, airplane pilot, fireman, and astronaut. Doctor and president occasionally make the list, but for the most part, boys crave a job where you go fast, burn things, or beat up on other boys. By adulthood, most of us realize that putting out fires is not as much fun as starting them, but a handful perseveres, finding life's purpose in flaming buildings or several million pounds of rocket fuel.

Clean-cut, friendly, and steady, Roger looks every bit the pilot he is. A native of Milwaukee, he always wanted to fly, but as a self-proclaimed underachiever, that flight was grounded for some time. After a stint in the Army, which Roger credits for teaching him motivation and hard work, he went to college and became an engineer at an auto plant. It was a good job, but his dream was to soar. He quit, entered flight school, and has never been happier.

Roger marches in Madison with the easygoing confidence one might expect of someone in his profession. Though the budget bill does not directly affect him, this Teamster protests on behalf of his siblings (both of them government employees), and for his wife, a teacher back home on the West Coast.

Instantly recognizable in his blue uniform, Roger is popular with other marchers. One boy excitedly whispers to his mom, "That man flies airplanes!" The poor mother is helpless as the lad streaks away to stand closer to the pilot and his colleague. Roger takes the attention in stride, admitting that a favorite perk of the job is the traditional cockpit visit by wide-eyed kids.

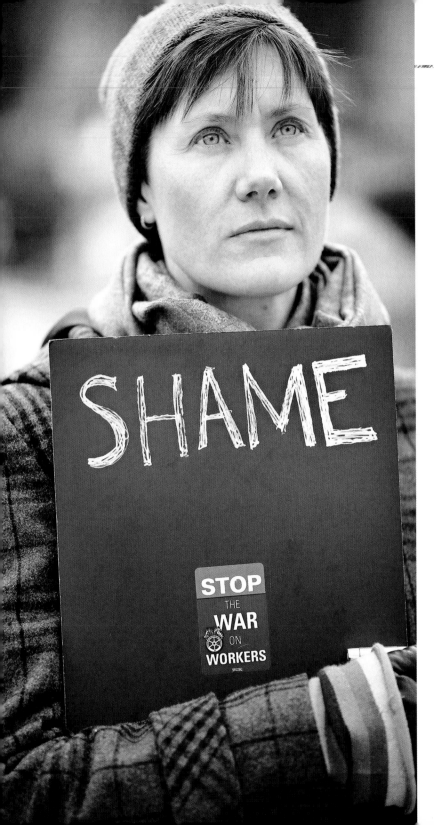

"We usually tell them a couple of lies," he laughs devilishly. "Like, that button is for the machine guns, and that one is for the missiles."

Being a pilot can be fun, but becoming one requires dedication and a unique temperament. Although each of us likes to believe we are capable of being the calm savior behind the controls of a jumbo jet, few are. Your neighbor Bob across the street is a heck of a guy, but you wouldn't get into a Hyundai with him, let alone an airplane. According to Roger, the entire purpose of flight school is to weed out the Bobs among us.

"You ever see those movie scenes where the guy is sweating and shaking, tosses his wings on the desk, and says, 'I can't take it'?…I saw that."

Such training may sound cruel, but pilot commitment is part of an unspoken agreement with passengers. In return for our adulation, pilots endure the rigors of flight school, and do not take chances with our lives. Roger takes his part of the bargain seriously.

"There are a hundred shortcuts in procedure, but you never take them."

The agreement is a good trade, at least for the public. It is what gets us from New York to California in six hours without hitting Pikes Peak on the way. For pilots, the accord carries a burden rarely seen by the public. In addition to brutal training, the hours are bad, there is little job security, and normal family life is nonexistent. Still, as Roger's pilot friend once pointed out. "When you walk through an airport, nine out of ten guys want your job."

Yes, but not really. We just want to date flight attendants and push buttons that launch missiles. That is the difference between those who want to be a pilot when they are 10, and those who take their morning coffee at thirty thousand feet. Men and women like Roger do not become pilots for the perks. They fly because there is nothing they would rather do. That is why they, not Bob, are in the nose of a 767.

Ironically, the same ideals that make a good pilot create vulnerability. With an even, reassuring voice, Roger explains this paradox, and his reason for protesting.

"Pilots are like teachers. We both love our jobs so much that we would do it for nothing. These are the people who need unions the most." ★

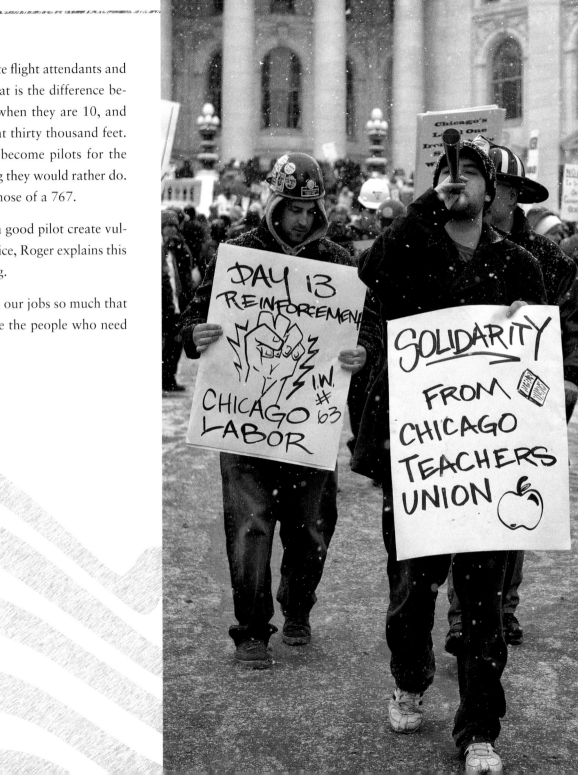

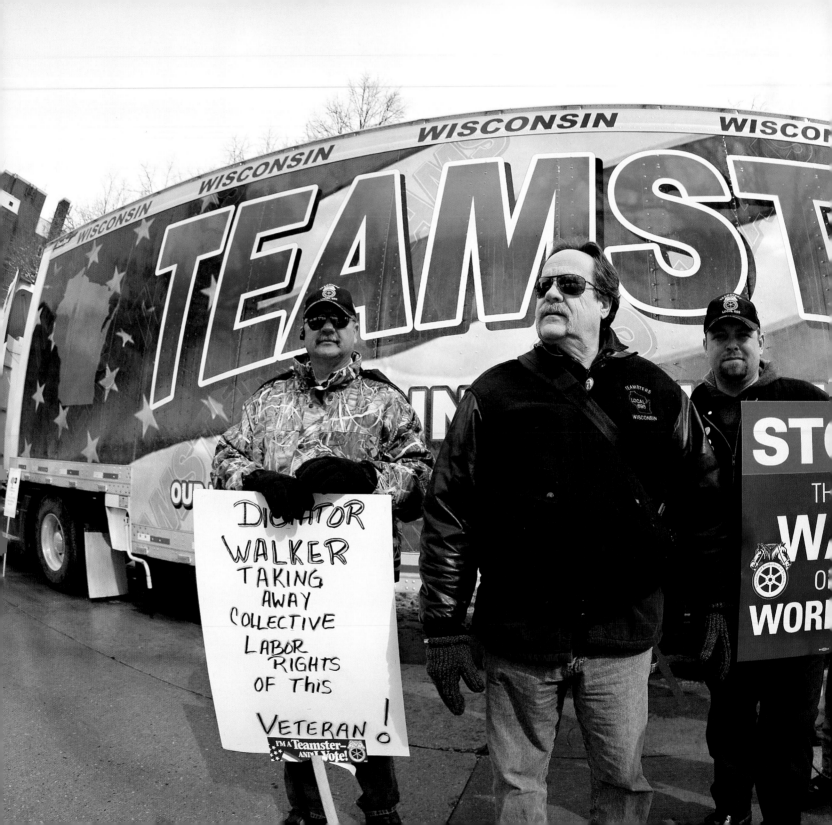

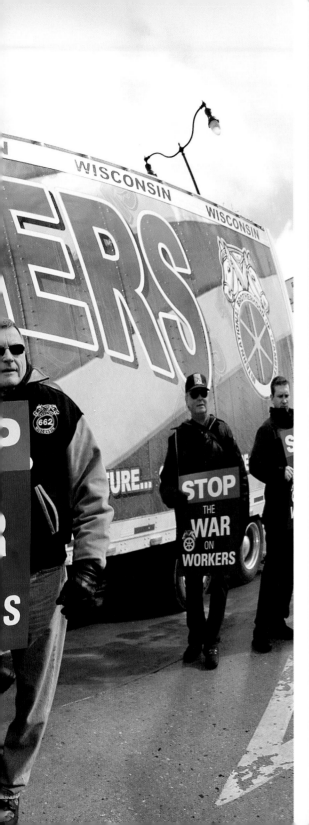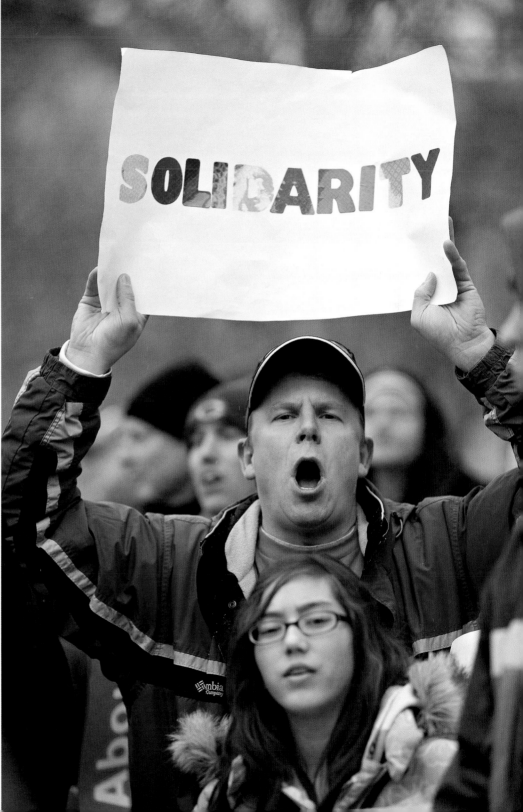

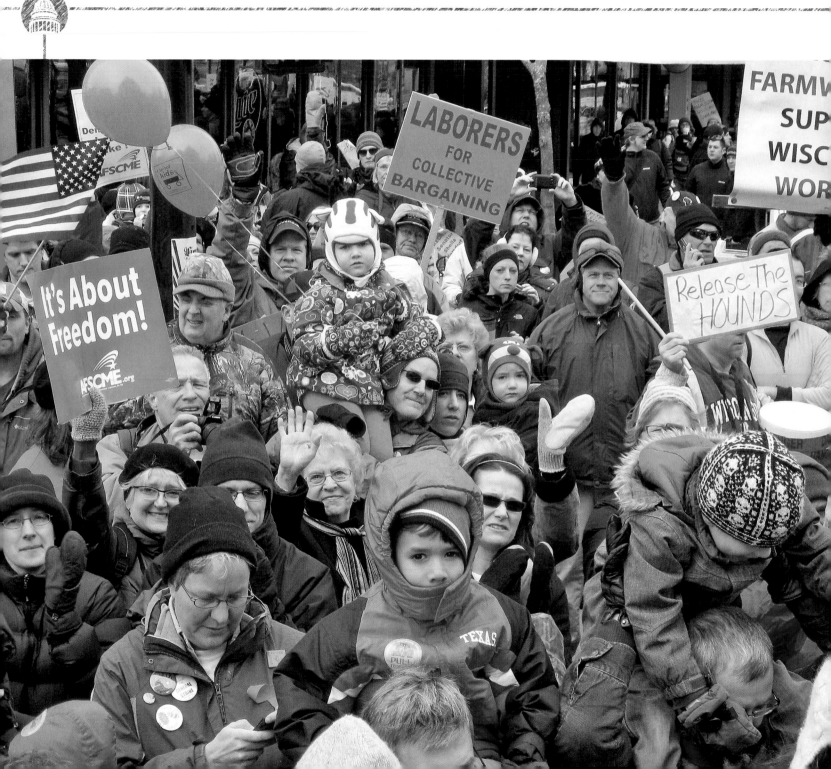

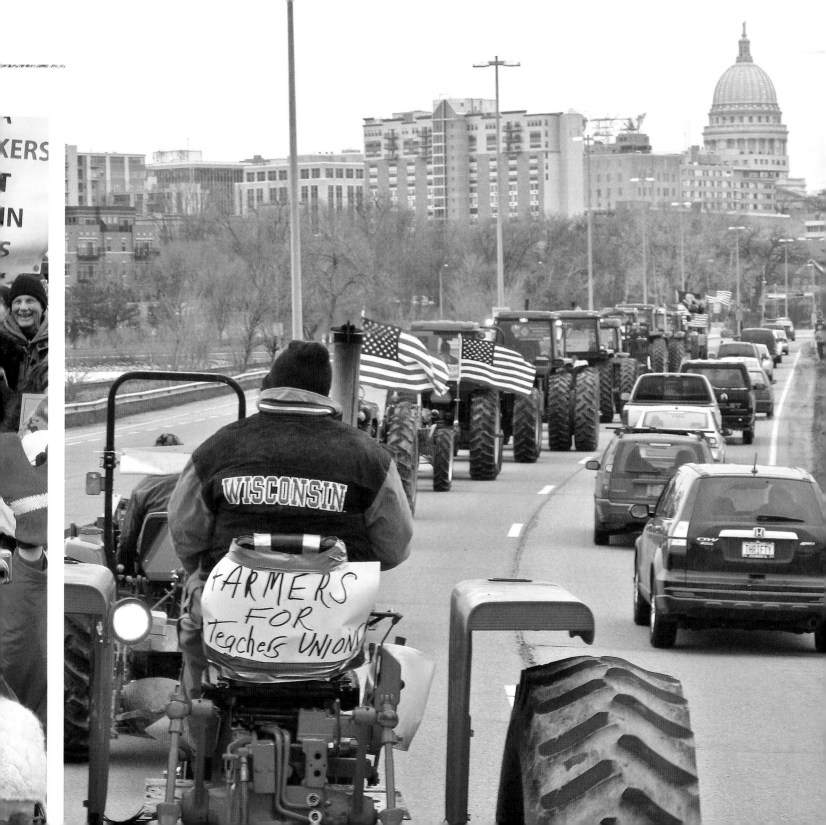

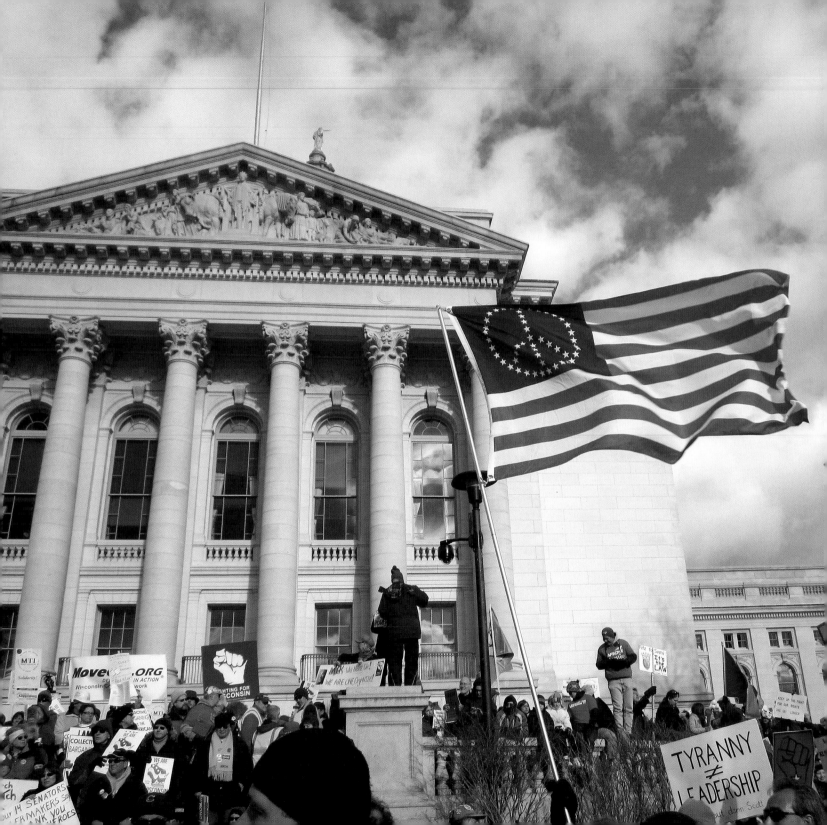

UNINTENDED
CONSEQUENCES

Author's note: Protesters often spoke deeply about a specific day or event that changed their entire outlook—that is the basis for this book. I just didn't know it was going to happen to me.

Watch any high school student at a football game and behold the perfect protester. They dance, sing, paint themselves—whatever it takes to deliver a message. Though entertaining, such exuberance can overwhelm the sluggish brains of adults. To them, teen energy is like uranium. Dispersed in the ground, it is pretty innocuous. Put a bunch of it together, and you've got a nuclear bomb.

Being a grumpy old guy, I tend to be among the overwhelmed. To me, the prospect of a world run by today's offspring conjures images of pestilence and a dozen other flavors of carnage. So, when rumors break that almost a thousand East High students are walking out of classes a second time, and are headed on a three-mile journey to the Capitol in support of their teachers, I have reservations. "Just what we need," I think, "a bunch of cell phone addicts who can't pull their pants up."

Word of the approaching army spreads swiftly across the Capitol grounds, and adults jockey for position at the top of the busy boulevard feeding downtown from the east. At an intersection below the hill, two police cars idle, their lights flashing, waiting. Moments later, a wall of students rounds the corner, floods the right lane, and charges up the hill.

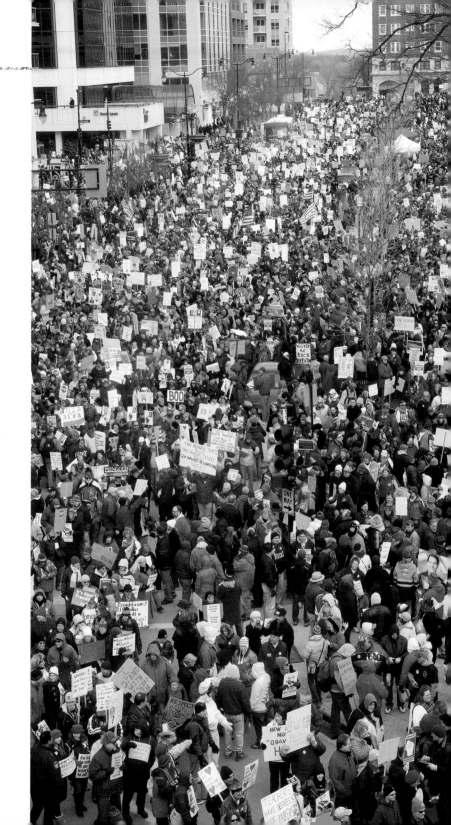

Jocks, freaks with purple hair, and girls in fashionably painful shoes quickly ascend the highland. Like Rocky Balboa, a swarm of students storms the high steps of the Capitol, turning with arms high to face the joyous adults below. Nurses, teachers, plumbers, and grandmas pump their fists in solidarity. After several minutes of jubilation, the group descends, blending peacefully into the crowd.

Surviving the initial pubescent attack in exceptionally good spirits, I head out with the newfound hope of a D-day soldier who just made it across the beach. Little do I know what lies ahead.

Not far up the street, eleven students sketch chalk pictures on the pavement, chattering in secret acronyms known only to teenagers. The artists appear to be underclassmen, maybe sophomores. I really *should* talk to some students, I suppose,

and these look as good as any. While contemplating the explosiveness of eleven uranium nuggets in such close proximity, I don't notice someone approaching.

"Do you want to sign our protest picture?" questions a girl, holding out a piece of chalk.

It's too late to retreat. "Actually, I'd like to talk to you."

"Why?" Clearly, she paid attention in class when they discussed talking to authors on the street.

"I'm writing a book about the rallies, and want to hear what you think."

In a flash, all eleven jump up and form a semicircle, firing off answers to questions I don't even ask: "This is *our* future! These are *our* programs." "We have a chance to stand up and

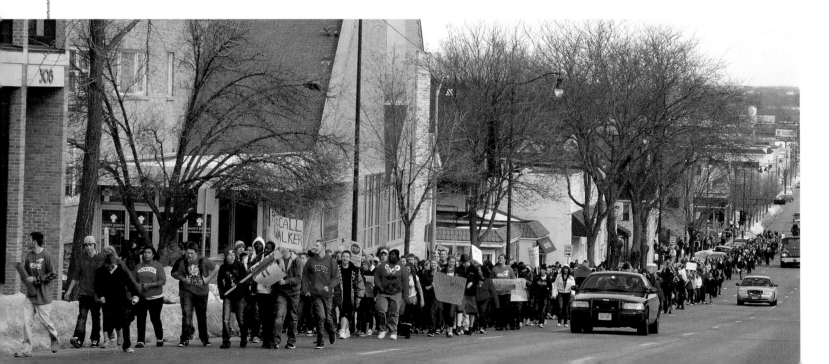

make a difference." "We have to be educated about what we are protesting, or we have nothing."

OMG! It is a VRYAN (Russian surprise nuclear attack) of rational thought, and it keeps coming.

"Our teachers buy classroom supplies out of their own pockets now. What will happen if this goes through?" "We won't take this lying down."

By the time the first strike is over, my hand is cramped from writing. No doubt, the fledglings have done their homework. Impressive as this is, protesting requires dedication, planning, and a willingness to suffer consequences. Is their commitment real, or are they just out for a day free from studying? I begin an interrogation to uncover their true values.

"Were you here for the first East High walkout?"

Several heads cock to one side in disappointment. Apparently, they are seasoned school skippers, and will not be patronized. I quickly up the ante. "Do you come here outside of class walkouts?"

Hands shoot into the air (you can leave school, but school doesn't leave you), each student shouting the number of days he or she has visited the Capitol. "Three!" "Two!" "Four!" "Five!"

This isn't bad for kids who never walked forty-three miles to school through nine-foot snowdrifts, but surely, they must have had adult help in planning. "How did you coordinate nearly a thousand classmates?" I inquire.

"Facebook!" they cry in harmony.

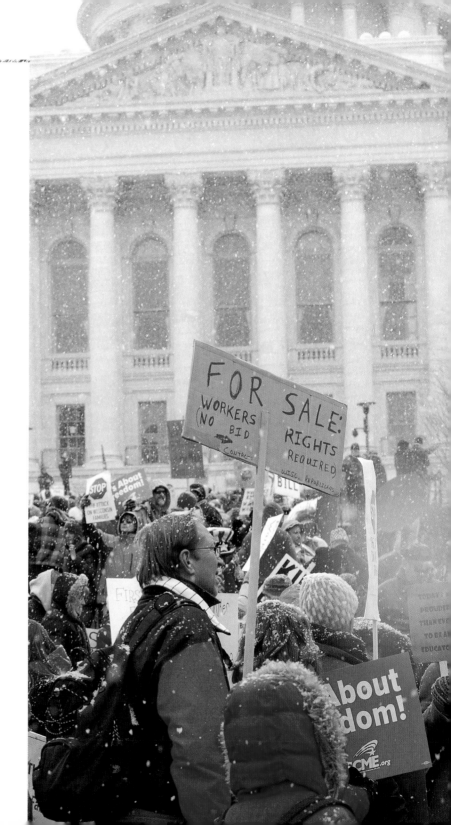

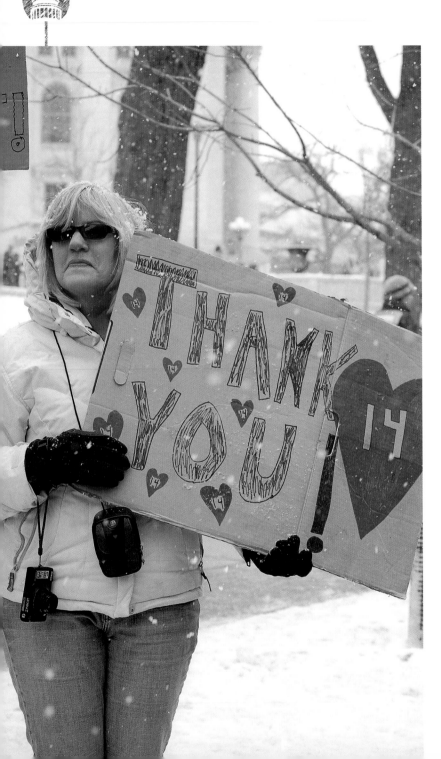

Teen social media—the kingpin of illiteracy and apathy—is used for useful communication? Brill! Nobody would expect that.

"Are *you* on Facebook?" a shy girl politely asks.

Suddenly feeling unhip, I reply sheepishly, "No."

They all stare at me as if I had been frozen in ice for a gajillion years.

Figuring no parents on Earth would knowingly allow their kids to cut class, I ask the AWOL students what will happen when they get home.

"Most of our parents support our decision to voice our opinions," one teen answers for the group. "As long as we make up our work, we won't get into trouble."

As I look for signs of alien abduction, one female Martian pushes forward, smiling with the devious look of someone about to take advantage of an old person.

"Have you ever played The Game?"

"Never heard of it."

"You lose!" she declares with obvious satisfaction.

"How can I lose if I've never played?" I'm not going to take a mental whupping lying down.

"You lose," she repeats.

Damn kids, no matter what planet they're from. (When I got home, I looked it up. Essentially, if you think about The Game, as you readers are now, you lose. Origins of The Game

are unknown, but one theory is that it was created in London in 1996 to "annoy people.")

Still stinging from humiliation at the hands of someone one-third my age, I make one more attempt to separate serious protesters from field-trippers. "What's your next step?"

They don't miss a beat. "We'll e-mail the governor."

Stunned, I surrender on the spot. They have a plan, and it is better than egg tossing, which is what I would have done at

their age. Picking up what is left of my ego, I make ready to leave. Before departing, I ask one final question. "What is your favorite chant?"

With powerful young lungs, the entire group shouts in unison. "Show me what democracy looks like! This is what democracy looks like!"

I bid the youngsters goodbye, and an hour later, stroll the upper sidewalk, pondering the transformation of America's

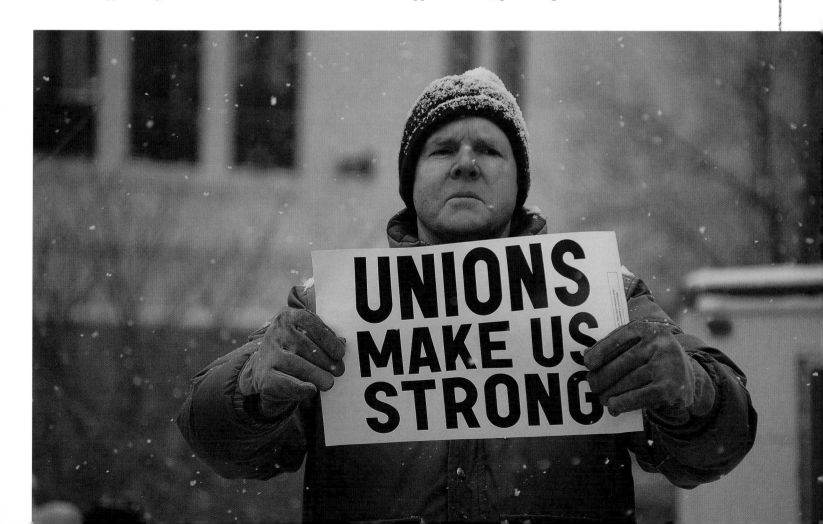

youth—or—is it a transformation of me? Earlier that day, "I knew" there was no such thing as an educated, dedicated, or inventive teenager, but I now have seen them with my own eyes. Heck, playing The Game on a couple of other clueless adults is even kind of fun.

Locked in thought, I barely notice a familiar refrain floating down from up high. From behind me comes a response. Up on two pedestals above the crowd are "my" students, leading their favorite chant.

I stop to take a candid shot and as I line it up, a group of manly boilermakers march by. From atop their perch, the students' high-pitched voices ring loud:

"Show me what democracy looks like!"

From below, the gruff roar of boilermakers retort:

"This is what democracy looks like!"

Now, I'm not going to say the Grinch's heart grew three sizes that day—and I still don't understand why kids can't pull up their pants—but Governor, I'd check your e-mail. ★

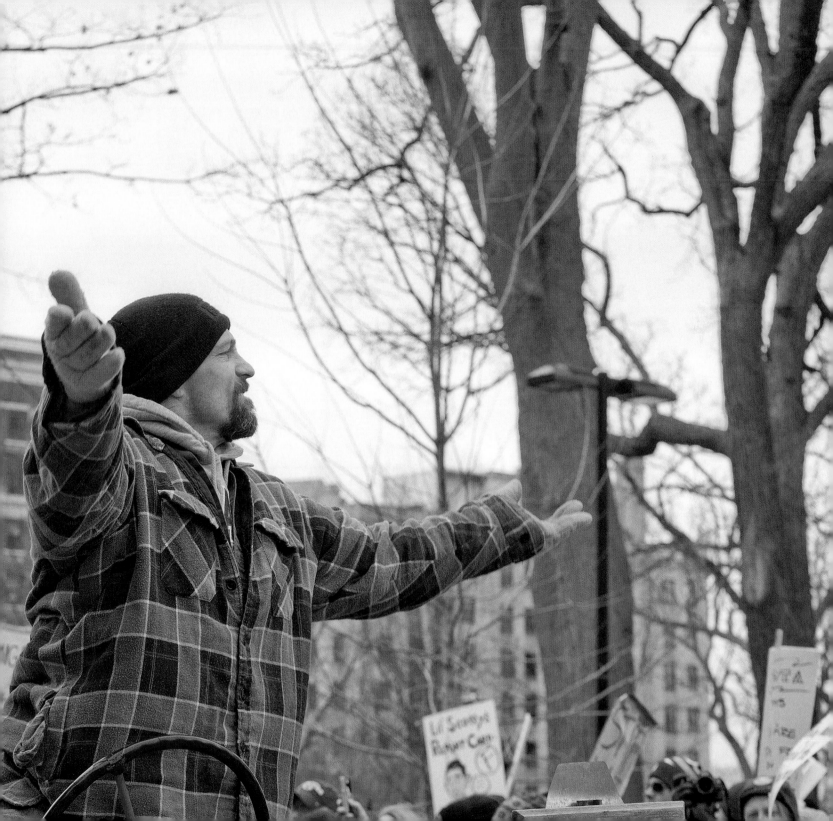

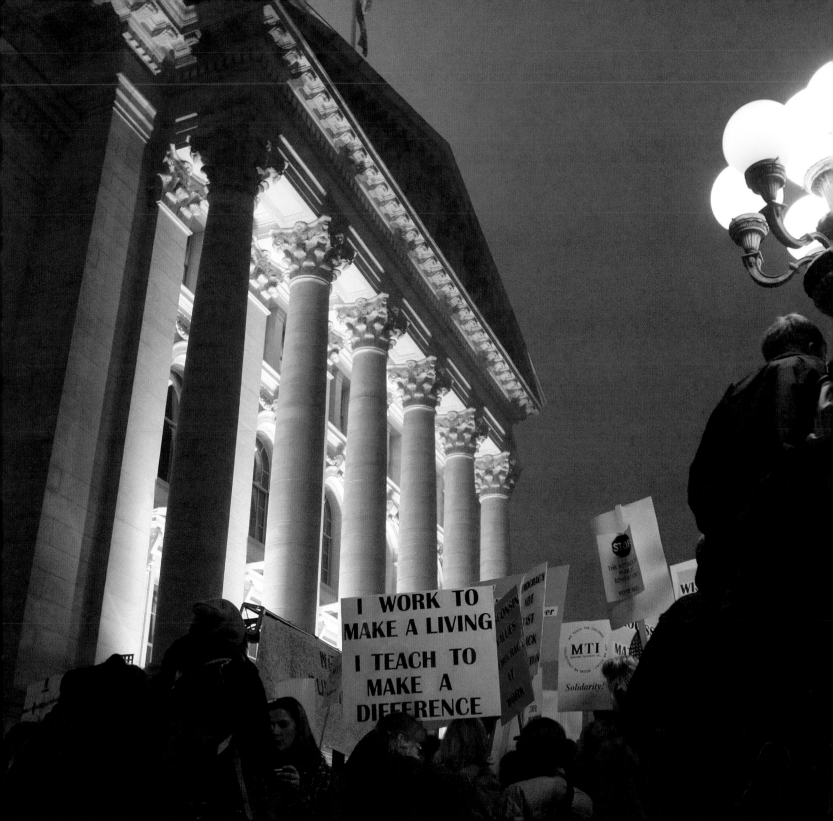

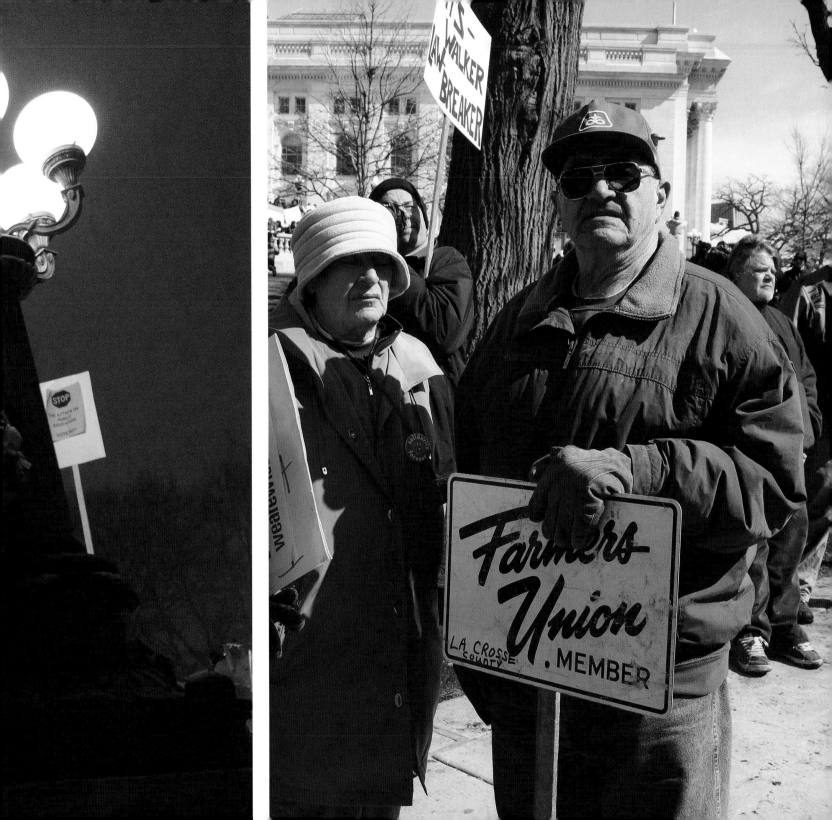

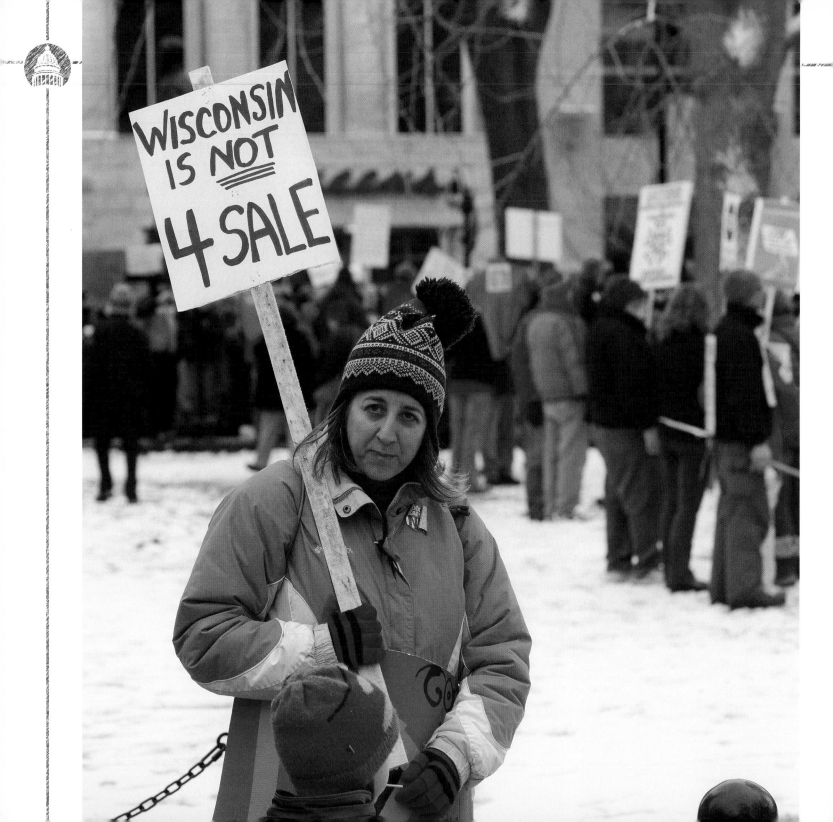

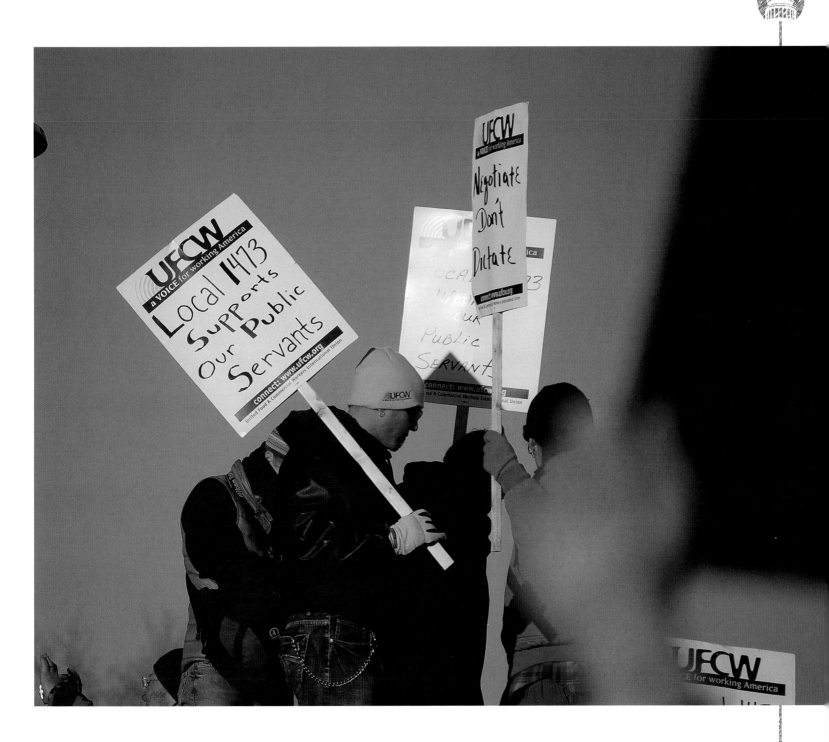

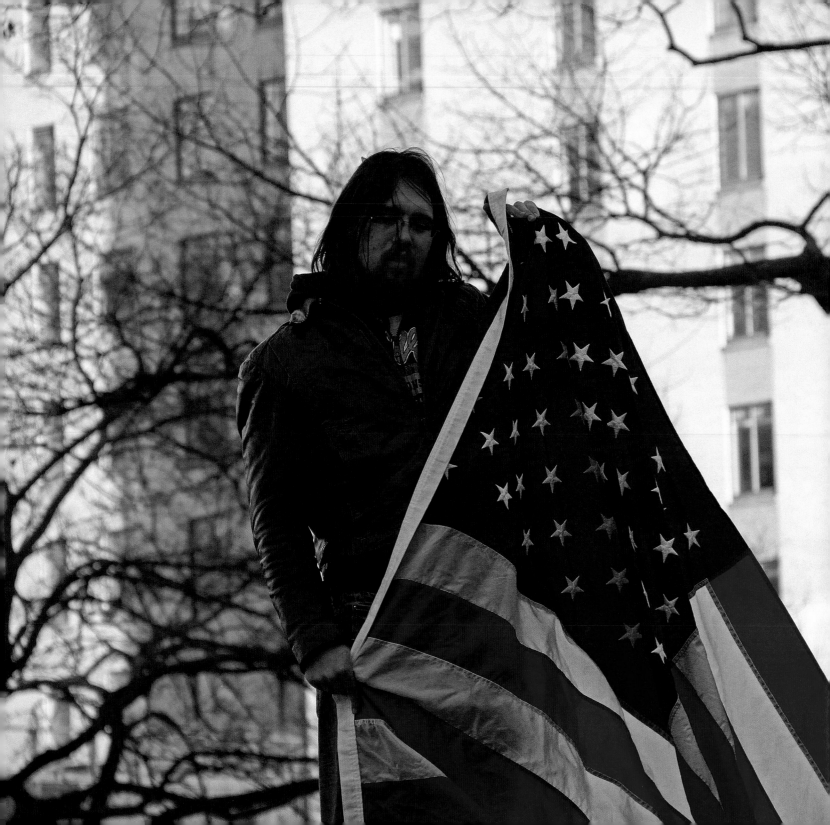

TIME TO RIDE

A lthough most rally attendees are Wisconsin residents, some do venture in from abroad. Border states supply the majority of outlanders, but distant places like Texas, California, and even Alaska are represented. Some visitors arrive via charters like the "Kathy Bus," organized by two Minnesota women named Kathy and Cathy. Others make the journey solo. All come with a unique story and perspective from the outside.

For one retired couple, the pilgrimage to Madison took seed decades ago in an interstate romance under the boundless sky of the Great Plains. Ray grew up in the windswept prairie of Nebraska, staking his claim in a farmhouse with eleven brothers and sisters. Every Saturday night, the family headed into town to sell cream and eggs, maybe taking in a twelve-cent movie. Money was tight and jobs were scarce, but Ray did his best to help out.

"I worked at the co-op. For fifty-nine hours of work, you made sixty-three dollars…and maybe a little 'free' gas."

Just thirteen miles away, Carol lived the simple Main Street life in South Dakota. In a house across the lane lived a girl, a dear friend who now resides near Madison. Carol recounts their first meeting.

"One day she slipped through the fence and said, 'Do you want to play?'" The two have been pals ever since.

Like many couples of the car era, Carol and Ray met during the Saturday night cruising ritual. "When I was going to high

149

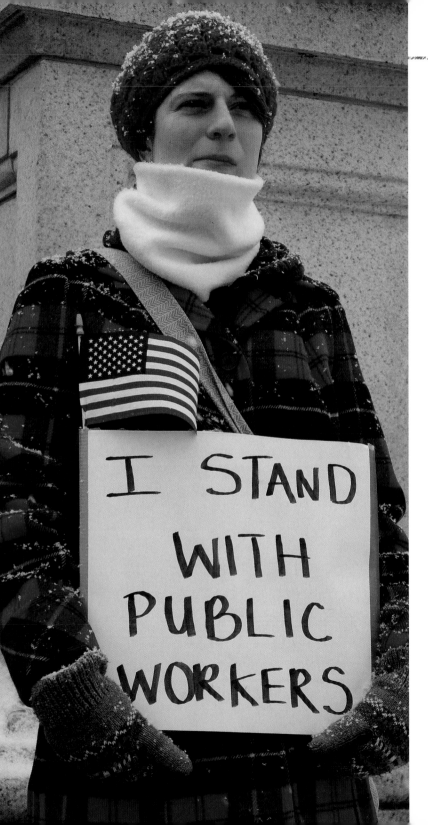

school, it was totally uncool to date a sand lizard (Nebraskan)," says Carol in a straight voice. "But, when I hit my twenties, I started getting desperate." She laughs heartily and Ray joins in.

"The barrel was getting empty."

Kindling their love affair at a famous local watering hole, the only drive-up bar in South Dakota, Carol soon took Ray home to meet her father.

"Dad had to work up to things. He'd get the mower out, sit there, and look at it for a while. Ray came over, grabbed the mower, and started cutting. Dad said, 'If you don't keep him, you're out of the house.'" That was forty-six years ago.

Credit to buy a house was hard to come by, so the young couple took on the burden of building their own, ordering a kit of precut lumber from Minneapolis. Every day after work, a tired Ray would piece together their honeymoon bungalow until ten or eleven o'clock at night.

"He built it all," glows Carol, who has lived with Ray on the same lot since 1967.

Eventually, Ray got a job laying brick, his lifelong profession. A fast learner, he quickly passed the journeyman's test, receiving his union card. The union job was better than many in the area, but not ideal.

"Everybody thinks bricklayers are rich, but the work is sporadic. You're gone most of the time, there are no sick days or vacation, and if it rains, you go home, unpaid."

"His body was ready to retire long ago," notes Carol, "but he had to keep working for the insurance."

Despite Ray's union tradition, it was Carol who first started following the protests. "She got my dander up," growls Ray. Avid motorcycle riders, when the Thunda Around the Rotunda biker rally for workers was announced, they packed up their Harley Davidson trike and headed for a visit with Carol's childhood friend in Wisconsin.

The pair admits that the Thunda ride from Goodman Park to the Capitol is one of the shortest rides they have ever taken, but it may be the most memorable.

"Bikers like to think of themselves as a hard-bitten bunch," reflects an emotional Carol, "but at the staging area, they were getting goose bumps. This was so important to them."

Unless you've sat on the back of a Harley trike while throngs cheer your arrival, it is hard to imagine what Carol and Ray have experienced on their trip. Anyone who has ridden a motorcycle understands the unity of raising a bent arm to passing riders. Those who have held up a fist with fellow union members must understand similar camaraderie. To raise that arm to thousands of supporters who are neither bikers nor union members is a feeling only Carol and Ray can know. Still, I ask them to explain what bikers from South Dakota will take away from the rally. It is Carol who speaks.

"There is common ground in America. We all want security, harmony, and to have things better for our kids. What's going on here is like a barn raising—everyone comes together for that common purpose, each bringing their own tools and skills....Raising a barn isn't easy."

Who would know this better than a couple who has spent their entire lives building? ★

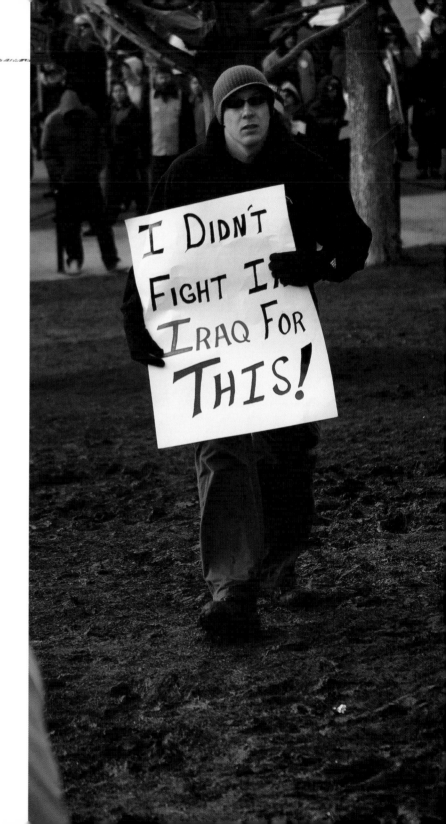

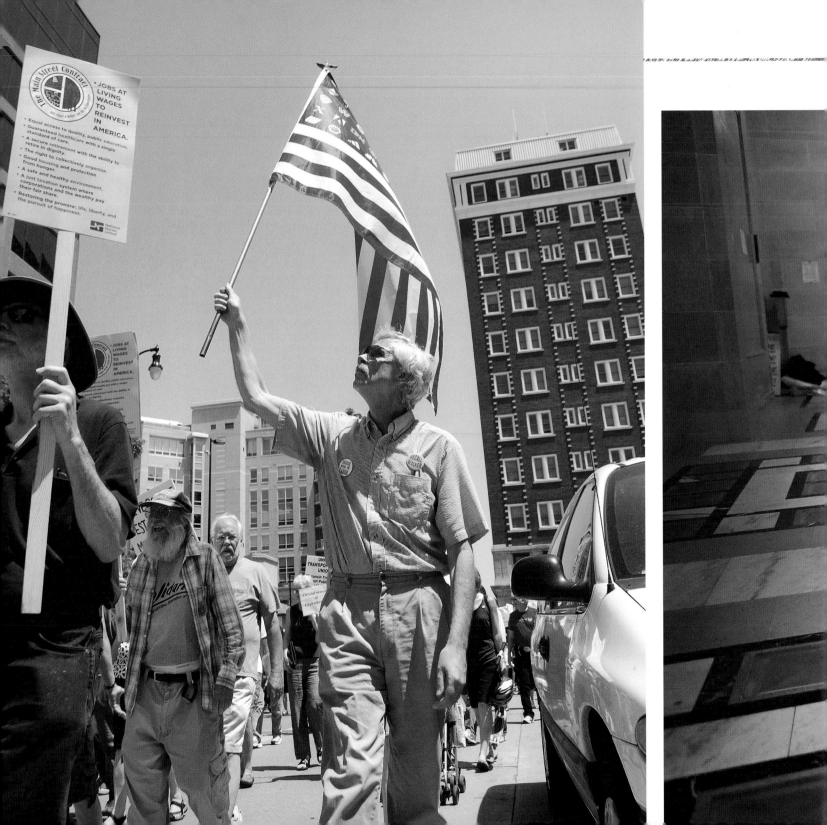

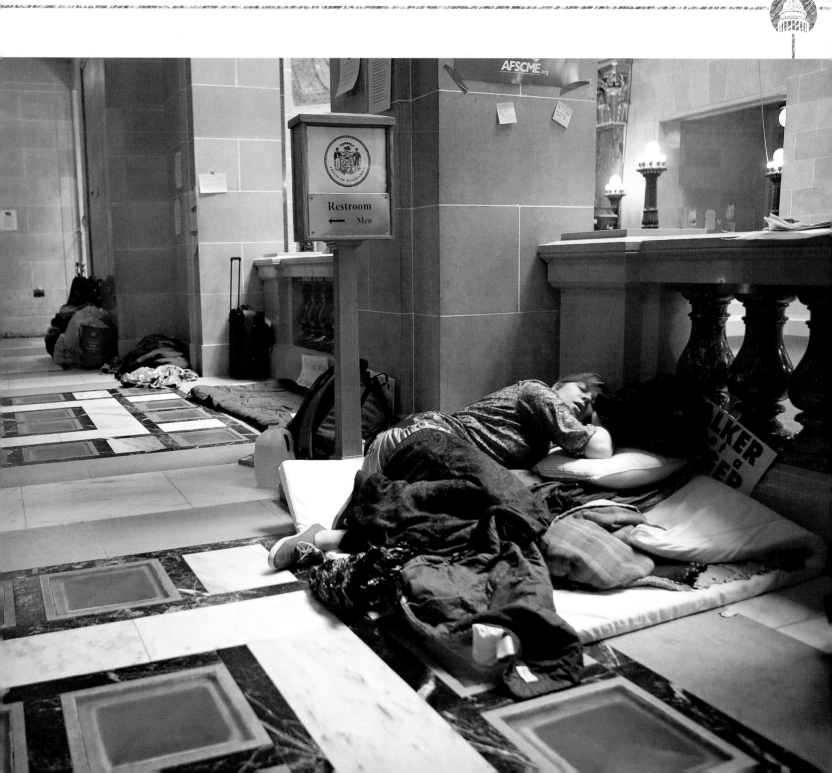

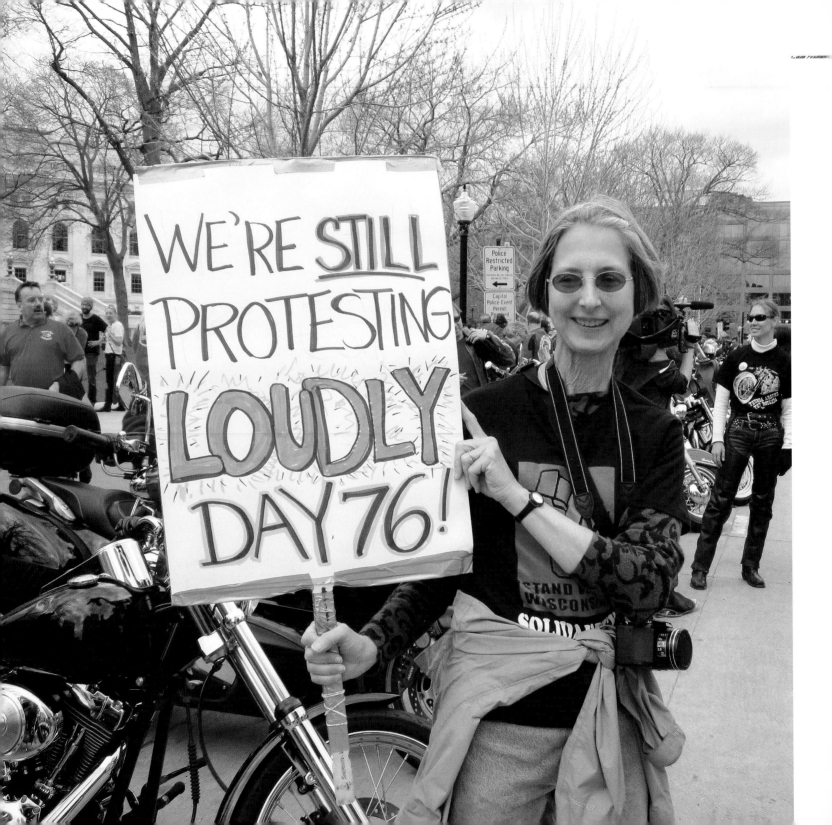

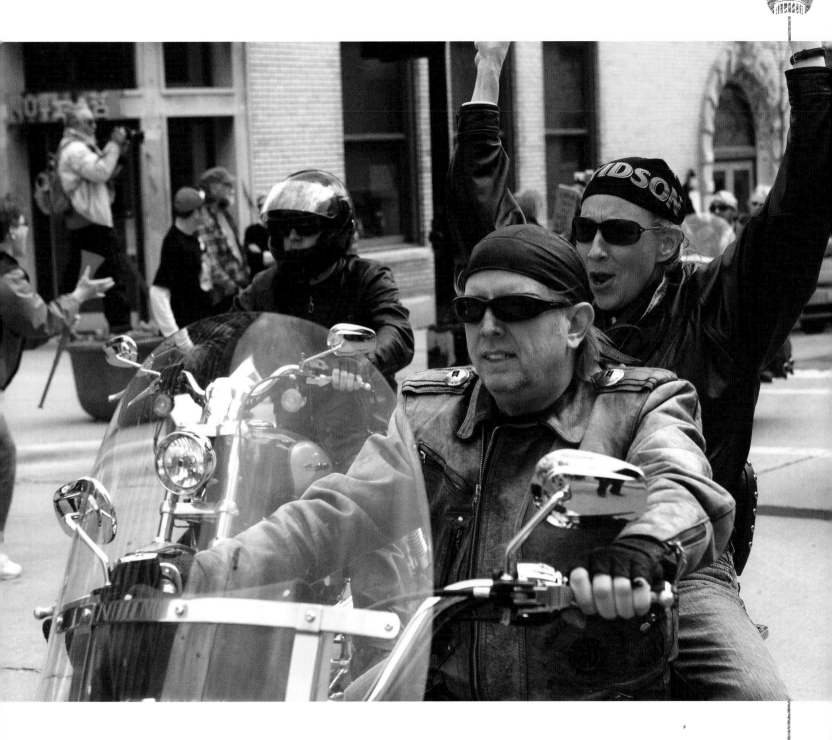

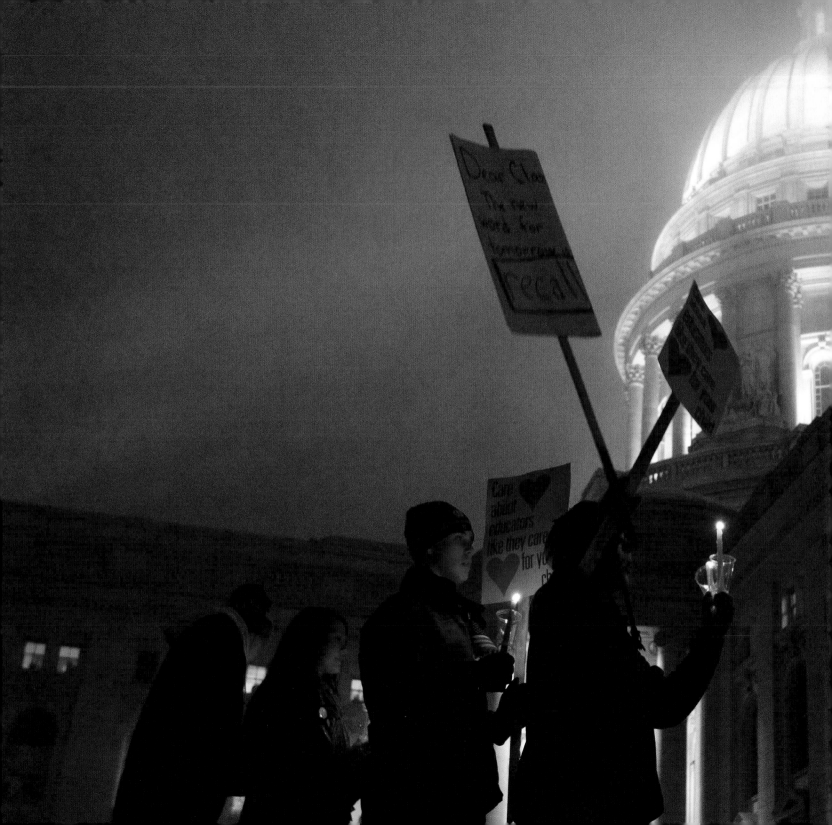

SECOND CHANCE

In a stuffy classroom below Bascom Hill, the high point of land overlooking the University of Wisconsin campus, Nancy listens attentively to her professor's words. A newly divorced mom, she wears formal hosiery that is a clear fashion break from the free-spirited attire of 1967. Reaching down to nonchalantly adjust her nylons, she notices movement outside the window. Across the way, a light haze slowly drifts past. Normally, fog didn't create a commotion, but it wasn't foggy out. Soon, an acrid air permeates the room, and students start buzzing. Whispers of "Tear gas!" shoot between the desks.

Antiwar protests are raging across the nation, and that day of blanched smoke would set a new course for Nancy, and Madison. The former housewife is soon embroiled in demonstrations, standing side by side students with whom she had previously shared little, except classes and ideals. On occasion, the single mom even takes her young child along. Madison, and Nancy, remain a hotbed of protest for the remainder of the war.

The 1960s come and go, as do the next four decades. Nancy has more children, becomes a social worker, retires, and now works part-time to make ends meet on her Social Security. I encounter her near a parking ramp. She is gingerly traversing her way down the sidewalk, and as I pass, she laughs apologetically, "I just have to get off my feet."

Initially, I keep walking, but something causes me to turn and go back, maybe curiosity about her dauntless venture into

downtown alone. As we slowly move along, Nancy speaks with fondness for those protest days.

"It was history. We were making history, and you just don't get many chances to do that."

With obvious pride, Nancy reminisces about peace, flowers, and a generation that redefined America. For her, it was a time when the people were as close to their government as they could be.

"Of course, it wasn't all fun," she admits. "I got spit on once, and another time a woman pointed her finger and yelled at me, 'You shouldn't exploit your child like that!'"

For a moment, Nancy travels back to a day she will never forget. When she returns, her voice exudes grit.

"You know, that woman was wrong. My kids have heard me tell protest stories all their lives, and their only regret is that they weren't able to take part. They feel like they missed out on something important. My daughter and two sons come here to protest whenever they can."

Patting the "Stop the War on Workers Rights" button clinging to her coat, a smile spreads across her face.

"This is *their* chance to make history." ★

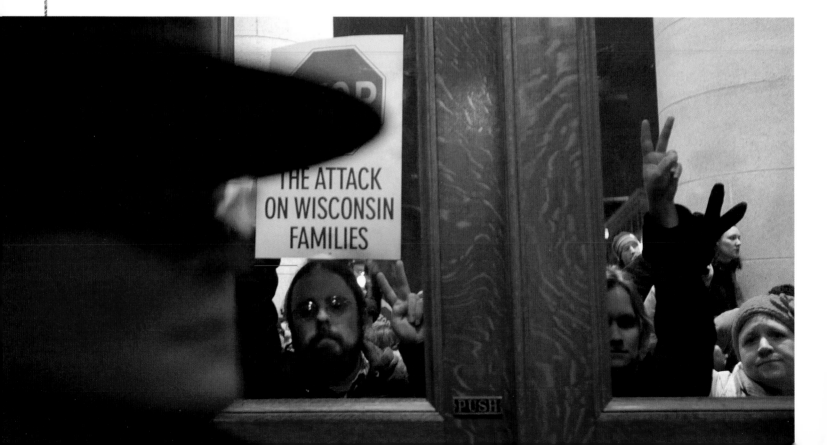

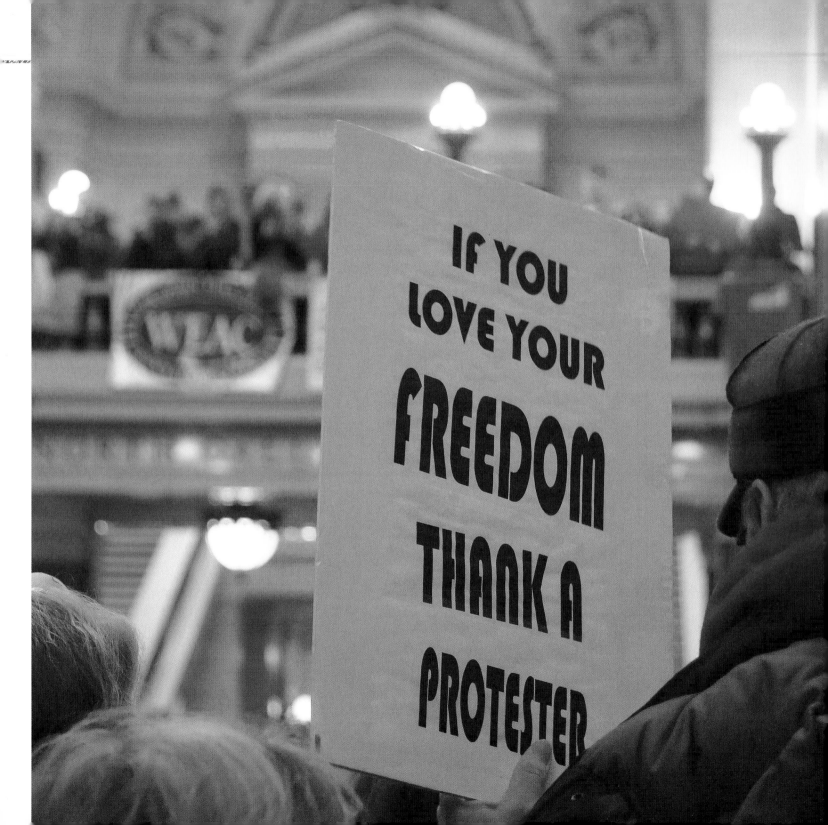

ACKNOWLEDGMENTS

When I started this project, it seemed simple enough—write some short stories and round up a few photographs. That ignorant euphoria lasted about a week. But as the path up the mountain kept getting more precarious, there always seemed to be someone there to catch me when I stumbled. I thank all of you for not letting this project fall to the ground with a big ol' thud.

Heather McElwain and Sue Boshers copyedited and proofread the text on a never-ending "need it yesterday" schedule. If there is a mistake, don't blame them. I probably changed something after they had read the pages. That is what authors do.

Robert and Deana Zorko listened to author rants at all hours of the day and night. That is what friends do.

If not for the photographers who generously shared their images, this book would have relied on my picture-taking abilities, which rank just above those of a six-year-old. I am indebted to you all. Six months ago, I didn't know any of you, but you shared anyway. Special thanks to Jim Escalante, Patrick DePula, and Mark Cavanah, who made the mistake of handing me their computers and telling me to "take what you like." I did.

There are three professional photographers I must thank personally—Michelle Martin, Mandie Habermann, and Martin Saunders. When this project was in its infancy, with a very uncertain future, they kept it alive by offering their images for virtually nothing. When I broached the subject of money, all three said, "I didn't take these photos to make money." If you readers want a family portrait, or need event photography, please go see them.

As husbands do, I will take credit for this book, even though you all know my wife did it. Yes, she triggered the idea, offered excellent advice on stories, and typeset every page—but I had to do the dishes.

Lastly, special thanks to all of the protesters I interviewed. Without a trace of fear, you opened your lives to some guy on the street. I'm not sure I would have done that. Thank you for not being me.

★ Michelle Martin Photography, Columbus, WI
michellemartinphotography.com

★ Martin Saunders Photography, Madison, WI
FotoMadison.com

★ Mandie Habermann, Red Gecko Studio, Madison, WI
redgeckostudio.com

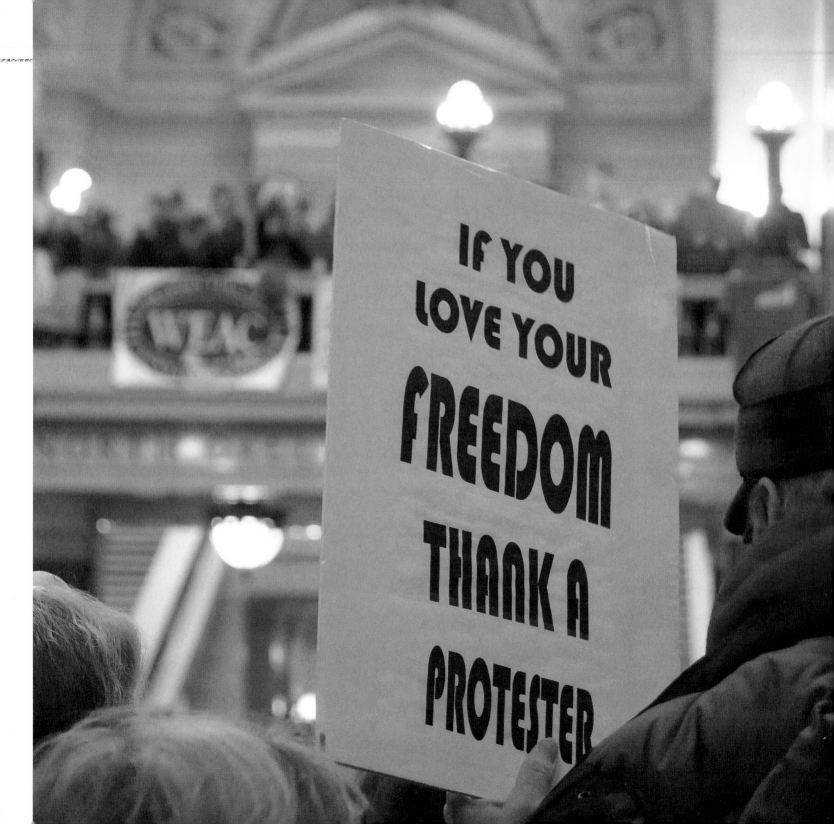

ACKNOWLEDGMENTS

When I started this project, it seemed simple enough—write some short stories and round up a few photographs. That ignorant euphoria lasted about a week. But as the path up the mountain kept getting more precarious, there always seemed to be someone there to catch me when I stumbled. I thank all of you for not letting this project fall to the ground with a big ol' thud.

Heather McElwain and Sue Boshers copyedited and proofread the text on a never-ending "need it yesterday" schedule. If there is a mistake, don't blame them. I probably changed something after they had read the pages. That is what authors do.

Robert and Deana Zorko listened to author rants at all hours of the day and night. That is what friends do.

If not for the photographers who generously shared their images, this book would have relied on my picture-taking abilities, which rank just above those of a six-year-old. I am indebted to you all. Six months ago, I didn't know any of you, but you shared anyway. Special thanks to Jim Escalante, Patrick DePula, and Mark Cavanah, who made the mistake of handing me their computers and telling me to "take what you like." I did.

There are three professional photographers I must thank personally—Michelle Martin, Mandie Habermann, and Martin Saunders. When this project was in its infancy, with a very uncertain future, they kept it alive by offering their images for virtually nothing. When I broached the subject of money, all three said, "I didn't take these photos to make money." If you readers want a family portrait, or need event photography, please go see them.

As husbands do, I will take credit for this book, even though you all know my wife did it. Yes, she triggered the idea, offered excellent advice on stories, and typeset every page—but I had to do the dishes.

Lastly, special thanks to all of the protesters I interviewed. Without a trace of fear, you opened your lives to some guy on the street. I'm not sure I would have done that. Thank you for not being me.

★ Michelle Martin Photography, Columbus, WI
michellemartinphotography.com

★ Martin Saunders Photography, Madison, WI
FotoMadison.com

★ Mandie Habermann, Red Gecko Studio, Madison, WI
redgeckostudio.com.

PHOTOGRAPHY CREDITS

All photographs used with permission. Copyright is maintained by the photographer.

Mark Cavanah: pages 26, 34, 56, 70, 94, 108, 123, 148

Patrick DePula: pages 40, 66, 80, 84, 90, 101, 106, 127, 139, 140, 141, 147

Jim Escalante: pages 7, 12, 20, 24, 27, 28, 42, 51, 91, 100, 115, 122, 126, 146, 155

Staci Fritz: page 112

Carol Ann Garner: pages 97, 145

Mandie Haberman, Red Gecko Studio: pages 2, 8, 25, 33, 36, 38, 43, 45, 59, 110, 120, 128

Kelly Hafermann: page 76

John Hart/Wisconsin State Journal, ©2011 Wisconsin State Journal: pages 44, 88

Timothy Hughes, Timothy Hughes Photographics: pages 78, 96

Victoria Huss: pages 10, 134, 135

Amandalynn Jones: page 17

M.P. King/Wisconsin State Journal, ©2011 Wisconsin State Journal: page 102

Michelle Martin, Michelle Martin Photography: pages 9, 15, 16, 18, 19, 31, 35, 48, 49, 54, 64, 65, 74, 86, 116, 117, 124, 125, 130, 132, 133, 152

Alexander McLimans: pages 144, 156

Paul McMahon, Heartland Images: pages 21, 22, 46, 104

Emily Mills: pages 69, 138

Stephanie Natale, Natale Photography: pages 58, 75

Ryan O'Hara: pages 47, 72

Scott Olson, ©2011 Getty Images: page 52

Nicole Peaslee: pages 82, 83

Chris Reeder: pages 55, 114

Martin Saunders, Martin Saunders Photography: pages 1, 5, 12, 14, 32, 41, 60, 62, 68, 73, 81, 98, 131, 137, 142, 162

Robert Stebler: pages 50, 92

Nathan Vergin: pages 39, 61, 63, 76, 85, 99, 109, 150, 151, 159

Dennis Weidemann: pages 6, 87, 113, 118, 152

Linda Weidemann: pages 4, 30, 66, 105, 107, 118, 136, 154

Krinstyna Wentz-Graff/Milwaukee Journal Sentinel, ©2011 Journal Sentinel, Inc. (reproduced with permission): page 158

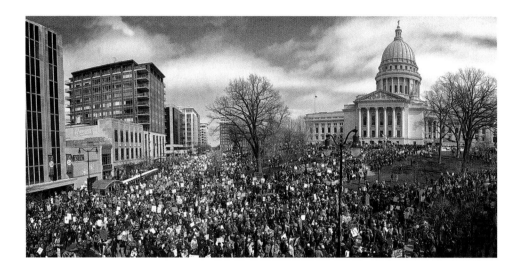

"Sometimes it just takes a look from people,
and they understand why you are here.
At that moment, it doesn't matter where
you come from, or what you do."

BERENS HOUSE